EMERGING ARTISTS 1978 – 1986

SELECTIONS FROM THE EXXON SERIES

BY DIANE WALDMAN

This exhibition is funded by a grant from
the National Endowment for the Arts.
Additional support has been provided by
Enichem Americus, Inc., and the
Grand Marnier Foundation.

SOLOMON R. GUGGENHEIM MUSEUM, NEW YORK

Library of Congress Cataloging-in-Publication Data

Waldman, Diane.
 Emerging Artists 1978-1986.

 Catalogue of an exhibition at the Solomon R.
Guggenheim Museum.
 Bibliography: pp. 80-138, passim
 1. Art, Modern—20th century—Themes, motives—
Exhibitions. I. Exxon Corporation. II. Solomon R.
Guggenheim Museum. III. Title.
N6487.N4S646 1987 709'.04'807401471 87-17596
ISBN 0-89207-063-6

EMERGING ARTISTS 1978–1986: SELECTIONS FROM THE EXXON SERIES

TABLE OF CONTENTS

EXXON EXHIBITIONS
AND PARTICIPATING ARTISTS

Young American Artists: 1978 Exxon National Exhibition
Organized by Linda Shearer
Siah Armajani, Scott Burton, John Egner, Denise Green, Bryan Hunt, Marilyn Lenkowsky, Robert Lawrance Lobe, Nachume Miller, Gordon Newton, Martin Puryear, Jenny Snider, Danny Williams, Scott Wixon

British Art Now: An American Perspective, 1980 Exxon International Exhibition
Organized by Diane Waldman
John Edwards, Alan Green, Tim Head, Keith Milow, David Nash, Hugh O'Donnell, Nicholas Pope, Simon Read

19 Artists: Emergent Americans, 1981 Exxon National Exhibition
Organized by Peter Frank
Michael Brakke, Guy de Cointet, Manny Farber, Vernon Fisher, Heidi Glück, Tom Green, William Haney, Patrick Hogan, Tom Holste, Barbara Kruger, Philip Larson, Jim Richard, Bill Richards, Darryl Sapien, Norie Sato, Gael Stack, John White, George Woodman, Frank Young

Italian Art Now: An American Perspective, 1982 Exxon International Exhibition
Organized by Diane Waldman
Sandro Chia, Enzo Cucchi, Nino Longobardi, Luigi Ontani, Giuseppe Penone, Vettor Pisani, Gilberto Zorio

New Perspectives in American Art: 1983 Exxon National Exhibition
Organized by Diane Waldman
Pegan Brooke, Bruce Cohen, Julie Cohen, Scott Davis, Steve Duane Dennie, Carol Hepper, Whit Ingram, Aaron Karp, Tom Lieber, Michael C. McMillen, Nic Nicosia

Australian Visions: 1984 Exxon International Exhibition
Organized by Diane Waldman
Peter Booth, Dale Frank, Bill Henson, Mandy Martin, Jan Murray, John Nixon, Susan Norrie, Vivienne Shark LeWitt

New Horizons in American Art: 1985 Exxon National Exhibition
Organized by Lisa Dennison
Phoebe Adams, Anthony Peter Gorny, Mark Innerst, Tobi Kahn, Mark Kloth, Rex Lau, Joan Nelson, Jim Peters, Irene Pijoan

Angles of Vision: French Art Today, 1986 Exxon International Exhibition
Organized by Lisa Dennison
Martine Aballéa, Richard Baquié, Judith Bartolani, Marie Bourget, Bernard Faucon, Philippe Favier, Ange Leccia, Georges Rousse, Patrick Tosani, Daniel Tremblay

PREFACE

A remarkable series of Guggenheim exhibitions sponsored by Exxon has come to an end and is summarized in the current selection. The program was dedicated to young art and subdivided into national and international presentations that spelled each other from year to year. The eight selections made largely by the Guggenheim's curatorial staff were begun in 1978 and terminated in 1986. In addition to the four exhibitions given to young artists in the United States, there was one each for emerging talents in Britain, Italy, Australia and France. Before moving to another as yet undefined phase that will undoubtedly continue with comparable objectives, it would seem appropriate to review the issues that the Exxon-sponsored program has raised.

Without doubt the most important feature of the Exxon series was its deliberate concern with the work of living artists. All museums, even those devoted to modern art, have found it difficult to accord sufficient care and attention to current explorations, particularly when this involves essays by the relatively unknown, unexposed and young. The reasons for the complications that arise are easily explained. Works offered to museums active in the field of contemporary art exceed demand by a wide margin. The efforts, therefore, to locate examples of high quality, to come to defensible decisions and to reach an acceptable consensus in an area in which subjective judgment is the most reliable measure, are difficult preconditions that nevertheless must be met before exhibitions can be staged and purchases can be consummated. Although funds required for experimental acquisitions are modest, it is nonetheless difficult to reserve them while a museum's other efforts are bent toward the purchase of relatively high-priced objects in less vulnerable categories. A regular, contemporary exhibition series with a built-in acquisition program is thus unlikely to survive as such unless set apart from other features and separately financed, as was the case with the Exxon Nationals and Internationals at the Guggenheim.

Coupled with the notion of young art, in this series, was its international dimension. The Guggenheim, as is well known, has its institutional roots in European art but has gradually come to reflect artistic values derived from an expanded international perspective. During recent decades an approximate parity between European and American art has come to be the Museum's natural stance in all its programs. As the art scene of the technological world has extended beyond its classical grounds, contributions from formerly neglected areas such as Japan, Australia and Latin America have widened the Guggenheim's horizons. This commitment to internationalism seems to us to have its greatest justification

in the art of the young, for in addition to the pleasure and advantage we derive from the possession of the works themselves, global interaction between artists and their environments may be expected to have a positive formative effect upon creative people while bestowing the benefits of a broadened perspective upon their viewing public.

With regard to museum selections of contemporary art, much remains that is problematical and perhaps forever irresolvable. A foolproof system for determining quality and distinction in this field escapes us now and always will. We know therefore, and our critics should know, that all that can fairly be asked is a conscientious, intelligent search on the part of informed curators whose integrity is not in doubt—a search for the purpose of achieving as unfiltered a reflection of a validly current sensibility as possible. Fortunately, selections are made not by computers but by human beings, and they are made not in a vacuum but very much in the midst of challenge, controversy and pressure, and in an atmosphere of ripening convictions on the part of curators as well as a responding art public. Added complications arise with choices of international art. Here perceptions quite naturally vary from country to country and Guggenheim curators inevitably run the risk of either forcing an American viewpoint upon prospective participants or allowing a foreign sensibility to assert itself against a judgment that quite understandably takes the reactions of the American art public into some account. The former condition may and occasionally did offend sensitivities in the countries of origin; the latter may and at times did add to the difficulty with which a foreign creative contribution could be validated here. It is often said that the visual arts need no translation but this is true only in a literal sense, since foreign cultures certainly do depend upon knowledgeable and tactful intermediaries to further their chances for acceptance when they are detached from their original cultural context.

What remains is to survey the cumulative effects that the four Exxon Nationals and the four Internationals have had since their inception in 1978. To begin with the artists, eighty-five have been presented to a New York public and in some instances to other centers, most of them for the first time. The effects upon their lives are difficult to assess, but no complaints have been registered as a result of the exposure that Exxon and the Guggenheim have provided for them. The number of artists would need to be significantly multiplied if one were to estimate how many in this country and abroad have been visited by Guggenheim curators for purposes of evaluation. There is ample evidence that those visited felt enriched and correspondingly appreciative for having been considered and encouraged, even if some had to cede their places to others in a process of gradual sifting. For the four curators who produced the eight Exxon shows and accompanying catalogues, the experience had very considerable formative benefits. The travel and search in this country and in four others could not but lead to expanded intellectual, cultural and aesthetic horizons, in addition to providing them with first-hand technical experience in a particular aspect of museum work. The Guggenheim's collection was enriched by many pieces that otherwise would not have come to us. The number of these acquisitions has more than equalled that of the artists selected. Together with other purchases and gifts, the painting, sculptures and examples in different media now make up the backbone of our contemporary holdings. It is taken for granted that many of these works will fall short of the expectations that the curators held at the time they recommended the purchases, but it is also already evident

that more than a few of them are finding an important place within the Museum's established compass and that some will have enhanced the collection in a lasting way. The Guggenheim's annual selections and purchases have been followed by alert avant-garde collectors who, closely upon our heels, have made acquisitions of their own, while dealers have repeatedly extended to artists sponsored by Exxon and the Guggenheim the welcome of their galleries. Thus such side effects have carried the advantages of museum exposure into other legitimate areas. Benefits derived by Exxon are also quite apparent, for the Corporation was rewarded for their courage in sponsoring contemporary art by being singled out in the world of institutional culture as the only concern that has supported a creative and frankly experimental activity with ample means and for an extended period of time. And finally one must add to the project's obvious advantages the contact that, through these exhibitions, was established between young artists and the visiting museum public—a public unlikely to seek out artists in their studios or even in commercial galleries in this country, to say nothing of those abroad.

These benefits to a variety of interested parties are far from negligible and, we trust, will be reflected at least in part in the current exhibition. For their generous support of *Emerging Artists 1978-1986*, the Guggenheim gratefully acknowledges the National Endowment for the Arts, Enichem Americus, Inc., and the Grand Marnier Foundation. As our series comes to a close, I am eager to extend the Guggenheim's abiding gratitude, on behalf of the Foundation's Trustees and the Museum's Staff, to the many individuals and organizations that have had a share in the initiation and the progressive development of the Exxon Nationals and Internationals at the Solomon R. Guggenheim Museum.

Thomas M. Messer, *Director*
The Solomon R. Guggenheim Foundation

Installation view, *Italian Art Now: An American Perspective, 1982 Exxon International Exhibition*, foreground, Giuseppe Penone, l. to r., *12 Meter Tree*, 1981, and *Breath*, 1978; middleground, Giuseppe Penone, *Breath of Leaves*, 1981; background, Vettor Pisani, l. to r., *Oedipus and the Sphinx. Theater on the Abyss*, 1980, and *R. C. Theatrum. Theater of Artists and of Animals*, 1982

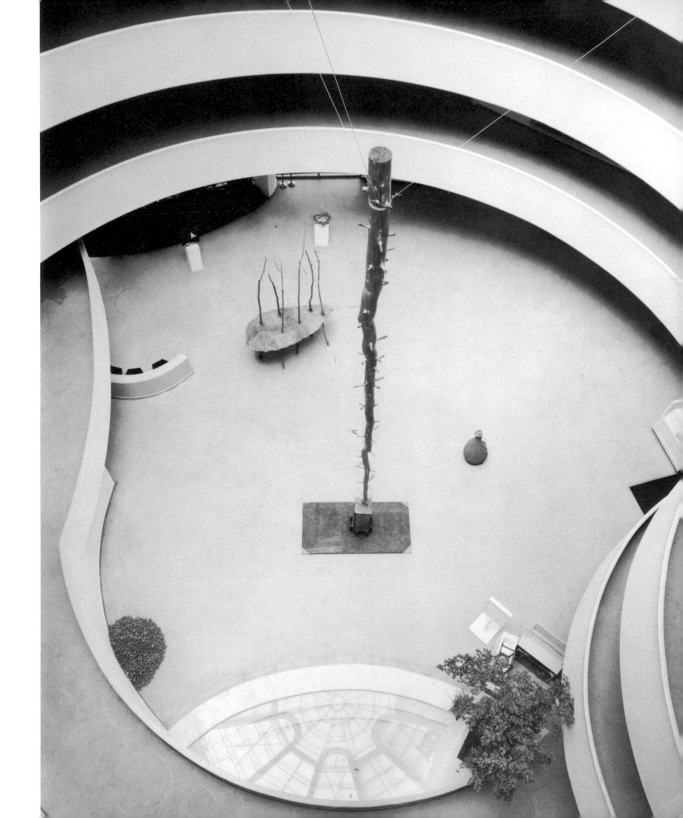

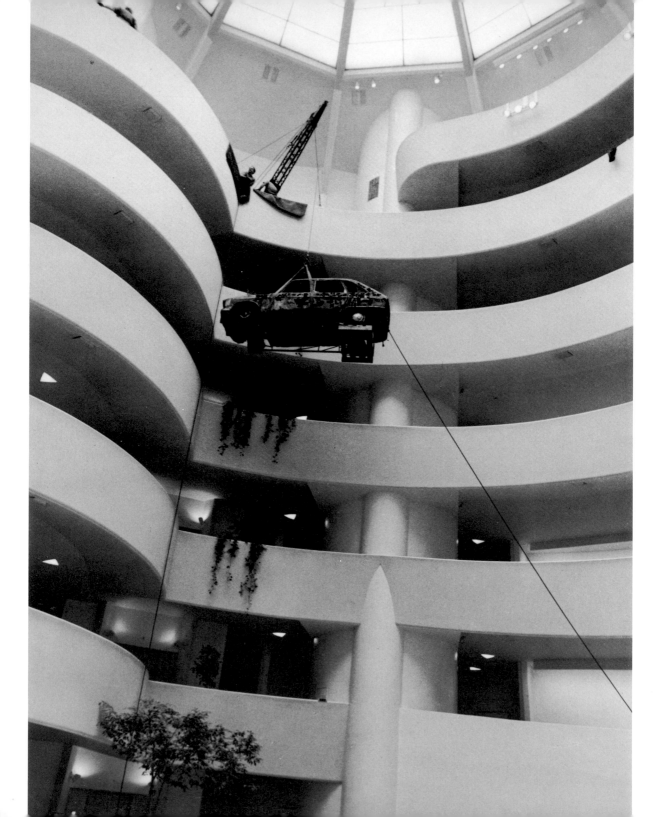

ACKNOWLEDGMENTS

For their essential financial support of the series of young talent exhibitions I would like to extend the Guggenheim Museum's sincere thanks to the Exxon Corporation. Without it this important program would not have been realized. The current, final Exxon selection was organized by Diane Waldman, the Guggenheim Museum's Deputy Director, who has played a leading part throughout the duration of the series. She relied upon the able assistance of many Museum staff members, and Mrs. Waldman and I are therefore happy to acknowledge all such contributions. We would particularly like to thank Susan Hapgood, Curatorial Coordinator, who worked diligently and enthusiastically on all phases of the project; Diana Murphy, Assistant Editor, for her intelligent editing of the catalogue; Lisa Dennison, Assistant Curator; Carol Fuerstein, Editor; and Jane Rubin, Associate Registrar. Special mention is also due to Hilda Bollen, Curatorial Intern; Carol Vaughan, Curatorial Fellow; Nina Nathan Schroeder, Curatorial Assistant; Sophie Hager and Karyn Zieve, Curatorial Fellows; Jonathan Danziger, Curatorial Intern; and Elisabeth Hodermarsky, Administrative Assistant.

T.M.M.

Richard Baquié, *Epsilon (working title)*, 1986, during installation of *Angles of Vision: French Art Today,* 1986 Exxon International Exhibition

Installation view, *New Perspectives in American Art: 1983 Exxon National Exhibition*, Michael C. McMillen, *The Witch of Draconis*, 1983

EMERGING ARTISTS 1978–1986
SELECTIONS FROM THE EXXON SERIES

BY DIANE WALDMAN

The Guggenheim Museum has a long history of support for emerging artists. As early as 1953 and 1954, in its exhibitions of *Younger European Painters* and *Younger American Painters*, the Guggenheim began to feature the work of younger, lesser-known individuals in a program that included periodic surveys of international painting and sculpture, reviewed the development of artists in mid-career, explored certain timely themes in twentieth-century art and featured large-scale retrospectives of some of this century's most renowned figures. As James Johnson Sweeney, curator of both shows, noted in the introduction to the *Younger European Painters* catalogue:

> This exhibition was conceived originally as the first section of a two part showing of work by younger contemporary artists....In both cases the term "younger" was intended to refer to the youth of the artist's reputation in comparison with the longer established names of our day. It was planned to be a selection from the broad field of contemporary work rather than a full representation of it. It was intended from the onset to stand as a frankly personal selection—representative of what one individual regarded as interesting pictorial expressions, rather than representative of the general consensus of opinion, either popular, or professional. Throughout, a strict personal "selection" is possibly the key to the character of the group.[1]

In the preface to the *Younger American Painters* catalogue, Sweeney stated that the presentation was "a companion exhibition to the [first] selection" and that "the two exhibitions were conceived as a single exhibition without any national distinctions." He cited lack of space as the primary reason for dividing the show into two parts. Having done so, however, he was tempted to ask—and answer—the question about the difference between the painting of younger European and younger American artists. He responded, in part, as follows:

> We are struck first of all by a brightness of palette, a liveliness and audacity—often a sharpness and coldness—in contrast with the warm sobriety of tone which (if we except certain northern expressionists) characterizes most of the European work. The shapes that go to make up the Americans' compositions are commonly active shapes conveying a restless rhythm quite foreign to the smooth flowing forms and the organized calm of the Europeans. Their composites lean towards a two dimensional emphasis supported by a stress on linear features more often than towards the Mediterranean stolidity of composition in which the third dimension is always patently suggested, if not asserted. The overall effect of the Americans' work is one of

insistence, urgency, eagerness, impatience in contrast with the Europeans' comfortable, easy-going assurance which in confrontation with it seems at times almost apathetic. In the younger Americans' work we recognize a predominantly emotive, decorative expression; in the Europeans', a fundamentally reasoned, structural one.[2]

Although the Guggenheim continued to show younger artists throughout the late 1950s to the late 1960s, it did not feature them in exhibitions devoted exclusively to young art, but in those that set older, recognized artists and newer talents side by side. The program of presenting the work of emerging artists resumed in 1969 under the auspices of the Theodoron Foundation, and that year Dan Christensen, Barry Flanagan, Bruce Nauman, Gerhard Richter, James Seawright, Richard Serra, John Walker, Peter Young and Gilberto Zorio were chosen for exhibition. As with succeeding Theodoron Awards and Exxon shows, the intention was to single out the work of a small number of young artists, many of whom had little or no previous museum exposure, and to acquire one piece by each for the Guggenheim's collection. The list of participants comprised four painters and five sculptors; however the representation was international, with five Americans, two Britons, one Italian and one German. While in subsequent exhibitions the Museum reverted to its practice of alternating between American and European art, this presentation continued the Guggenheim's efforts to encourage young artists, an idea first articulated by Sweeney. Implicit in our choice of the artists for the 1969 show was an awareness of the role they played in signaling a new tendency or trend in contemporary art. At the same time, though, the Museum wished to recognize talented individuals who might not be part of a school or trend. The selection was meant to be a representation of some contemporary issues rather than an all-inclusive survey of recent art. Above all, we wished to encourage the experimental, even idiosyncratic qualities that often characterize emerging art at its best. This exhibition launched a series of small-scale presentations, and the Theodoron Awards were offered again in 1971 but, due to lack of funding, could not be repeated until 1977. The artists chosen for the 1971 show were Power Boothe, Ron Cooper, Billy Bryant Copley, Mary Corse, Guy Dill, Andrew Gerndt, Harriet Korman, Dona Nelson, Michael Singer and George Trakas; the 1977 exhibition featured John Duff, Steve Gianakos, Darryl Hughto, Michael Hurson, Mary Miss, Elizabeth Murray, Katherine Porter, Allen Ruppersberg and James Surls.

Beginning in 1978, with the support of the Exxon Corporation, the Guggenheim Museum inaugurated a new series of exhibitions, also designed to provide visibility for an emerging generation of promising young artists. We decided that it would be best to alternate, on an annual basis, between presentations of art from America and abroad. In focusing on one nation rather than on many, the Museum sought to identify artists who articulated their national origin and at the same time acknowledged an awareness of international developments in contemporary art. In keeping with this premise, each of the curators involved in the series was encouraged to select a relatively small number of artists and to provide each with the opportunity of showing more than one or two examples of his or her work.

As Linda Shearer, curator of the first Exxon National Exhibition, indicated in her introductory remarks for the show's catalogue, the late 1970s appeared to be a time of

stylistic diversity in the United States. The orderly and rapid progression of styles that characterized American art of the 1950s and 1960s was replaced, in the 1970s, by a complexity that "... best describes the uncertainties and ambiguities of the experience and art of our own decade."[3] This complexity involved a renewed exploration of the organic abstraction that attracted such early pioneers as the European Kandinsky and the Americans Dove, Hartley and O'Keeffe, a reintroduction of the image, a return to constructed form based upon both two- and three-dimensional elements, and a new interest in sculpture that entered the realm of architecture or was conceived with a social end in mind. Nature as well as man-made structures also played significant roles in the thinking of these young artists, in contradistinction to the Minimalists of the 1960s, who stressed industrial materials, repetitive units and geometric forms. Above all, the artists of the late 1970s insisted on the primacy of the individual sensibility rather than a group aesthetic.

In the catalogue for the 1978 Exxon National Exhibition, several of the artists stated that their work grew out of their experience with performance art and Conceptual Art. The premise of Conceptual Art—that concept is more important than end product—inspired them to reach beyond painting and sculpture to architecture and the applied arts. In both areas, of course, there were precedents in the work of the Russian artists Lissitzky, Rodchenko and Tatlin, but whereas they conceived of architecture and the applied arts as serving different functions, Siah Armajani, Scott Burton and others of their generation preferred to blur the distinction between disciplines.

The social function of furniture and the behavioral dynamics it generates, two issues that were undoubtedly influenced by performance art, played a fundamental role in the development of Scott Burton's chairs and tables. In contrast to Armajani's and Burton's more publically oriented work, Martin Puryear's sculpture was highly individuated and subjective rather than objective in its conception and resolution. He, too, was impressed, as were Burton, Armajani and many of their contemporaries, by the power of the object as it was defined by the Minimalists, but sought in his art to redefine the object in terms of its own particular qualities instead of characterizing or classifying it as an object as such. Robert Lawrance Lobe, while also an admirer of Minimalism, turned to nature as the direct source for his work, rejecting geometry and the rationalization and intellectualization of the process of making art in favor of the closest possible association with actual forms, such as trees, found in the landscape around New York.

The 1981 Exxon National Exhibition was organized by a freelance curator, Peter Frank. Under his direction both the scope of the Exxon shows and the age range of the participants were expanded; nineteen artists were included and their ages varied widely, with the oldest being sixty-four and the youngest thirty-one. The selection was broadly based, encompassing among others Heidi Glück, Barbara Kruger and Gael Stack, and was intended to reflect the multifaceted nature of contemporary art at that time. Glück's monochromatic, non-objective and Minimalist-influenced paintings stood in striking contrast to Barbara Kruger's photographs, in which she used words and appropriated imagery to comment on social and political issues; Stack's diaristic work was based on a calligraphic and extremely painterly visual language of evocative and enigmatic forms. Much of the art presented was witty, all of it was highly personalized and thus seemed to speak of the numerous directions artists were investigating at the beginning of the decade.

A fascination with nature and natural phenomena also informed the work of several artists in the 1983 Exxon National Exhibition. Carol Hepper, like Robert Lobe, was able to draw upon her surroundings to furnish the raw material of her work; from the driftwood and animal bones and skins of South Dakota, from nature and from earlier cultures, she fashioned a statement that reflected both past and present. Strikingly different from Hepper's orientation were those of Julie Cohen and Michael C. McMillen, both of whom used box constructions to evoke memory, reminiscence, nostalgia. Pegan Brooke, like a number of artists in the 1978 show, was influenced by Klee at an early stage in her development. But Brooke's encounters with Incan and Mayan sites induced her to alter her vocabulary of forms. Stimulated by the lush, dense vegetation and the intense heat and light of Peru and the Yucatan, she turned to a more direct interpretation of landscape and, from the heightened experiences that issued from her observations, produced a new and rich body of imagery.

In the course of the first three Exxon Nationals, other ongoing concerns revealed themselves as well. The geometry of pure form in painting, as it was explored by the de Stijl movement in the early twentieth century, played a vital role in the genesis of American abstraction during the 1930s. It resurfaced, albeit in a vastly different expression, in the Minimalist painting of, most notably, Agnes Martin, Robert Mangold, Brice Marden and Robert Ryman. In this decade it has emerged in the work of, among others, painters Heidi Glück and Scott Davis, who were included in the 1981 and 1983 Exxon shows, respectively. Far from reconstituting the ideas of preceding generations, however, Glück brought to reductive painting a new delicacy and poetry, while Davis introduced a sense of whimsy and wit that would have been unthinkable previously. Although Mondrian was very important in Davis's development, it was Duchamp's influence that was decisive, especially in those canvases that explored chance effects and involved veiled meanings and ironic commentaries.

Alternating with this sensibility was a more painterly one, as evidenced in the work of Denise Green, featured in the 1978 National, and Aaron Karp and Tom Lieber, two participants in the 1983 show. Similar to Puryear, Green acknowledged the role of personal experience in the creative process, and this principle, largely denied in the work of the Minimalists, endowed her painting with a high degree of subjectivity and intimacy. Karp, like Green, mediated between systematic imagery, painterly process and vibrant optical effects, and the result, in his canvases as well as his works on paper, was an expressiveness that separated his art from the more purely reductive idiom. Lieber, inspired by Rothko and the late paintings of Philip Guston, developed a personal syntax in his art that admitted into a lyrical, abstract field reflections of the human form in various stages of existence. The unfolding of the human identity, as it was portrayed by Lieber, endowed the works with a hallucinatory presence reminiscent of the ghostly forms that inhabit Giacometti's paintings. They expressed Lieber's exploration of his own psyche and represented an aspiration to renew the relationship between figure and field.

More recently, as the Exxon National of 1985 demonstrated, a new emphasis upon the figure, on religious imagery and on the appropriation of images, and a continued attraction to landscape and abstraction were some of the issues that held great interest for America's younger artists. As we near the end of the decade, we are witnessing, in America at least, a diversity of approaches in many media—installation, painting, sculpture, photog-

raphy and myriad variations thereon—and this phenomenon has remained evident throughout the course of the Exxon program.

In 1980 the Guggenheim Museum initiated the Exxon International series with an exhibition of younger British artists. As it had earlier, the Guggenheim presented artists who were relatively unknown to the museum-going public. In choosing the participants in the show, I attempted to offer an American view of some of the most interesting aspects of new British art. As I wrote of the British artists then, "Although they do not represent a single direction and each was selected exclusively on the basis of his own merits, they do share certain qualities in common. Generally, they eschew monumental size for its own sake, they reject the heroic posture. If their work is small it lacks preciosity; if large, it remains related to the human dimension. The sense of intimacy despite large scale, characteristic of American painting of the 1950s, absent in much of 1960s art, is present once again in the British art of the 1970s."[4] Foremost among the tendencies that emerged in British art of the late 1970s was an ongoing commitment to abstract form and content, a commitment that was rooted in the pioneering work of Barbara Hepworth and Ben Nicholson and remains current to this day. Equally compelling was the deep concern with sculpture. Far less evident at the time of the organization of the show, although more pronounced several years later, was a revival of interest in the figure, largely the result of the resurgence of Expressionism elsewhere. The reticence, elegance and whimsy that appear to be fundamental to the British temperament informed and continue to inform much British art, whatever its idiom. It was this singular temperament and a resolute individuality that was conveyed by the young British artists selected for the first Exxon International Exhibition.

A very different sensibility emerged in the Italian Exxon International of 1982. The exhibition featured seven painters and sculptors who looked for inspiration to the artists of the early Renaissance, to the world of alchemy and the occult, to *Pittura Metafisica*, to *Arte Povera* and to performance art. In speaking of himself and his contemporaries, the Futurist Carlo Carrà once explained that the most avant-garde commitment on the part of the Italians of his generation was tempered by a fascination for early Renaissance art, in particular for Giotto and Uccello. Allegorical, mythological and Oriental subjects, themes of androgeny and hermaphrodism, and deliberate clumsiness in drawing, paint handling and the representation of perspectival space became preoccupations of many vanguard artists in the 1920s and 1930s; significantly, they were also of central concern to many young Italians working in the early 1980s. In contrast to the artists exploring this mode were other young Italians who premised their art on a Minimalist aesthetic. Common to all of these artists, however, was an awareness of their culture. This consciousness of Italy's ancient past imbued all of their work, even the most reductive statement, with a vision that lent it its singular grace. The continuum of past and present, of ancient culture and new and vital civilization which informs other aspects of Italian life, also infuses even the most recent art of that country.

Nothing could be further removed from this sensibility than that expressed by the young Australians as they were presented in the 1984 Exxon International Exhibition. As I remarked in my catalogue text:

We see in the young Australian art of today a directness, a powerful emotive sensibility that finds expression in an intense pathos or humor, a sense of melodrama, a raw energy, a rude sense of color and form and finally an awkwardness that is both uncomfortable and reassuring in its vitality and affirmation of feeling. Recent Australian art is disquieting because, like Australia itself, it directly confronts our consciousness. It refuses to be polite and quiet. It refuses to draw upon pop imagery we can consume and forget like supermarket products. Art in Australia, because it is ungainly and demanding, does not conform to our expectations of a seemly art. It asks of us rather than simply gives to us. To this extent it is unyielding and unsympathetic and distinct from the humanist landscape and portrait painting that has evolved since the Renaissance. It also stands outside the tradition of social realism in that it speaks more intensely of individual inner feelings than of the issues of the day.[5]

The paintings, photographs and installations in the exhibition (few Australian artists were concentrating on sculpture at the time) were both deeply autobiographical in nature and yet also a reflection of the state of art in Australia and the state of art as it was seen by its young creators. In this country, too, respect for European art was boundless; however there was an increasing awareness of Australia, of its position and place in the world and of its unique culture. Younger artists looked to their own artistic heritage, in particular to the expressionistic work of Arthur Boyd, Sidney Nolan, John Perceval and Albert Tucker. They also turned to the important precedent of Fred Williams's landscape paintings and to the landscape itself for their inspiration. Many of the artists expressed great admiration for the intense light, the land—tamed in the cities, unruly in the bush and the outback—the immense sky which sits very low on the horizon and provides an ever-changing panorama that runs the entire gamut of color from silver to orange to black, the lush Pacific coast and the rich red desert, the exotic foliage, the ungainly animals and graceful birds. Out of this country full of unexpected and dramatic contrasts developed an aesthetic that was equally varied and dynamic. This aesthetic, given individual expression by eight artists, was the underlying theme of the 1984 Exxon exhibition.

In 1986 the Guggenheim held the last in its series of Exxon Internationals. The country selected was France; the young artists in the show represented some of the more compelling new directions in that nation's contemporary art. In recent French art both painting and sculpture have been less in evidence than other media, and emphasis has been placed on the photographic image, on assembled objects and on constructions that negate the boundary between painting and sculpture. French art of the 1970s had displayed a pronounced Minimalist character, and in the early 1980s the analytical and theoretical underpinnings of this art were replaced by a revival of figuration that drew upon popular culture for its imagery and upon a form of narration that included mythological and historical references. Lately, however, there has been a return to Minimalism and Conceptualism, and language is often used as a vital tool. Dada and Duchamp hold renewed interest for the young artists investigating these modes and who have, in turn, renovated the tradition of the poetic association between actual object and image, between image and language. The diaristic nature of some recent French art has precedents in the work of Christian Boltanski and Jean Le Gac, who seek to reconstruct their own histories through memory. (Both were shown at the Guggenheim in 1972 in *Paris, Amsterdam, Düsseldorf*, an exhibition which was not in the series under discussion yet is nonetheless related to the

program.) As Lisa Dennison has said of these two artists, "They explore the ambiguous relationship between art and reality, intending to prove that in the failure of representation to re-present the lived reality, art is, unavoidably, fiction."[6] The fictional strategies that they invented have proven highly influential for many younger French artists who have chosen to further explore the distinction between art and reality by creating composite images of actual events that, in their finished form, read as fiction. Many of the objects and scenes that the artists have selected are, like their other materials, taken from the mundane world, but there is nothing commonplace about the way in which they are composed or arranged in the works of art. From quotidian objects or events the artists have wrought distillations of memory and experience.

In the years that the present exhibition spans, Neo-Expressionism emerged as the one movement that could legitimately claim international status. Prior to its appearance many individuals rather than a coherent group seemed to dominate both American and European art. While the term Neo-Expressionism was applied generically to a style of art from several nations, it was largely identified with that of three cities—Rome, New York and Berlin. Each of these cosmopolitan centers provided a conducive climate in which variations of this mode flourished. The young Italians in the Exxon exhibition who were most closely identified with Neo-Expressionism—Sandro Chia, Enzo Cucchi and Nino Longobardi— drew on Italy's rich and complex history and revived and transformed diverse artistic sources, including the social realism of the 1930s, the late paintings of de Chirico and such ancient techniques as bronze casting, to fashion an idiom of the 1980s, one that accommodated the sparest and the most elaborate expressions alike. One of the American forms of Neo-Expressionism was graffiti art, which offered a tough and genuine commentary on contemporary society. Graffiti art was truly anarchical in spirit, an art of the streets and the subways. Other versions of American Neo-Expressionism depended on the media for their mythology and visual vocabulary; like their European counterparts, these modes appropriated imagery from earlier art and at the same time engaged in social and political commentary. Unlike their European analogues, however, all these variations of American Neo-Expressionism remained equally concerned with formalist issues and with the immediate visual impact of the image. Sweeney's words seem equally appropriate to describe this art, for it too possessed "a liveliness and audacity...a sharpness and coldness...in contrast with the warm sobriety of tone which...characterizes most of the European work." German Neo-Expressionism, on the other hand, found its sources in the generation of German artists that directly preceded World War I. References to Beckmann, Kirchner and others abounded in the jagged forms, acidic colors, controversial themes and strident voices of the newer painting.

A linkage can be found between Neo-Expressionism and the work of artists not associated with that movement, for example the Australian Peter Booth, whose desolate landscapes reveal a sensibility, an inner shriek and a need to communicate from deep within that align him with artists who had adopted that mode. And like them, Booth looked to earlier sources—in his case, Australian as well as European art—for precedents. However while Neo-Expressionist activity was in evidence elsewhere, other concerns have developed independently of it—both outside the three centers of Neo-Expressionism and even within them—that have proven to be of much interest. In Britain, for example, the most important

new investigations have been made in the area of sculpture. And in America and France we have seen a significant revival of Pop, Conceptual and Minimal forms in painting, sculpture and other media. Neo-Expressionism has not left a decisive imprint on successive generations, and this absence of a common gestalt has kept the notion of a unified school or style very much open to question. What we may very well witness in the remaining years of this decade is the surprising and often unpredictable element in art that is the result of the individual sensibility.

Although it has been useful to bring before the public the work of young artists from America, Britain, Italy, Australia and France, looking at each nation's art for its distinctive qualities, it is equally important to consider this art in a cross-cultural context. In organizing *Emerging Artists 1978-1986: Selections from the Exxon Series*, we have decided to disregard national boundaries in order to make manifest some of the issues that have seemed to engage young artists in recent years. Among these currents are appropriation, the return to reductive form, the renewed interest in sculpture, the increased emphasis on politically or socially oriented art and the revival of landscape and figurative imagery. For example the Australian Mandy Martin and the American Joan Nelson both work in the idiom of landscape, depicting stark views of industrial sites or other locales where man's interventions have become as permanent a feature as the natural surroundings themselves. Despite significant differences between the two artists' palettes and techniques, the somber effects they produce and the sinister messages they convey about the modern environment are disturbingly similar. In the area of photography, the tableaux of Nic Nicosia are decidedly American in their reliance on Pop culture for their subject matter, yet they share with the photographs of the Frenchman Georges Rousse an imagery that is part actuality, part fiction. By combining painting and installation with photography, Rousse, like Nicosia, is able to meld these very disparate processes. In Rousse's and Nicosia's art it is the photographic image that both supports and undermines what we are given to view as complete. But just as Rousse's most recent work is more geometric in orientation and thus may be as profitably compared in its formal concerns to the paintings and installations of the Australian John Nixon or to the cross constructions of the Briton Keith Milow, so do the light and illusion that are part of these photographs endow them with a presence that transcends form and medium. As such, there is in his work both an expression of the palpable and the immaterial, and a desire to extract from the real a sense of the imagined.

The fictional strategies devised by many of the artists in the French Exxon International find their parallel in the work of the American Michael McMillen, who makes of reality a touching fiction. Using elements drawn from the real world—crumbling tenements, dusty hallways, cheap hotels—McMillen fashions constructions which reveal him to be an astute observer of daily existence, but someone for whom life can be viewed as poetic metaphor. The distillation of experience, so central to the creative act, finds its way into the work of artists involved with myth, allegory and fantasy; abstract imagery, whether geometric or organic; and objects constructed from scraps of the real world, whether urban or rural. It finds its way as well into the work of those artists who use language to create visual effects and to comment on real-life situations. It affects visual statements of the most minimal order and those that purport to express reality in all its detail. The primary goal of the

Exxon series has been to present the young artist, the artist in the formative stages of development. While this ambition courts both success and failure, we feel the risks are eminently worthwhile. It is our hope to renew this series, to welcome another generation of young artists to our program and to provide them with a broader forum for valuable dialogue.

NOTES

1. James Johnson Sweeney, *Younger European Painters: A Selection*, exh. cat., Solomon R. Guggenheim Museum, New York, 1953, unpaginated.

2. James Johnson Sweeney, *Younger American Painters: A Selection*, exh. cat., Solomon R. Guggenheim Museum, New York, 1954, unpaginated.

3. Linda Shearer, *Young American Artists: 1978 Exxon National Exhibition*, exh. cat., Solomon R. Guggenheim Museum, New York, 1978, p. 8.

4. Diane Waldman, *British Art Now: An American Perspective, 1980 Exxon International Exhibition*, exh. cat., Solomon R. Guggenheim Museum, New York, 1980, p. 9.

5. Diane Waldman, *Australian Visions: 1984 Exxon International Exhibition*, exh. cat., Solomon R. Guggenheim Museum, New York, 1984, p. 10.

6. Lisa Dennison, *Angles of Vision: French Art Today, 1986 Exxon International Exhibition*, exh. cat., Solomon R. Guggenheim Museum, New York, 1986, p. 8.

Installation view, *Young American Artists: 1978 Exxon National Exhibition*, Siah Armajani, *Lissitzky's Neighborhood, Center House*, 1978

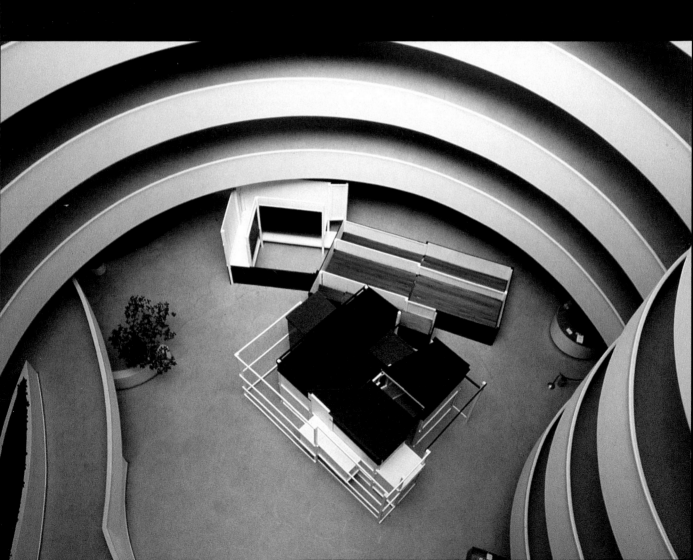

DENISE GREEN

To Draw On. 1977
Oil, wax and crayon on canvas, 60 x 60″
Exxon Corporation Purchase Award, 1978
78.2424

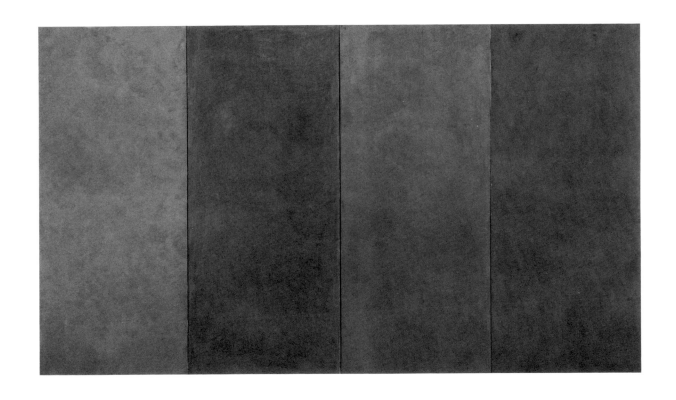

ALAN GREEN

Four Vertical Reds. 1978
Oil, tempera and acrylic on canvas,
total 96 x 144¼″
Exxon Corporation Purchase Award, 1980
80.2673.a-d

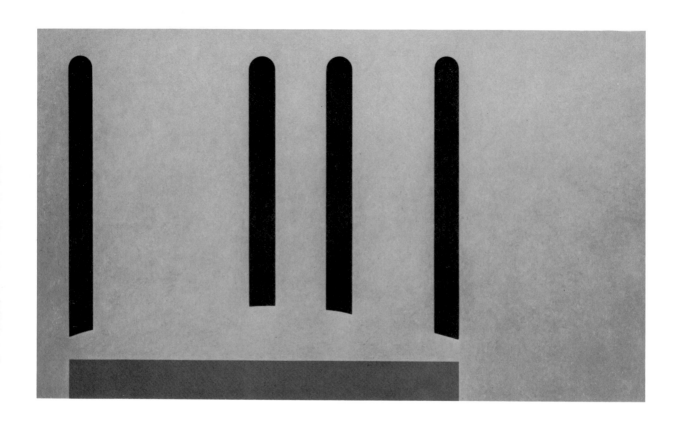

SCOTT DAVIS

Thinking and Working. "The Garden (Poussin's Backyard)." 1983
Oil on canvas, 51 x 84¹⁄₁₆″
Exxon Corporation Purchase Award, 1983
83.3049

HEIDI GLÜCK

Untitled. 1979
Ink and acrylic on canvas, 11¾ x 41⅛"
Exxon Corporation Purchase Award, 1981
81.2801

GAEL STACK

Up Against the Wall. 1976
Chalk, pencil and oil pastel on paper, 23 x 29″
Exxon Corporation Purchase Award, 1981
81.2818

TOM LIEBER

Rising. 1983
Acrylic on canvas, 96 x 84″
Exxon Corporation Purchase Award, 1983
83.3105

DANNY WILLIAMS

The Mountain King. 1977
Acrylic on paper, 59⅝ x 51″
Exxon Corporation Purchase Award, 1978
78.2432

HUGH O'DONNELL

Palaestra. 1979
Oil on canvas and wood, 79 x 103"
Exxon Corporation Purchase Award, 1980
80.2677

AARON KARP

A Fist for Balla. 1983
Acrylic on canvas, 89 x 79⅛″
Exxon Corporation Purchase Award, 1983
83.3089

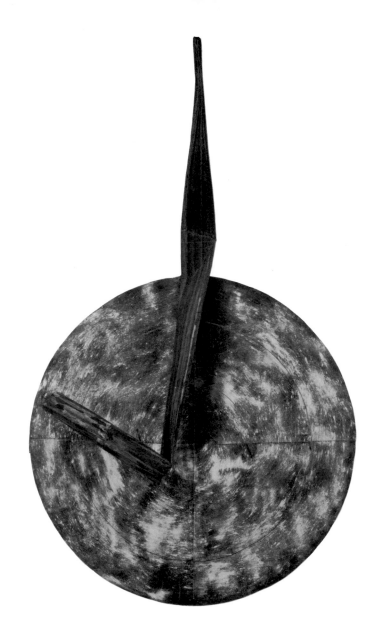

MARK KLOTH

Passing Stage. 1985
Metal, casein and dry pigment on canvas,
113 x 68 x 23½″
Exxon Corporation Purchase Award, 1985
85.3326

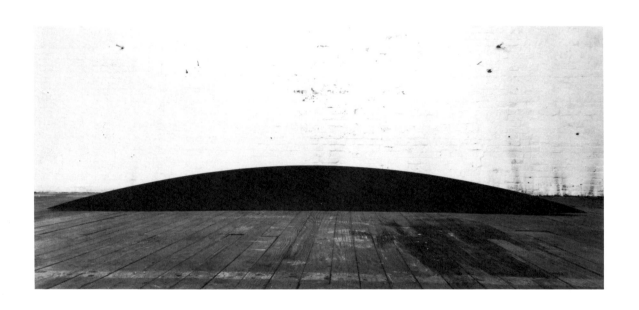

MARTIN PURYEAR

Bask. 1976
Staved pine wood, 12 x 146¾ x 24″
Exxon Corporation Purchase Award, 1978
78.2430

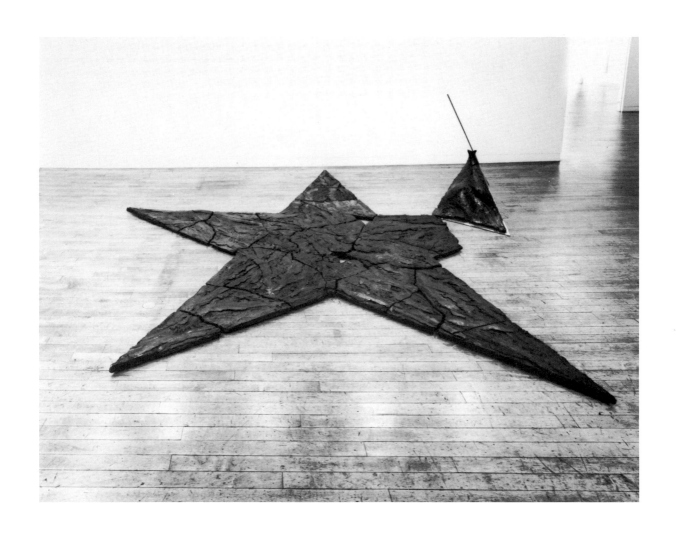

GILBERTO ZORIO

Star (To Purify Words). 1980
Terra-cotta, 195″ diameter
Exxon Corporation Purchase Award, 1982
82.2921

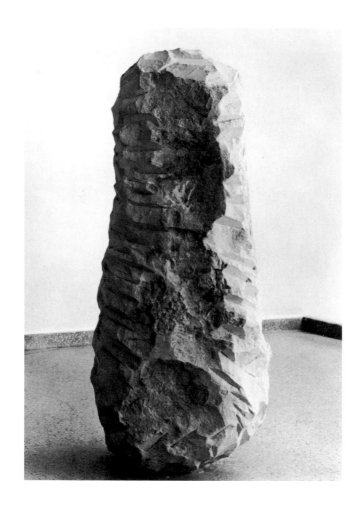

NICHOLAS POPE

Large White Column. 1979
Chalk, 49″ high
Exxon Corporation Purchase Award, 1980
80.2678

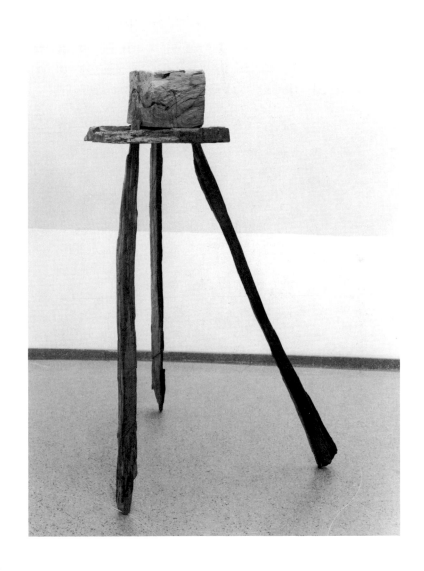

DAVID NASH

Rough Cube. 1977
Sycamore and beech wood, 63 x 40 x 40″
Exxon Corporation Purchase Award, 1980
80.2676

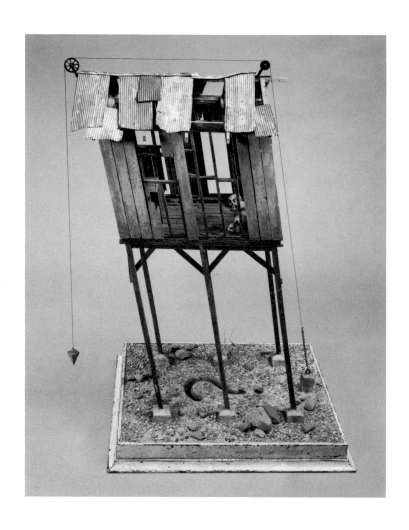

MICHAEL C. McMILLEN

A Circuit of Desire. 1982
Mixed media, 31½ x 22 x 16″
Exxon Corporation Purchase Award, 1983
83.3112

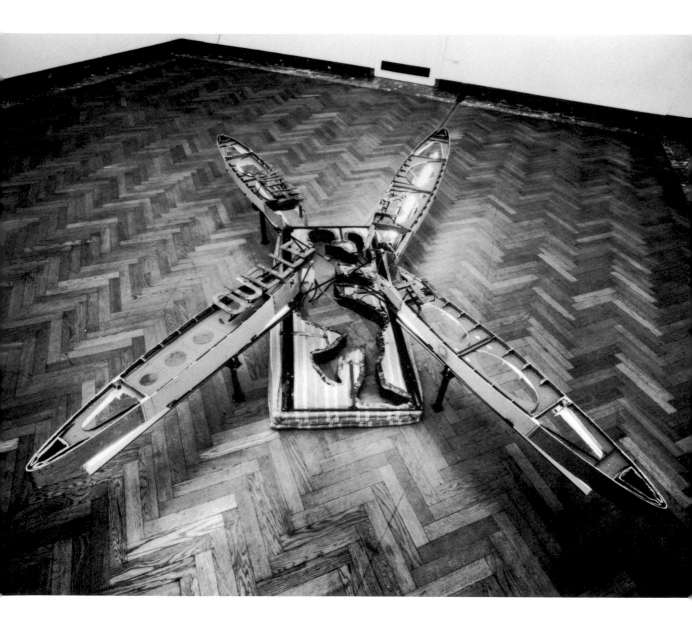

RICHARD BAQUIE

Wing Slices. 1987
Mattress, metal , airplane wings and
fluorescent tubes, 22⁷⁄₈ x 163³⁄₈ x 157¹⁄₂″
Exxon Corporation Purchase Award, 1986
87.3506

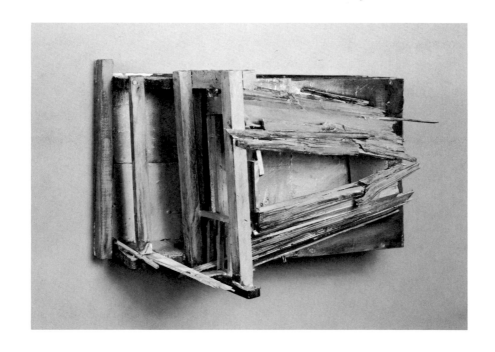

JULIE COHEN

Untitled #18. 1983
Gesso, acrylic and oil on wood, 12 x 18 x 11″
Exxon Corporation Purchase Award, 1983
83.3047

CAROL HEPPER

Synchrony. 1983
Mixed media, 67 x 57 x 75″
Exxon Corporation Purchase Award, 1983
83.3084

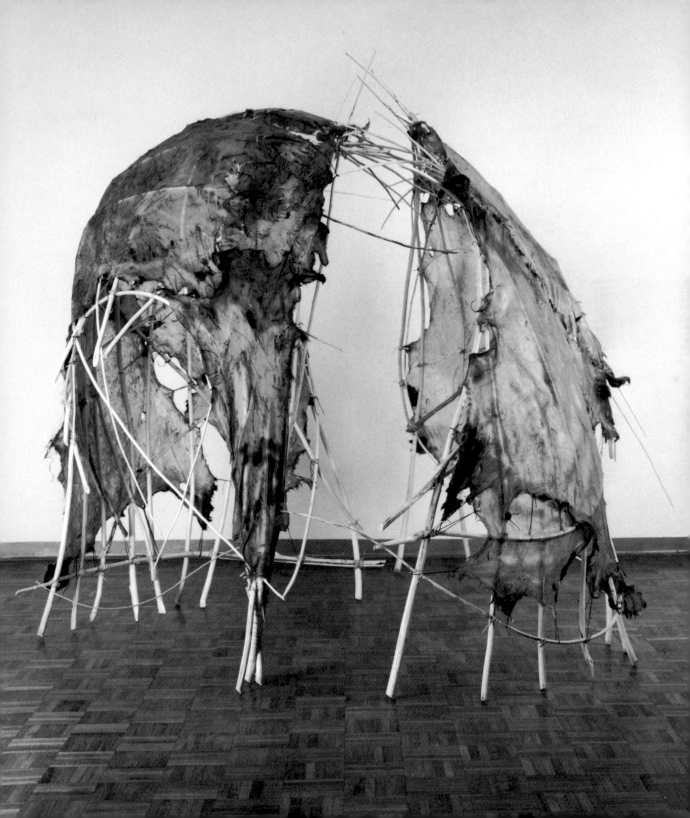

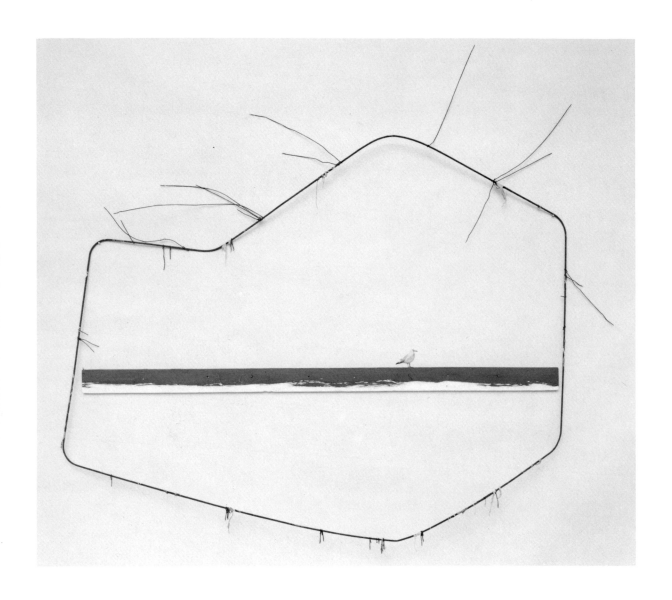

WHIT INGRAM

Wind, Bird, Ocean. 1982
Mixed media, 60 x 83½ x 2¼"
Exxon Corporation Purchase Award, 1983
83.3088

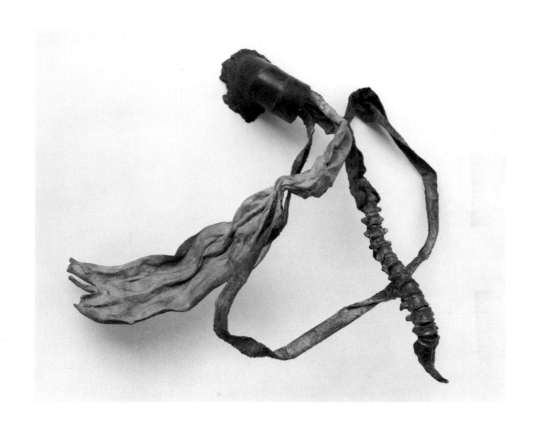

PHOEBE ADAMS

Sleep. 1985
Cast bronze with patina, 66 x 48 x 36″
Exxon Corporation Purchase Award, 1985
85.3316

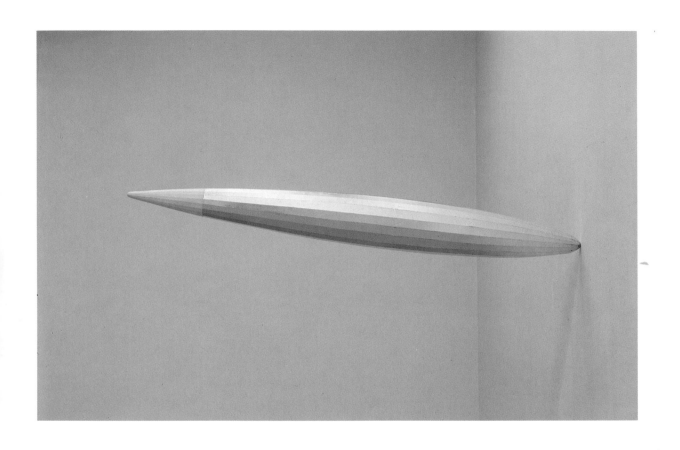

BRYAN HUNT

King Crest. 1976
Spruce wood, silk and aluminum leaf,
8 x 64 x 7"
Exxon Corporation Purchase Award, 1978
78.2425

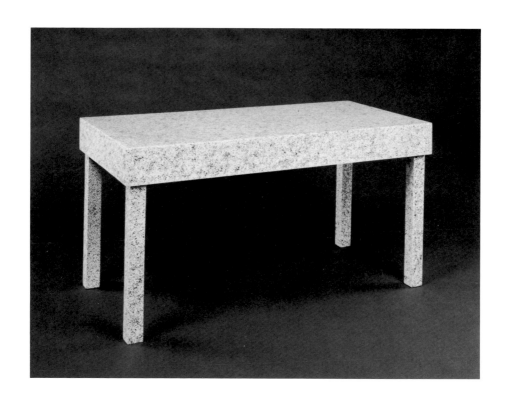

SCOTT BURTON

Table IV (Spattered Table). 1977
Painted and lacquered wood, 18 x 35 x 17″
Exxon Corporation Purchase Award, 1978
78.2422

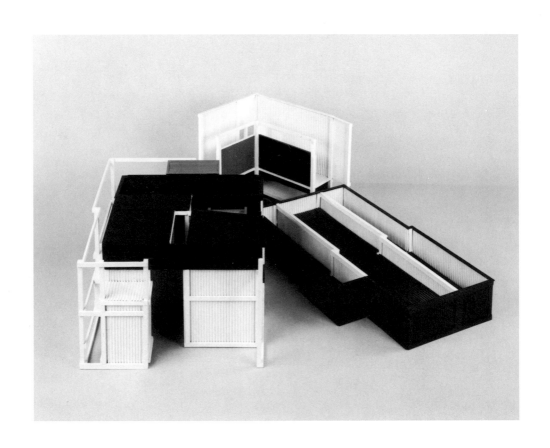

SIAH ARMAJANI

*Model for Lissitzky's Neighborhood,
Center House.* 1978
Balsa wood, enamel, plastic and corrugated
cardboard, two parts, total 11⅝ x 37¾ x 36¼"
Exxon Corporation Purchase Award, 1978
78.2435

GEORGES ROUSSE

Untitled. Guggenheim, 1986
Cibachrome print mounted on aluminum,
114 x 35¾"
Exxon Corporation Purchase Award, 1986
86.3486

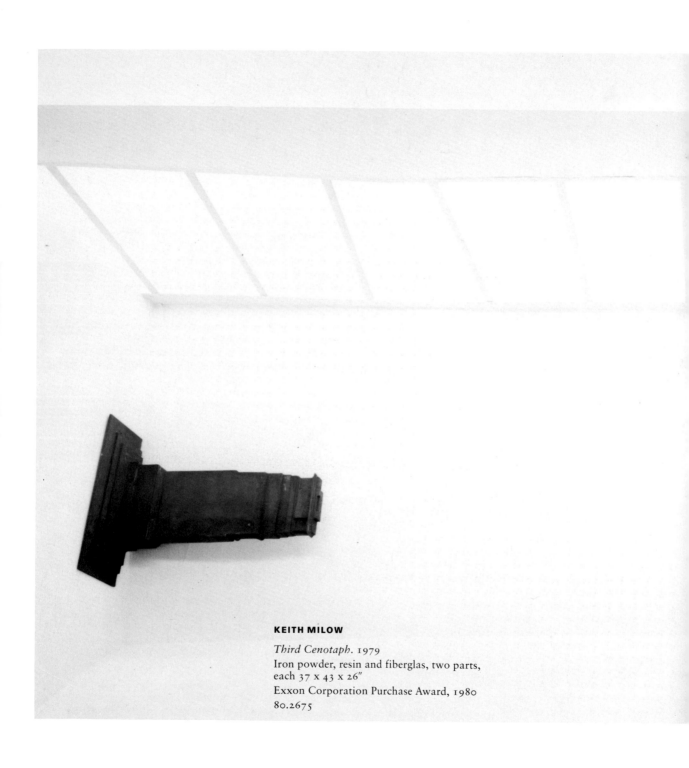

KEITH MILOW

Third Cenotaph. 1979
Iron powder, resin and fiberglas, two parts,
each 37 x 43 x 26"
Exxon Corporation Purchase Award, 1980
80.2675

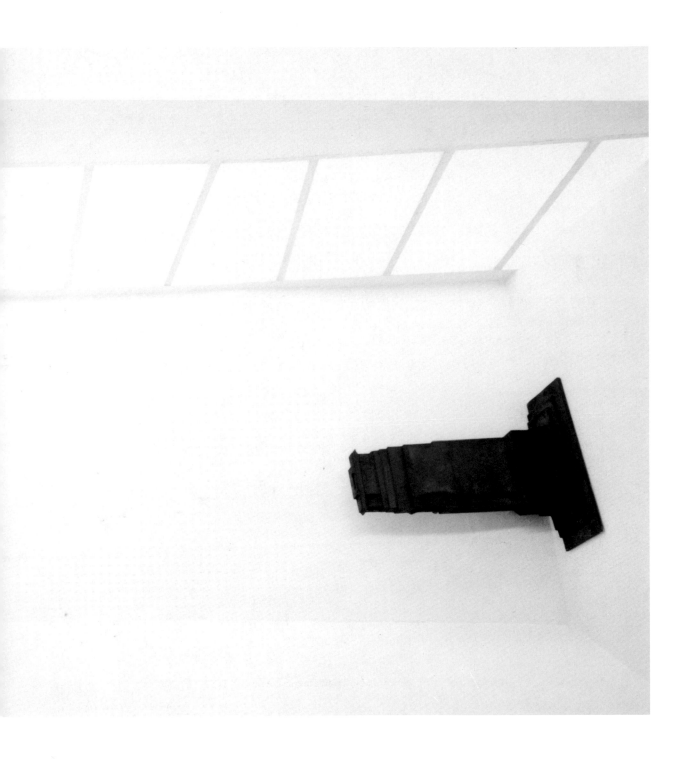

JOHN NIXON

Self-Portrait (Non-Objective Composition).
1984
Enamel on canvas with mallet; canvas,
66⅞ x 43⅜"; mallet, 11⅜ x 4⅛ x 1⅞"
Exxon Corporation Purchase Award, 1984
84.3229.a-b

ANGE LECCIA

American Kiss. 1986
Spotlights, 23⅛ x 25 x 14″
Exxon Corporation Purchase Award, 1986
86.3476

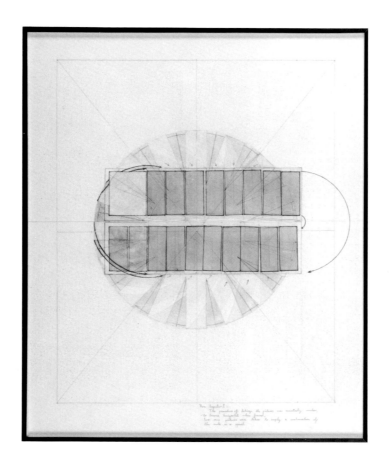

Non-Sequitur I, detail

SIMON READ

Non-Sequitur I. 1978
Watercolor, ink, pencil and collage on paper,
in frame, 24 x 23″, and eighteen pairs of color
bromide photographs mounted on paper-
board, in two frames, 24 x 96″ and 24 x 120″
Exxon Corporation Purchase Award, 1980
80.2679.a-c

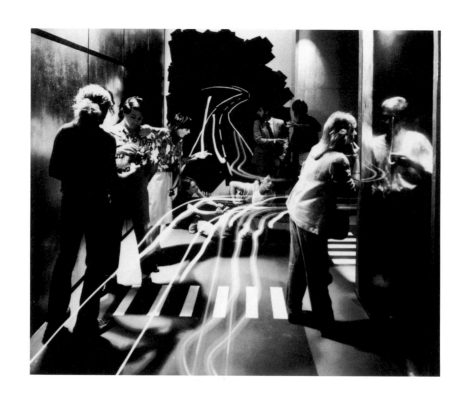

NIC NICOSIA

Near (Modern) Disaster #4. 1983
Cibachrome print, 40 x 50"
Exxon Corporation Purchase Award, 1983
83.3117

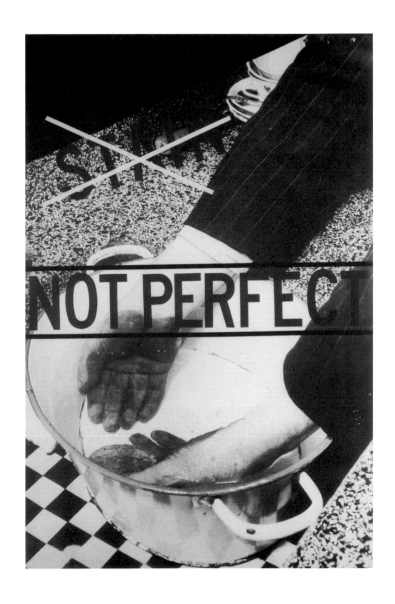

BARBARA KRUGER

Not Perfect. 1980
Photostat and collage on paper, 60 x 40″
Exxon Corporation Purchase Award, 1981
81.2809

BERNARD FAUCON

The Stained Glass (The Thirteenth Room). 1985
Fresson color photograph, 24¾ x 24¾"
Exxon Corporation Purchase Award, 1986
86.3466

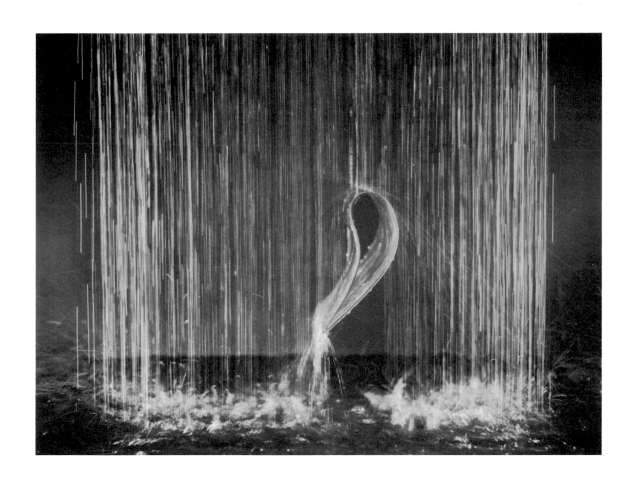

PATRICK TOSANI

The Rain Comma. 1986
Cibachrome print, 47½ x 62½"
Exxon Corporation Purchase Award, 1986
86.3494

A NEW YORK MELODRAMA

account compiled from various sources

In the spring of 1899, among the small houses, farms, and shanty towns of upper Fifth Avenue, rose the Van Zoult mansion. It was the materialization of Mrs. Caroline Van Zoult's dream: she now felt she could accede to greater respectability. Her husband had not survived the stress and financial strain that this construction had entailed and had succumbed to a stroke several months earlier. As for their grown-up daughter, Emma, she was above all pleased to leave the bustle and noise of Downtown and much preferred this new rural atmosphere.

Mrs. Caroline Van Zoult's next project was to find a wealthy, honorable husband for her daughter. But Emma, an idealistic, romantic young woman, remained indifferent to her mother's aspirations. She had long ago given up expressing her own desires, as Mrs. Van Zoult never took the slightest interest in them. A patient girl, she humored her mother but had plans of her own: she was secretly betrothed to her best friend's brother, Anton, a young scientist. He was not particularly rich, but he had a promising future. They often met in a small laboratory he had built on a vacant lot by the East River.

Mrs. Caroline Van Zoult spent the summer and fall entertaining, attending all the important functions, and despairing over Emma's total lack of interest in these matters.

2

On a cool November afternoon, Mrs. Van Zoult jubilantly informed her daughter that an ideal son-in-law had at last been found. Emma, unable to contain herself any longer, flatly refused to comply with her mother's designs on her life. She bluntly announced that she had already chosen a fiancé. Mrs. Van Zoult might have accepted him had his family and fortune been notable, but the thought of her daughter marrying a poor, unknown scientist was more than she could bear. She expressly forbade Emma ever to see this "Anton" again.

Later that evening, Emma slipped quietly out of the house and joined Anton at his laboratory. In light of Mrs. Van Zoult's attitude, they decided to elope. But first they would hide there until Anton had finished his current experiment.

The experiment in question was an attempt to cross-breed a mineral with a vegetable. Anton hoped to obtain this hybrid through the action of a new type of radiation. Emma, fascinated by the idea, became his assistant. After three days of work, Anton proclaimed the experiment a success.

They were preparing for their departure when the police, alerted by Mrs. Van Zoult, burst into the laboratory and arrested Anton. Emma was brought home and locked up in her room by her mother.

3

In the days that followed, Emma noticed a curious phenomenon: all the familiar objects she touched sprouted buds of the mineral-plant. Frightened at first by this unexpected side-effect of the experiment, she soon found it almost amusing, as she felt no change in herself, no pain or discomfort. Her mother, on the other hand, shrieked in horror on discovering the growths and despaired once more at having such a problematic daughter. Knowing nothing of the experiment and believing Emma to be seriously ill, she called for the family doctor, a certain Irving J. Winthrop, to cure her.

Doctor Winthrop moved into the house shortly thereafter in order to take better care of his patient, and confined her to her room, fearing contamination. Doctor Winthrop was actually quite pleased with the situation: a study of and cure for this unique ailment would bring him professional celebrity. And, at long last, he might have a chance to declare to Emma the secret love he had been hiding within himself for so many years.

Thus the weeks passed. Anton had been released from prison. He, too, caused mineral-plants to sprout on the things he touched, and he was greatly worried about Emma. He learned of the situation in the mansion from the servants. With their help, he had messages sent to her while he set to work on a plan for their escape.

4

To celebrate New Year's Eve 1900, Mrs. Caroline Van Zoult prepared particularly elaborate festivities and prided herself on the number of distinguished guests who had accepted her invitation. At the stroke of midnight, she had a thought for her poor daughter and went up to her room to wish her all the best for the New Year. But when she opened the door, she found the room empty.

Despite all her inquiries, Mrs. Van Zoult never saw or heard from her daughter ever again. She developed neurasthenia and, little by little, became a recluse.

Doctor Winthrop, disheartened by his shattered hopes, nevertheless thought of assembling the material he had collected on the phenomenon. He presented it to the Academy in February of 1900. But instead of the honors he had been expecting, he was accused of charlatanism and of having fabricated the entire story, and was expelled from the Order of Physicians.

Perhaps it was their failures that brought Mrs. Caroline Van Zoult and Doctor Winthrop together. In any event, they were married a few months later. They lived out the rest of their lives in the mansion, consoling themselves as best they could.

As for Emma and Anton, different rumors tend to confirm that they settled in a remote valley of the Adirondack Mountains, where they were adopted by an Indian tribe and honored as powerful medicine men.

MARTINE ABALLEA

A New York Melodrama. 1986
Five framed texts and three display cases
containing various objects; four texts,
each 23⅝ x 15¾"; fifth text, 9⅝ x 11⅞";
cases, each 19¾ x 15⅜ x 2⅜"
Exxon Corporation Purchase Award, 1986
86.3436.a-h

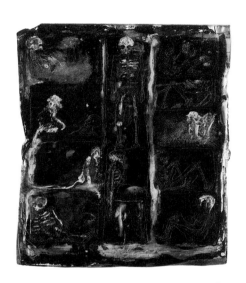

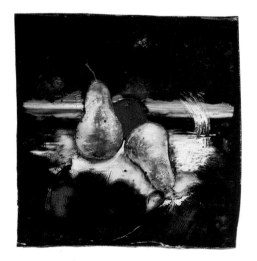

PHILIPPE FAVIER

Untitled. 1985
Stained-glass color and ceramic glaze
on glass, 6⅛ x 5⅜"
Exxon Corporation Purchase Award, 1986
86.3468

PHILIPPE FAVIER

Still Life with Pears. 1986
Stained-glass color and ceramic glaze
on glass, 5¼ x 5"
Exxon Corporation Purchase Award, 1986
87.3510

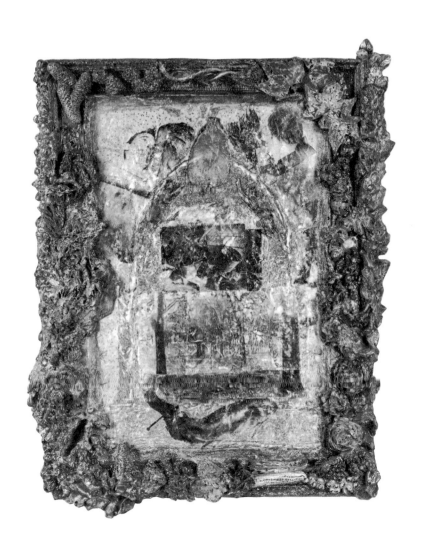

ANTHONY PETER GORNY

Transitivity Volume I: Nature. 1983–85
Book, mixed media, 56 x 45 x 6"
Exxon Corporation Purchase Award, 1985
85.3323

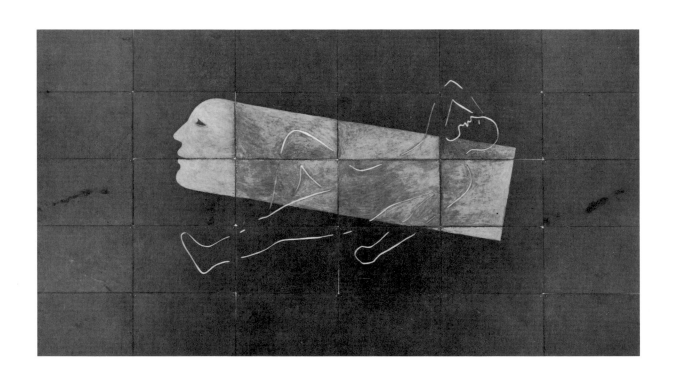

DANIEL TREMBLAY

Untitled. 1984
Slate, 58¾ x 108½"
Exxon Corporation Purchase Award, 1986
86.3495

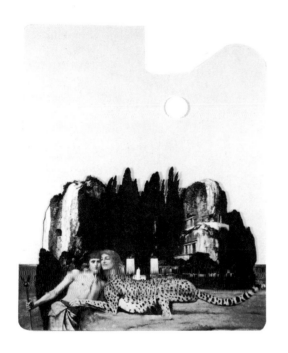

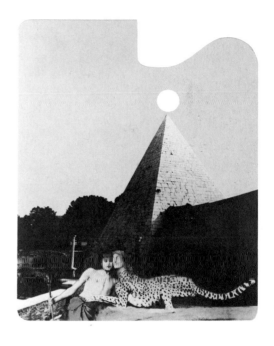

VETTOR PISANI

Oedipus and the Sphinx. Theater on the Abyss:
In Front of the Island of the Dead. 1979
Collage on glass, 29½ x 23¾ x ½"
Exxon Corporation Purchase Award, 1982
83.2982

VETTOR PISANI

Oedipus and the Sphinx. Theater on the Abyss:
Cemetery of Artists and Poets. 1980
Collage on glass, 29½ x 23⅝ x 4¼"
Exxon Corporation Purchase Award, 1982
82.2923

NINO LONGOBARDI

Untitled. 1980
Oil on charcoal on canvas, 79⅛ x 118⅞″
Exxon Corporation Purchase Award, 1982
82.2924

PETER BOOTH

Painting 1984. 1984
Oil on canvas, 72 x 120⅜"
Exxon Corporation Purchase Award, 1984
84.3199

ENZO CUCCHI

The Mad Painter. 1981–82
Oil on canvas, 119½ x 83¾"
Exxon Corporation Purchase Award with
additional funds contributed by
The Junior Associates, 1982
82.2927

SANDRO CHIA

Running Men. 1982
Oil on canvas, 79¼ x 144″
Exxon Corporation Purchase Award with
additional funds contributed by Adrian
and Robert Mnuchin and Barbara
and Donald Jonas, 1982
82.2926

PEGAN BROOKE

Snake Wave. 1983
Acrylic and mixed media on canvas, 73 x 51⅞"
Exxon Corporation Purchase Award, 1983
83.3045

JAN MURRAY

Screened Landscape. 1983–84
Oil on canvas, 65½ x 84″
Exxon Corporation Purchase Award, 1984
84.3225

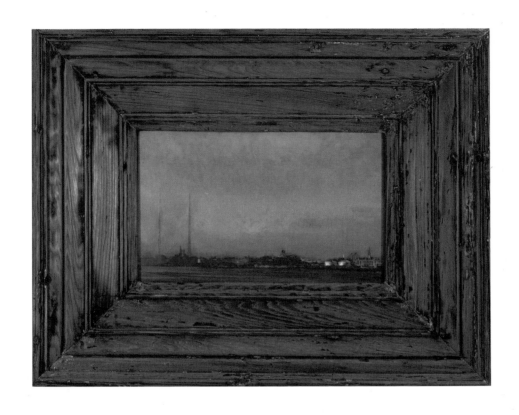

MARK INNERST

Brooklyn Seen from the East River Park. 1985
Oil on acrylic on wood, 17¼ x 21¾"
Exxon Corporation Purchase Award, 1985
85.3324

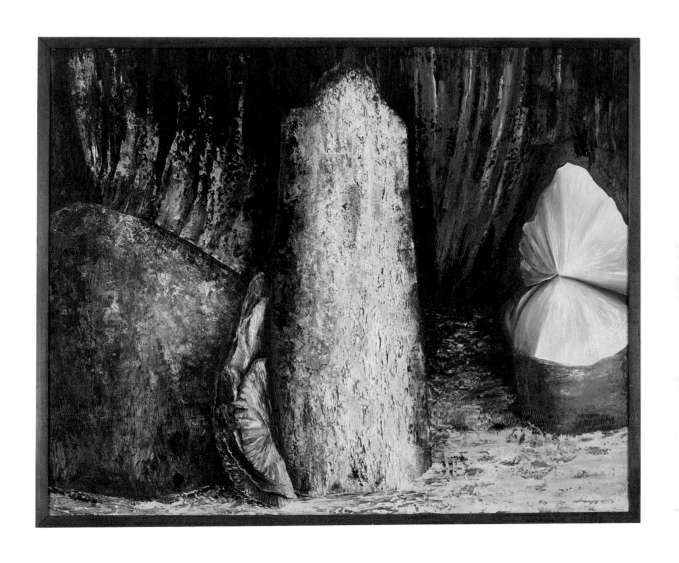

SUSAN NORRIE

Deserted. 1984
Oil on plywood, 84⅝ x 105¾"
Exxon Corporation Purchase Award, 1984
84.3230

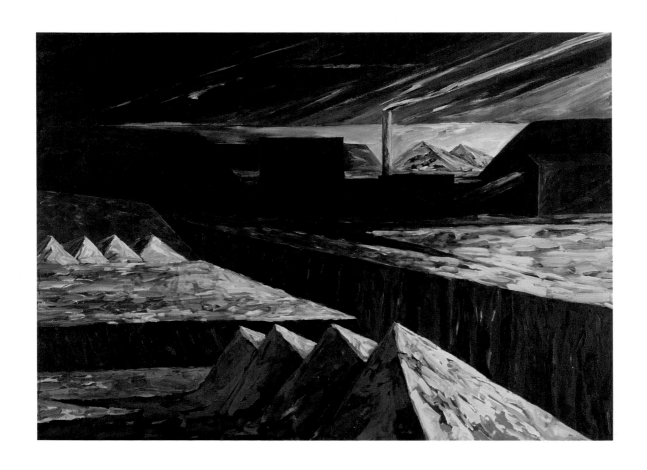

MANDY MARTIN

Chasm. 1984
Oil on canvas, 68⅜ x 96⅛"
Exxon Corporation Purchase Award, 1984
84.3218

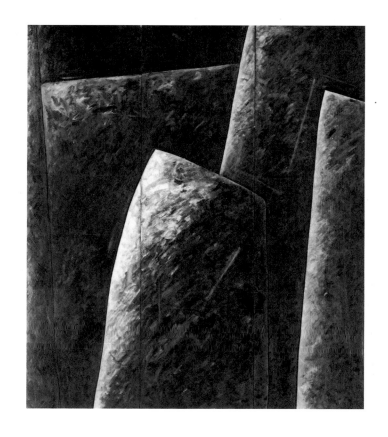

REX LAU

Perilously Close to the Rock. 1985
Oil on Hydro-stone, 72 x 63"
Exxon Corporation Purchase Award, 1985
85.3327

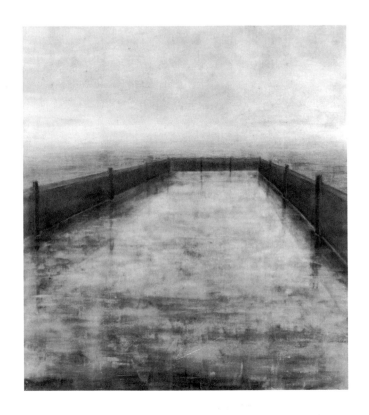

JOAN NELSON

Untitled. Summer 1985
Pigment and wax on board, 17⅞ x 15⅞"
Exxon Corporation Purchase Award, 1985
85.3333

TOBI KAHN

Rema. 1985
Acrylic on Masonite, 54 x 39½″
Exxon Corporation Purchase Award, 1985
85.3325

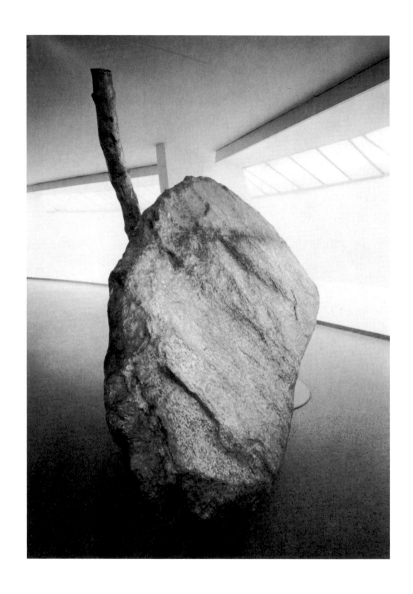

ROBERT LAWRANCE LOBE

Tree Supporting Boulder. 1977
Aluminum, 78 x 83 x 55″
Exxon Corporation Purchase Award, 1978
78.2427

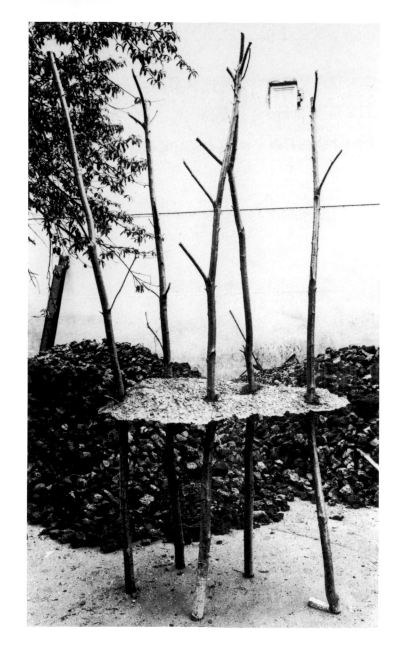

GIUSEPPE PENONE

Breath of Leaves. 1981
Wood and bronze, 137¾ x 59 x 35½"
Exxon Corporation Purchase Award, 1982
82.2963

ARTISTS' BIOGRAPHIES
SELECTED ONE-PERSON EXHIBITIONS
SELECTED BIBLIOGRAPHIES

MARTINE ABALLEA

Born in Roslyn, New York, August 11, 1950. Studied at Barnard College, Columbia University, New York, B.A., 1971; London School of Economics, 1971–72. Lives in Paris.

Selected One-Person Exhibitions

Galerie das Fenster, Hamburg, *The Elastic Hotel*, February 1976

Franklin Furnace, New York, *Sleep-Storm Crystals*, January 21–February 10, 1978

Institute for Art and Urban Resources, P.S.1, Long Island City, New York, *The Turquoise Zone Seduction*, December 3, 1978–January 21, 1979

Locus Solus, Genoa, *Memorial Fish Laboratories*, March 10–April 10, 1981

A.R.C., Musée d'Art Moderne de la Ville de Paris, *Nouveaux Phénomènes naturels*, March 15–April 24, 1983. Catalogue with text by the artist

Musée de Trouville, *Les Clichés de l'aventure*, August 15–September 30, 1984. Catalogue with text by Gilbert Lascault

Galerie d'Art du Centre Culturel de l'Université de Sherbrooke, Canada, October 12–November 17, 1985. Traveled to Musée du Bas-Saint-Laurent, Rivière-du-Loup, Canada, February 20–March 31, 1986

Selected Bibliography
By the Artist

Clam Holiday (handbill), Paris and New York, 1975

Triangle, Paris, 1977

Element Rage, Paris, 1979

Geographic Despair, Paris, 1979

Prisonnière du sommeil, Paris, 1987

On the Artist

Michel Nuridsany, "Les Nuits vertes de Martine Aballéa," *Le Figaro*, October 3, 1980, p. 24

Anne Dagbert, "Martine Aballéa, Gloria Friedmann, Andréas Pfeiffer: Galerie Gillespie-Laage-Salomon," *Art Press*, November 1980, p. 40

Nancy Wilson-Pajic, "Martine Aballéa, 'Green Nights,'" *Artforum*, vol. XIX, January 1981, p. 79

Delphine Renard, "Les Fictions scientifiques de Martine Aballéa," *Art Press*, September 1983, p. 33

Anne Dagbert, "Quatre Français en Amérique," *Art Press*, June 1985, p. 64

Anne Moeglin-Delacroix, "Rêves d'artiste: A propos des livres de Martine Aballéa," *Nouvelles de l'Estampe*, March 1986, pp. 27–29

Michel Nuridsany, "Trois Français à New York," *Le Figaro*, November 18, 1986, p. 35

PHOEBE ADAMS

Born in Greenwich, Connecticut, May 1, 1953. Studied at Philadelphia College of Art, B.F.A., 1976; Skowhegan School of Painting and Sculpture, Maine, 1977; State University of New York, Albany, M.A., 1978. Lives in Philadelphia.

Selected One-Person Exhibitions

Nexus Gallery, Philadelphia, February 3–28, 1981

Lawrence Oliver Gallery, Philadelphia, September 21–October 20, 1984; October 9–November 8, 1986

Grace Borgenicht Gallery, New York, April 26–May 21, 1985

Curt Marcus Gallery, New York, March 6–April 1, 1987

Selected Bibliography

Edward J. Sozanski [review], *The Philadelphia Inquirer*, September 27, 1984, p. E6

Edward Sozanski, "A Guggenheim Opening for Two Philadelphia Artists," *The Philadelphia Inquirer*, October 30, 1985, pp. C1, C6

Edward J. Sozanski [review], *The Philadelphia Inquirer*, November 6, 1986, p. C5

Paula Marincola [review], *Artforum*, vol. XXV, January 1987, p. 117

SIAH ARMAJANI

Born in Teheran, Iran, July 10, 1939. Studied at Macalester College, St. Paul, Minnesota, B.A., 1963. Lives in St. Paul.

Selected One-Person Exhibitions

Philadelphia College of Art, *Siah Armajani: Red School House for Thomas Paine*, March 4–25, 1978. Catalogue with text by Janet Kardon

Max Protetch Gallery, New York, *Siah Armajani: "First Reading Room" Installation, Models & Notations*, March 1979, traveled to Landmark Center, St. Paul, 1979; *Siah Armajani: Doors, Windows, Notations and Models*, March 12–April 4, 1981; *Siah Armajani: Dictionary for Architecture II*, March 8–April 2, 1983; *Dictionary for Building III*, April–May 1984; *Dictionary for Building IV*, November 1–30, 1985

Sullivan Hall Gallery, Ohio State University, Columbus, *Reading Room #2*, 1979. Traveled to Kansas City Art Institute, 1979; permanently installed at Ohio State University, 1979

Joslyn Art Museum, Omaha, *Siah Armajani: Reading Garden #2*, June 14–September 7, 1980. Catalogue with text by Holliday T. Day. Traveled to University of Nebraska, Omaha

Hudson River Museum, Yonkers, New York, *Siah Armajani: Office for Four*, April 11–July 5, 1981. Catalogue with text by Julie Brown

Baxter Art Gallery, California Institute of Technology, Pasadena, *Siah Armajani: Poetry Lounge*, March 3–April 25, 1982. Catalogue with text by David Antin

Institute of Contemporary Art, University of Pennsylvania, Philadelphia, *Siah Armajani: Bridges/Houses/Communal Spaces/Dictionary for Building*, October 11–December 1, 1985. Catalogue with texts by Janet Kardon and Kate Linker

Kunsthalle Basel, *Siah Armajani*, March 22–April 26, 1987. Catalogue with texts by Jean-Christophe Ammann and Patricia Phillips. Traveled to Stedelijk Museum, Amsterdam, May 16–June 28, 1987

Galerie Rudolf Zwirner, Cologne, *Siah Armajani*, May 19–June 12, 1987

Selected Bibliography

Mike Steele, "Computer Art: Switched-on Idea," *The Minneapolis Tribune*, January 12, 1969, pp. 1, 8

Christopher Finch, "Process and Imagination," *Design Quarterly*, no. 74/75, 1969, pp. 22–30

Lucy Lippard, *Six Years: The Dematerialization of the Art Object from 1966 to 1972*, New York, 1973, pp. 163, 204

Joshua Kind, "Statues and Sculpture," *New Art Examiner*, October 1975, pp. 67–68

Allison Skye and Michelle Stone, *Unbuilt America*, New York, 1976, pp. 5, 25–26

Robert Pincus-Witten, "Siah Armajani: Populist Mechanics," *Arts Magazine*, vol. 53, October 1978, pp. 126-128

Holliday T. Day [review], *New Art Examiner*, vol. 6, Summer 1979, p. 14

Cynthia Nadelman, "New York Reviews," *Art News*, vol. 78, Summer 1979, p. 175

Robert Berlind, "Armajani's Open-Ended Structures," *Art in America*, vol. 67, October 1979, pp. 82-85

Marsha Miro, *Sculpture at Cranbrook 1978-1980*, Bloomfield Hills, Michigan, 1979, unpaginated

Kay Larson, "Is There a Crimp in the Beauty Parlor?" *The Village Voice*, September 10, 1980, p. 77

Pat Thomson, "Construction I: Siah Armajani," *Dialogue*, vol. 3, November–December 1980, pp. 56-57

James Jordan, "Artist/Artificer/Armajani," *Dialogue*, vol. 4, January–February 1981, pp. 7-8

Christopher Knight, "Little Poetry Lounge on the Prairie," *Los Angeles Herald Examiner*, March 17, 1981, pp. B1, B8

Kay Larson, "Spring Cleaning: Siah Armajani," *New York Magazine*, March 30, 1981, p. 49

Jayne Merkel [review], *Artforum*, vol. XIX, March 1981, pp. 89-90

John Caldwell, "A Cerebral Game at the Hudson," *The New York Times,* Westchester edition, April 8, 1981, p. 1

Kim Levin, "House and Gardens," *The Village Voice*, July 1, 1981, pp. 77-78

Ronald J. Onorato, "Reviews: New York," *Art Express*, vol. 1, September–October 1981, p. 61

Thomas Hine, "Little Room for Improvement in Philadelphia: Memorial to Louis Kahn," *The Washington Post*, October 16, 1981, p. E61

Linda Brady, "Siah Armajani: Reading Room," *Dialogue*, vol. 4, November–December 1981, p. 40

Melinda Wortz, "Siah Armajani: Baxter Art Gallery," *Art News*, vol. 8, December 1981, p. 131

John Beardsley, *Art in Public Places*, Washington, D.C., 1981, pp. 33, 60-61

Melanie Taylor, "The Exuviae of Visions: Architecture as a Subject for Art," *Perspecta*, no. 18, 1981, pp. 66-73

Suzanne Muchnic, "Poetic Pews at Cal Tech," *Los Angeles Times*, March 21, 1982, calendar section, p. 85

Kate Linker [review], *Artforum*, vol. XX, March 1982, pp. 72-73

John Bowsher, "Siah Armajani: Social Studies," *Artweek*, April 17, 1982, p. 1

Tom Finkelpearl, "Play at Work: Siah Armajani's Office for Four," *Images and Issues*, vol. 2, Spring 1982, p. 79

Diana Shaffer, "Garden, Newsstand, and Usable Space: The Art of Siah Armajani," *Art Express*, vol. 2, May–June 1982, pp. 33-35

Grace Glueck, "Serving the Environment," *The New York Times*, June 27, 1982, pp. C25-26

Calvin Tomkins, "The Art World: Like Water in a Glass," *The New Yorker*, March 21, 1983, pp. 92-97

Grace Glueck, "Siah Armajani," *The New York Times*, March 25, 1983, p. C25

John Ashbery, "Armajani: East Meets Midwest," *Newsweek*, April 4, 1983, p. 72

Timothy F. Rub, "Siah Armajani: Max Protetch," *Arts Magazine*, vol. 58, September 1983, p. 35

Ann Sargent-Wooster, "Review of Exhibitions, New York: Siah Armajani at Max Protetch," *Art in America*, vol. 71, November 1983, pp. 220-221

Mildred Friedman, "Site: The Meaning of Place in Art and Architecture," *Design Quarterly*, no. 122, 1983, pp. 6-9

Michael Brenson, "Art: Siah Armajani," *The New York Times*, April 13, 1984, p. C26

Jean-Christophe Ammann, "A Plea for New Art in Public Places," *Parkett*, July 1984, pp. 7-35

Patricia C. Phillips [review], *Artforum*, vol. XXIII, September 1984, pp. 111–112

Calvin Tomkins, "The Art World: Perception at All Levels," *The New Yorker*, December 3, 1984, pp. 176–181

Stacy Paleologos Harris, ed., *Insights/On Sites: Perspectives on Art in Public Places*, Washington, D.C., 1984, pp. 24–25, 33–38

Michael Brenson, "Siah Armajani," *The New York Times*, November 15, 1985, p. C24

Patricia C. Phillips, "Siah Armajani's Constitution," *Artforum*, vol. XXIV, December 1985, pp. 70–75

Patricia Fuller, *Five Artists at NOAA: A Casebook on Art in Public Places*, Seattle, 1985, passim

Allan Temko, "Yerba Buena's Revolutionary Pair of Towers," *San Francisco Chronicle*, January 28, 1986, p. 4

Nancy Princenthal, "Master Builder," *Art In America*, vol. 74, March 1986, pp. 126–133

Douglas C. McGill, "Sculpture Goes Public," *The New York Times Magazine*, April 27, 1986, pp. 42–45, 63, 66, 85–87

Victoria Geibel, "The Act of Engagement," *Metropolis*, July–August 1986, p. 32

RICHARD BAQUIE

Born in Marseille, May 1, 1952. Studied at Ecole Régionale des Beaux-Arts et d'Architecture, Marseille-Luminy, Diplôme Nationale Supérieure d'Expression Plastique, 1981. Lives in Marseille.

Selected One-Person Exhibitions

Galerie Eric Fabre, Paris, September 20–October 15, 1984

Galerie Arlogos, Nantes, May 4–July 8, 1985

A.R.C.A. (Action Régionale pour la Création Artistique), Marseille, December 16, 1985–February 9, 1986. Catalogue with text by Michel Enrici

Musée National d'Art Moderne, Centre Georges Pompidou, Paris, January 14–March 22, 1987

Palais des Beaux-Arts, Brussels, April 4–May 10, 1987

Selected Bibliography

By the Artist

"Richard Baquié: Tout Projet commence par une histoire," *Public*, no. 3, 1985, pp. 64–65

On the Artist

Marc Partouche, "Albi," *Axe Sud*, Summer 1984

Christian Schlatter, "L'Art des récits privés (II)," *Artistes*, Summer 1984, pp. 98–103

Patrick Krebs [review], *Flash Art*, Winter 1984–85

Brigitte Cornand, "Avec ses drôles de machines soufflantes, ronflantes," *Actuel*, December 1985, p. 195

Marc Partouche, "Visite chez Richard Baquié," *Mars*, Winter 1985–86, pp. 2–5

Philippe Piguet, "Richard Baquié: Le Temps de rien," *L'Evénement*, January 16–22, 1986, p. 114

Henri-François Debailleux, "Portrait: Richard Baquié," *Beaux-Arts Magazine*, February 1986, pp. 74–76

Jean-Louis Marcos, "Richard Baquié," *Art Press*, February 1986, p. 81

Brigitte Cornand, "Vive le génie," *Actuel*, March 1986, pp. 88–89

Jean-Louis Marcos, "Le Cabanon de L'ESPACE-TEMPS," *Art Press*, June 1986, p. 39

Jérôme Sans, "Richard Baquié," *FIAC Magazine*, October–November 1986, p. 37

Anne Richard, "Sculpture/Objet/Image 1985, mort d'un espace de fiction," *Opus International*, Winter 1986, pp. 18–23

Christian Schlatter, "Richard Baquié," *Le Petit Journal des Galeries Contemporaines*, January–February 1987, pp. 5–6

Jac Fol Ri, "Baquié le passager," *CNAC Magazine*, January–March 1987, p. 14

Henri-François Debailleux and Hervé Gauville, "Crashe à Beaubourg," *Libération*, February 6, 1987, pp. 32–33

Mona Thomas, "Richard Baquié ou la subli-mation mécanique," *Beaux-Arts Magazine*, February 1987, p. 96

Alain Paire, "Errances et passions," *Le Provençal Dimanche*, March 1, 1987, p. 23

Patrick Javault, "Centre Georges Pompidou," *Art Press*, March 1987, p. 78

Frédéric Valabrèque, "Richard Baquié: Le Roman de titres," *Artefactum*, April 1987, pp. 22–25

Daniel Soutif, "Richard Baquié," *Artforum*, vol. XXV, May 1987, pp. 161–162

PETER BOOTH

Born in Sheffield, England, November 20, 1940. Studied at Sheffield College of Art, 1956–57; National Gallery School, Melbourne, 1962–65. Lives in Melbourne.

Selected One-Person Exhibitions

Pinacotheca, Melbourne, March–April 1969; August–September 1970; September 1971; August 1972; August 1975; November 1976; November 1977; October 1978; November 1979; November 1980; November 1981; November–December 1982; November 1983

Central Street Gallery, Sydney, April–May 1969

Chapman Powell Gallery, Melbourne, May 1973; April 1974

Art Gallery of New South Wales, Sydney, *Project 12: Peter Booth*, March–April 1976. Brochure with text by Frances Lindsay

Monash University Gallery, Melbourne, *Peter Booth: A Retrospective*, May 1976

CDS Gallery, New York, *Peter Booth*, January 6–February 2, 1986; *Peter Booth: Recent Paintings*, February 5–28, 1987

Selected Bibliography

Interview with Bruce Pollard, "Peter Booth: The Distance Is Closer," *Source*, September 7, 1971, p. 30

Graeme Sturgeon [review], *The Australian*, May 25, 1976, p. 20

Graeme Sturgeon [review], *The Australian*, November 20, 1976, p. 20

Mary Eagle, *The Age*, October 4, 1978, p. 2

Frances Lindsay, "Peter Booth," *Art and Australia*, vol. 16, no. 1, 1978, pp. 47–54

Jennifer Phipps, "Flash Art Australia: Peter Booth," *Flash Art*, December 1981–January 1982, p. 60

Paul Taylor, "Angst in My Pants," *Art & Text*, September 1982, pp. 48–60

Robert Rooney [review], *The Weekend Australian*, November 27–28, 1982, p. 27

Memory Holloway, *The Age*, December 1, 1982, p. 14

Helen Topliss, "Leaves from a Dream Diary. A Note on the Art of Peter Booth," *Helix*, no. 11–12, 1982

Sally MacMillan, "The World Hails an Australian Visionary," *The Weekend Australian Magazine*, February 21–22, 1987, p. 10

Michael Brenson, "Two Artists Who Flourish in a Postmodern Climate," *The New York Times*, February 22, 1987, pp. C33–35

PEGAN BROOKE

Born in Orange, California, July 19, 1950. Studied at University of California, San Diego, B.A., 1972; Drake University, Des Moines, B.F.A., 1976; University of Iowa, Iowa City, M.A., 1977; Stanford University, Palo Alto, California, M.F.A., 1980. Lives in Oakland.

Selected One-Person Exhibitions

Eve Drewlowe Gallery, University of Iowa, Iowa City, *Pegan Brooke: Horse—An Offering*, November 21–29, 1977

Jan Shotwell Gallery, Des Moines, *Pegan Brooke: All Life Is Rhythm—Pictures*, April 17–29, 1978

Stanford University, Palo Alto, *Pegan Brooke: Paintings and Drawings—MFA Exhibition*, May 13–29, 1980

Hansen Fuller Goldeen Gallery, San Francisco, *Pegan Brooke: Paintings and Drawings*, May 26–June 27, 1981

Fuller Goldeen Gallery, San Francisco, *Pegan Brooke: Paintings and Drawings*, February

8- March 5, 1983; August 28–September
27, 1985

Scottsdale Center for the Arts, Arizona,
Pegan Brooke: Paintings and Drawings,
April 29–June 12, 1983

Pamela Auchincloss Gallery, Santa Barbara,
Pegan Brooke: Paintings and Drawings,
February 10–March 14, 1984

Des Moines Art Center, *Pegan Brooke:
Visions*, May 3–June 16, 1985. Catalogue
with text by Neal Benezra

Selected Bibliography

Nick Baldwin, "Brooke's Rhythm," *Des
Moines Sunday Register*, April 23, 1978,
p. 5B

Andree Marechal-Workman, "Bruce Beasley:
New York," *Artweek*, June 20, 1981, p. 6

Alan Temko, *San Francisco Chronicle*, June
20, 1981, p. 36

Thomas Albright, *San Francisco Chronicle*,
February 19, 1983, p. 38

Andree Marechal-Workman, "A Logic of
Conflict," *Artweek*, February 26, 1983, p. 6

Chuck Anderson, "From the Bay to the
Valley," *New Times*, May 4–10, 1983,
pp. 13–15

Jan Alfred, "Pegan Brooke at Fuller
Goldeen," *Images and Issues*, vol. 4, July/
August 1983, p. 52

David Dahl, "Pegan Brooke," *Santa Barbara
Arts Council Art News*, February 1984, p. 4

Mark Levi, "The Tropical Mindscape of
Pegan Brooke," *Images and Issues*, vol. 4,
May/June 1984, pp. 14–15

Eliot Nusbaum, "Pegan Brooke Show:
Danger Lurks Within These Images," *Des
Moines Sunday Register*, May 12, 1985,
p. 5C

Kenneth Baker, "Pictures That Look Better
at a Distance," *San Francisco Chronicle*,
September 21, 1985, p. 41

Dan Nadaner, "Alternatives to Formalism,"
Artweek, September 21, 1985, p. 7

SCOTT BURTON

Born in Greensboro, Alabama, June 23, 1939.
Studied with Leon Berkowitz, Washington,
D.C., 1957–59; with Hans Hofmann,
Provincetown, Massachusetts, Summers
1957–59; Columbia University, New York,
B.A., 1962; New York University, M.A., 1963.
Lives in New York.

Selected One-Person Exhibitions

Whitney Museum of American Art, New
York, performance, *Scott Burton: Group
Behaviour Tableaux*, April 18 and 19, 1972.
Also presented at American Theatre Lab, New
York, October 27–29, 1972

Festival of Contemporary Arts, Allen Memo-
rial Art Museum, Oberlin, Ohio, performance,
Scott Burton: Lecture on Self, May 5, 1973.
Brochure with text by Athena Tacha-Spear

Artists Space, New York, *Scott Burton: Two
Chair Pieces*, December 6–27, 1975

Solomon R. Guggenheim Museum, New York,
performance, *Scott Burton: Pair Behaviour
Tableaux*, February 24–April 4, 1976.
Brochure with text by Linda Shearer

Droll/Kolbert Gallery, New York, *Scott
Burton: Pragmatic Structures—Tables and
Chairs*, November 15–December 3, 1977

Brooks Jackson Gallery Iolas, New York,
Scott Burton: Four Tables, May 9–June 3,
1978

Protetch-McIntosh Gallery, Washington, D.C.,
Scott Burton: Sculpture Equals Furniture,
April 3–21, 1979

Daniel Weinberg Gallery, San Francisco, *Scott
Burton: Recent Sculpture*, February 5–March
28, 1980

University Art Museum, University of Cali-
fornia, Berkeley, performance, *Scott Burton:
Individual Behaviour Tableaux*, February
13–March 2, 1980. Brochure with text by
Michael Auping

Max Protetch Gallery, New York, *Scott
Burton: New Tables*, April 9–May 2, 1981;
*Tables and Chairs: Vintage Modern and Recent
Burton*, May 7–29, 1982; *Scott Burton: New
Work*, November 17–December 30, 1982;

Scott Burton: Geometric Granite Furniture Series, March 2–30, 1985; *Scott Burton: New Works in Granite and Selected Works in Wood*, May 1–31, 1986

Dag Hammarskjold Plaza Sculpture Garden, New York, *Scott Burton: Granite Chairs, A Pair, 1978–81*, April 10–July 1981

Daniel Weinberg Gallery, Los Angeles, *Scott Burton: Recent Work*, November 10–December 11, 1982; *Scott Burton: Furniture Sculpture—Recent Geometric Granite Works*, September 2–27, 1986

The Contemporary Arts Center, Cincinnati, *Scott Burton Chairs*, March 11–April 20, 1983. Catalogue with text by Charles F. Stuckey. Traveled to Walker Art Center, Minneapolis, July 10–August 21, 1983; Fort Worth Art Museum, September 24–November 6, 1983; Contemporary Arts Museum, Houston, November 12, 1983–January 9, 1984

McIntosh-Drysdale Gallery, Houston, *Geometric Granite Furniture Series: Four New Works*, May 31–August 18, 1984

The Tate Gallery, London, *Scott Burton*, September 25–December 9, 1985. Catalogue with text by Richard Francis

Baltimore Museum of Art, *Scott Burton*, December 7, 1986–February 1, 1987. Catalogue with text by Brenda Richardson

Selected Bibliography

By the Artist

"Make a Political Statement," *Art-Rite*, Summer 1974, p. 24

"Furniture Landscape," "Furniture Pieces," "Chair Drama," *TriQuarterly*, vol. 32, Winter 1975, unpaginated

"Furniture Journal: Rietveld," *Art in America*, vol. 68, November 1980, pp. 102–108

"The Meaning of Place in Art and Architecture," *Design Quarterly*, October 1983, pp. 10–11

On the Artist

Harris Rosenstein [review], *Art News*, vol. 71, Summer 1972, p. 14

Roberta Smith [review], *Arts Magazine*, vol. 47, December 1972–January 1973, pp. 81–82

Ronald Argelander, "Scott Burton's Behaviour Tableaux (1970–72)," *The Drama Review*, vol. 17, September 1973, p. 109

John Russell, "Scott Burton and Pamela Jenrette," *The New York Times*, December 13, 1975, p. C17

Edit de Ak and Walter Robinson, "An Article on Scott Burton in the Form of a Resumé," *Art-Rite*, Winter 1975, pp. 8–10

John Perreault, "Burton's Robot Lovers," *SoHo Weekly News*, March 11, 1976, p. 16

Carter Ratcliff [review], *Artforum*, vol. XIV, March 1976, pp. 60–61

Steven Simmons [review], *Artforum*, vol. XIV, May 1976, pp. 66–67

Robert Pincus-Witten, "Scott Burton: Conceptual Performance as Sculpture," *Arts Magazine*, vol. 51, September 1976, pp. 112–117

John Perreault, "Scott Burton," *SoHo Weekly News*, November 24, 1977, p. 26

Richard Lorber [review], *Artforum*, vol. XVI, February 1978, pp. 64–65

Robert Pincus-Witten, "Camp Meetin: The Furniture Pieces of Scott Burton," *Arts Magazine*, vol. 53, September 1978, pp. 103–105

Roberta Smith, "Scott Burton: Designs on Minimalism," *Art in America*, vol. 66, November–December 1978, pp. 138–140

John Howell, "Acting/Non-Acting: Interview with Scott Burton," *Performance Art Magazine*, no. 2, 1979, pp. 7–10

Nancy Foote, "Situation Esthetics: Impermanent Art and the Seventies Audience," *Artforum*, vol. XVIII, January 1980, pp. 22–23

Michael Auping, "Scott Burton: Individual Behavior Tableaux," *Images and Issues*, Summer 1980, pp. 46–47

John Romine, "Scott Burton," *Upstart*, vol. 5, May 1981, pp. 6–9

John Perreault, "Usable Art," *Portfolio*, vol. 3, July–August 1981, pp. 60–63

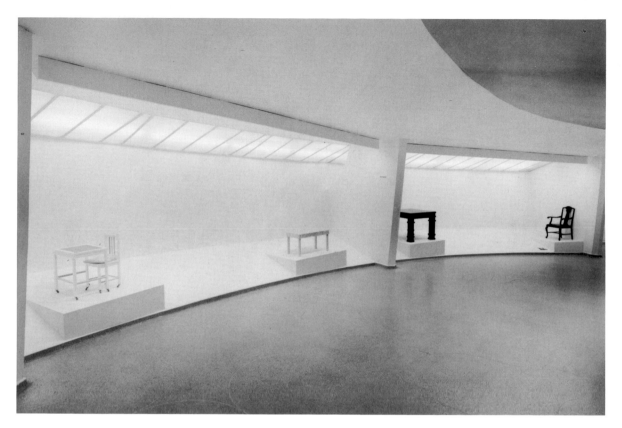

Installation view, *Young American Artists:
1978 Exxon National Exhibition*, Scott
Burton, l. to r., *Child's Table and Chair*, 1978,
Spattered Table, 1977, *Untitled*, 1975–77, and
Bronze Chair, 1975

Nory Miller, "Movables," *Progressive
Architecture*, vol. LXII, September 1981,
pp. 194–197

Robert Stearns, "Scott Burton Goes to the
Services," *Dialogue*, vol. 4, Fall 1981, p. 18

Donald Kuspit [review], *Artforum*, vol. XX,
March 1982, p. 78

John Russell, "Chairs by Scott Burton and
Others," *The New York Times*, May 21, 1982,
p. C22

Peter Schjeldahl, "Scott Burton Chairs the
Discussion," *The Village Voice*, June 1, 1982,
p. 86

Calvin Tomkins, "Like Water in a Glass," *The
New Yorker*, March 21, 1983, p. 92

Donald Kuspit [review], *Artforum*, vol. XXI,
March 1983, p. 78

Ronny H. Cohen, "Scott Burton," *LAICA
Journal*, vol. 36, Spring 1983, pp. 62–66

Paula Tyler, "Scott Burton: An Essay on Chairs," *Artweek*, October 22, 1983, pp. 1, 16

Gerald Marzorati, "Portrait of the Artist as a Young Furniture Maker," *Metropolitan Home*, vol. 15, November 1983, p. 28

Calvin Tomkins, "Perception at All Levels," *The New Yorker*, December 3, 1984, p. 176

Denise Domergue, *Artists Design Furniture*, New York, 1984, pp. 56–59.

Stacy Paleologos Harris, ed., *Insights/On Sites: Perspectives on Art in Public Places*, Washington, D.C., 1984, pp. 24–25

Dorothy C. Miller, Robert Rosenblum and J. Walter Severinghaus, *Art at Work: The Chase Manhattan Collection*, New York, 1984, pp. 49–50

Peter Schjeldahl, "Scott Burton: Un Romantisme, réaliste et austère," *Art Press*, vol. 90, March 1985, p. 32

Patricia C. Phillips, "Scott Burton," *Artforum*, vol. XXIII, Summer 1985, p. 105

Lynne Cooke, "Scott Burton," *Artscribe*, vol. 55, December 1985–January 1986, pp. 51–55

Prudence Carlson, Lynne Cooke, Hilton Kramer, Kim Levin, Mark Rosenthal and Phyllis Tuchman, *Art of Our Time: The Saatchi Collection*, vol. 4, New York, 1985, p. 22

Committee on the Visual Arts, Massachusetts Institute of Technology, *Artists and Architects Collaborate: Designing the Wiesner Building*, Cambridge, Massachusetts, 1985, pp. 60–67

Patricia Fuller, *Five Artists at NOAA: A Casebook on Art in Public Places*, Seattle, 1985, pp. 23–36

Douglas C. McGill, "Art People: Public Space, But Is It Art?" *The New York Times*, February 7, 1986, p. C30

Patricia C. Phillips, "Baltimore: Scott Burton," *Artforum*, vol. XXV, April 1987, p. 134

SANDRO CHIA

Born in Florence, April 20, 1946. Studied at Accademia di Belle Arti, Florence, degree, 1969. Lives in Rome and New York.

Selected One-Person Exhibitions

Galleria la Salita, Rome, *L'ombra e il suo doppio*, April 16–May 1971; 1972; *Sandro Chia: Ex libris*, February 1973; December 12, 1973–January 1974; June 1974; 1975; December 21, 1976–January 1977; *Sandro Chia: Pupa, preliminari per una mostra d'arte a Roma*, December 14, 1977–January 1978

Galleria Diagramma, Milan, 1972

Galleria de Domizio, Pescara, *Graziosa girevole*, May 1975

Galleria l'Attico, Rome, 1975

Galleria Tucci Russo, Turin, March 1976; 1978

Galleriaforma, Genoa, 1977

Galleria Sperone, Rome, 1977; December 1979

Galleria De Crescenzo, Rome, March 1978

Galerie Paul Maenz, Cologne, November 1978; 1980

Framart Studio, Naples, December 15, 1978–January 31, 1979

Galleria dell'Oca, Rome, 1978

Galleria Mario Diacono, Bologna, *Sandro Chia: Maria Dia(i)cona*, January 13–February 3, 1979. Catalogue with text by Mario Diacono

Sperone Westwater Fischer, New York, January 1980; April 4–25, 1981

Art and Project, Amsterdam, March 1980

Galleria Mario Diacono, Rome, September 11–October 10, 1981, catalogue with text by Mario Diacono; April 23–May 20, 1983, catalogue with text by Mario Diacono

Anthony d'Offay Gallery, London, December 3, 1981–January 8, 1982

Galerie Albert Baronian, Brussels, February 1982

James Corcoran Gallery, Los Angeles, *Sandro Chia: Recent Paintings*, April 6–28, 1982; August 3–31, 1984

Sperone Westwater, New York, October 30–November 27, 1982; May 2–30, 1987

Stedelijk Museum, Amsterdam, *Sandro Chia*, April 7–May 29, 1983. Catalogue

Leo Castelli Gallery, New York, March 20–27, 1982; *Sandro Chia*, April 30–June 3, 1983; *Sandro Chia*, January 5–26, 1985

Galleria Sperone at SIMA, Palazzo Grassi, Venice, *Sandro Chia: Disegni, acquarelli, pastelli, tempere*, April 1983. Catalogue

Galerie Bruno Bischofberger, Zürich, June 11–July 7, 1983; October 19–November 16, 1985

Städtisches Museum Abteiberg, Mönchengladbach, West Germany, *Sandro Chia*, August 14–September 18, 1983. Catalogue with text by Johannes Cladders

Galerie Daniel Templon, Paris, September 17–October 26, 1983; *Sandro Chia: Aquarelles, dessins, pastels*, May 12–June 9, 1984

Galerie Natalie Seroussi, Paris, September 20–November 1983

Kestner-Gesellschaft, Hannover, *Sandro Chia*, December 9, 1983–January 29, 1984. Catalogue with texts by Henry Geldzahler, Carl Haenlein, Michael Krüger and Anne Seymour. Traveled to Staatliche Kunsthalle, Berlin, March 6–28, 1984

Galerie Silvia Menzel, Berlin, December 1983–January 1984

Fruitmarket Gallery, Edinburgh, *Sandro Chia*, 1983. Catalogue with interview with the artist by Carter Ratcliff

Akira Ikeda Gallery, Tokyo, *Sandro Chia*, April 9–28, 1984, catalogue; March 3–29, 1986, catalogue; *Sandro Chia*, January 10–24, 1987, catalogue with text by the artist

Museé d'Art Moderne de la Ville de Paris, *Sandro Chia: Peintures, 1976–1984*, May 11–June 24, 1984

Ausstellungshallen Mathildenhöhe, Darmstadt, *Sandro Chia*, July 9–August 19, 1984. Catalogue with texts by Henry Geldzahler, Carl Haenlein, Michael Krüger and Carter Ratcliff

Ascan Crone, Hamburg, *Sandro Chia: Neue Bilder, Skulpturen, Aquarelle*, October 25–November 25, 1984. Catalogue with texts by Michael Krüger and the artist

Galerie Michael Haas, Berlin, *Sandro Chia*, March 23–May 11, 1985. Catalogue with text by Heiner Bastian

Kunsthalle Bielefeld, *Passione per l'arte/ Leidenschaft für die Kunst*, May 11–June 22, 1986. Catalogue with text by Ulrich Weisner

Mario Diacono, Boston, *Sandro Chia*, April 10–May 2, 1987. Brochure with text by Mario Diacono

Selected Bibliography

By the Artist

Bibliographie, Rome, 1972

with Achille Bonito Oliva, *Intorno a se*, Rome, 1978

Mattinata all'opera, Modena, 1979

with Achille Bonito Oliva and Enzo Cucchi, *Tre o quattro artisti secchi*, Modena, 1979

Carta d'Olanda, Amsterdam, 1980

"Murals in Time," *Art and Antiques*, May 1986, pp. 56–61

On the Artist

Luciana Rogozinski, "Sandro Chia: Mario Diacono/Bologna," *Flash Art*, March-April 1979, p. 54

Francesco Vincitorio, "Dice Sandro Chia," *L'Espresso*, February 3, 1980, p. 91

Thomas Lawson, "Sandro Chia at Sperone Westwater Fischer," *Art in America*, vol. 68, March 1980, p. 122

"Italienische Kunst Heute," *Kunstforum*, vol. 39, March 1980, special issue, passim

Ginestra Calzolari, "Sandro Chia," *Acrobat Mime Parfait*, October 1980, pp. 24–27

Roberto G. Lambarelli, "Sandra Chia, del paradosso o della parodia," *Acrobat Mime Parfait*, October 1980, pp. 16–23

Jean-Christophe Ammann, *Annuario Skira*, Geneva, 1980, passim

Achille Bonito Oliva, "Sandro Chia," *Domus*, June 1981, p. 55

Thomas Lawson, "Sandro Chia: Sperone Westwater Fischer," *Artforum*, vol. XIX, June 1981, p. 91

Carter Ratcliff, "A New Wave from Italy:

Sandro Chia," *Interview*, vol. 11, June–July 1981, pp. 83–85

Michael Krugman, "Sandro Chia," *Art in America*, vol. 69, October 1981, pp. 144–145

Pari Stave, "Sandro Chia," *Art News*, vol. 80, October 1981, pp. 224–225

Anne Seymour, *The Draught of Dr. Jekyll: An Essay on the Work of Sandro Chia*, London, 1981

Danny Berger, "Sandro Chia in His Studio: An Interview," *The Print Collector's Newsletter*, vol. XII, January–February 1982, pp. 168–169

René Payant, "Ces formes qui ironisent: A propos de Sandro Chia et Enzo Cucchi," *Art Press*, March 1982, pp. 20–22

Stuart Morgan, "London-Sandro Chia, Anthony d'Offay Gallery," *Artforum*, vol. XX, May 1982, p. 91

Grace Glueck, "Sandro Chia," *The New York Times*, November 12, 1982, p. C21

Stellan Holm, "Sandro Chia-Il pittore," *Clic*, December 1982, pp. 70–71

Susan A. Harris, "Sandro Chia," *Arts Magazine*, vol. 57, January 1983, pp. 28–29

Michael Kohn, "Sandro Chia," *Flash Art*, January–February 1983, pp. 63–64

Gerald Marzorati, "Sandro Chia: The Last Hero," *Art News*, vol. 82, April 1983, pp. 58–66

Jules B. Farber, "Holland Focus: 2 High C's from Italy," *International Herald Tribune*, May 7–8, 1983, p. 7

Vivien Raynor, "Art: Neo-Expressionists or Neo-Surrealists?" *The New York Times*, May 13, 1983, p. C17

Robert Hughes, "Doing History as Light Opera," *Time*, May 16, 1983, p. 79

Interview with Heiner Bastian, "Samtale med Sandro Chia," *Louisiana Revy*, vol. 23, June 1983, pp. 34–39, 51–52, 56

Jamey Gambrell, "Sandro Chia at Castelli Greene St.," *Art in America*, vol. 71, October 1983, pp. 188–189

Claude Royer [review], *Flash Art*, December 1983-January 1984, pp. 37–38

Sperone Westwater, New York, and Leo Castelli Gallery, New York, *Sandro Chia*, New York, 1983

Gerard-Georges LeMaire, "Sandro Chia: Galerie Daniel Templon," *Artforum*, vol. XXII, January 1984, p. 86

William Wilson, "Galleries: La Cienega Area," *Los Angeles Times*, August 10, 1984, part VI, p. 16

Achille Bonito Oliva, *Dialoghi d'artista*, Milan, 1984, pp. 288–295

E. Darragon, "Trans-avant-garde Painting: Sandro Chia and Enzo Cucchi," *Critique*, vol. 40, 1984, pp. 693–703

Vivien Raynor [review], *The New York Times*, January 20, 1985, p. C44

Kim Levin [review], *The Village Voice*, January 29, 1985, p. 81

Amei Wallach, "Acquiring Art in a Big Way," *Newsday*, February 9, 1986, p. 1

Dr. Henriette Käth-Hinz, "Bilder für die Ewigkeit," *Pan*, May 1986, pp. 82–85

Suzanne Stephens, "An Equitable Relationship," *Art in America*, vol. 74, May 1986, pp. 116–123

Keiichi Kurosawa, "Sandro Chia: Akira Ikeda Gallery," *Flash Art*, March-April 1987, p. 100

JULIE COHEN

Born in New York, April 24, 1955. Studied at Pratt Institute, Brooklyn, 1973; Ithaca College, New York, 1974–76; School of Visual Arts, New York, B.F.A., 1979; Hunter College, New York, M.A., 1982. Lives in New York.

One-Person Exhibition

Fiction Nonfiction, New York, September 10–October 4, 1987

ENZO CUCCHI

Born in Morro d'Alba, Italy, November 14, 1949. Lives in Ancona and Rome.

Selected One-Person Exhibitions

Galleria Luigi De Ambrogi, Milan, *Montesicuro, Cucchi Enzo giù*, 1977

Incontri Internazionali d'Arte, Palazzo Taverna, Rome, *Ritratto di casa*, 1977; *Solchi d'Europa*, June 1985

Galleria Giuliana De Crescenzo, Rome, *Mare Mediterraneo*, May 24–June 24, 1978, catalogue with text by the artist; *Alla lontana alla francese*, January 15–February 15, 1979

Galleria Mario Diacono, Bologna, *La cavalla azzurra*, February 10–March 3, 1979. Catalogue with texts by Mario Diacono and the artist

Galerie Paul Maenz, Cologne, *5 monti sono santi*, September 12–October 10, 1980; *Enzo Cucchi: Viaggio delle lune*, November–December 1981, catalogue with texts by Diego Cortez and the artist, traveled to Art and Project, Amsterdam, December 17, 1981–January 16, 1982

Sperone Westwater Fischer, New York, February 14–March 10, 1981

Galerie Bruno Bischofberger, Zürich, *Enzo Cucchi*, March 28–April 18, 1981; *La città delle mostre*, April 30–June 4, 1983

Galleria Mario Diacono, Rome, *Enzo Cucchi*, October 20–November 14, 1981, brochure with text by Mario Diacono; *Enzo Cucchi: Tetto*, 1984, catalogue with text by Mario Diacono

Galleria Sperone, Rome, *Enzo Cucchi*, November 15–30, 1981; *Roma: Enzo Cucchi*, October–November 1986, catalogue with text by Achille Bonito Oliva

Museum Folkwang, Essen, *Enzo Cucchi: Un'immagine oscura*, December 17, 1982–January 23, 1983. Catalogue with text by Zdenek Felix

Sperone Westwater, New York, *Enzo Cucchi*, March 5–26, 1983; *Enzo Cucchi: Vitebsk/Harar*, November 8–December 1, 1984, catalogue with text by Mario Diacono and interview with the artist by Diacono

Stedelijk Museum, Amsterdam, *Enzo Cucchi: Recent Work*, November 11, 1983–January 8, 1984. Catalogue with text by the artist. Traveled to Kunsthalle Basel, January 20–February 26, 1984

Anthony d'Offay Gallery, London, *Enzo Cucchi: Italia*, May 16–June 15, 1984. Catalogue with text by the artist

The Institute of Contemporary Art, Boston, *Enzo Cucchi*, September 6–November 5, 1984. Brochure with text by Elisabeth Sussman

Mary Boone/Michael Werner Gallery, New York, *Enzo Cucchi: Vitebsk/Harar*, November 3–24, 1984. Catalogue with text by Mario Diacono

Galerie Bernd Klüser, Munich, *Enzo Cucchi*, March 29–May 15, 1985, set of three catalogues, *34 disegni cantano I* with text by Jean-Christophe Ammann, *34 disegni cantano II* with text by Jean-Christophe Ammann, and *Il deserto della scultura* documenting creation of sculpture by Cucchi for Louisiana Museum, Humlebaek, Denmark, with texts by Jean-Christophe Ammann, Knud Jensen and Bernd Klüser; *Solchi d'Europa*, September 1985, catalogue with interview with the artist by Bruno Corà, Helmut Friedel and Hans Albert Peters

Kunstmuseum Düsseldorf, *Disegni vivono nella paura della terra–Zeichnungen leben in der Angst vor der Erde*, May 9–July 14, 1985. Brochure

Fundación Caja de Pensiones, Madrid, *Enzo Cucchi*, December 12, 1985–February 2, 1986. Catalogue with texts by Carmen Bernárdez, Bruno Corà, Jacobo Cortines, Mario Diacono and Sandro Penna and interviews with the artist. Traveled to CAPC, Musée d'Art Contemporain, Entrepôt Lainé, Bordeaux, March 7–April 26, 1986

Solomon R. Guggenheim Museum, New York, *Enzo Cucchi*, May 6–July 6, 1986. Catalogue with texts by Diane Waldman and the artist

Musée National d'Art Moderne, Centre Georges Pompidou, Paris, *Enzo Cucchi— Voyages*, June 4–August 24, 1986. Catalogue with texts by Dominique Bozo, Bruno Corà, Eric Darragon, Maurice Roche and the artist

Kunsthalle Bielefeld, *Enzo Cucchi: Guida al disegno*, January 18–March 1, 1987. Catalogue with texts by Achille Bonito Oliva, Mario Diacono, Carla Schulz-Hoffmann and Ulrich Weisner

Städtische Galerie im Lenbachhaus, Munich, *Testa*, July 1–September 13, 1987. Catalogue with texts by Helmut Friedel et al.

Selected Bibliography

By the Artist

Il veleno è stato sollevato e trasportato, Macerata, 1976

with Achille Bonito Oliva, *Canzone*, Modena, 1979

"Lettera di un disegno dal fronte," *Domus*, March 1981, p. 52

"Letter from Enzo Cucchi," *Artscribe*, May–July 1984, p. 39

with Bruno Corà, "Enzo Cucchi: Solchi d'Europa," *A.E.I.U.O.*, December 1985, pp. 7–17

with Jean-Christophe Ammann and Bernd Klüser, *Skulptur für Basel*, Munich, 1985

with Mario Diacono, *La cerimonia delle cose/The Ceremony of Things*, New York, 1985

with Joseph Beuys, Anselm Kiefer and Jannis Kounellis, *Ein Gespräch/Una discussione*, Zürich, 1986

On the Artist

Roberto G. Lambarelli, "Enzo Cucchi: Giuliana De Crescenzo/Roma and Mario Diacono/Bologna," *Flash Art*, March–April 1979, p. 51

Jean-Christophe Ammann, Paul Groot, Pieter Heynen and Jan Zumbrink, "Un altre arte? Enzo Cucchi. Wat is dat trouwens, een criticus?" *Museumjournaal*, December 1980, pp. 294–295

Roberto G. Lambarelli, "Enzo Cucchi: Emilio Mazzoli/Modena," *Flash Art*, March–April 1981, p. 51

Lewis Kachur, "Enzo Cucchi," *Arts Magazine*, vol. 55, April 1981, p. 13

Richard Flood, "New York: Enzo Cucchi," *Artforum*, vol. XIX, May 1981, p. 69

René Payant, "Ces formes qui ironisent: A propos de Sandro Chia et Enzo Cucchi," *Art Press*, March 1982, pp. 20–22

Danny Berger, "Enzo Cucchi: An Interview," *The Print Collector's Newsletter*, vol. XIII, September–October 1982, pp. 118–120

Paul Groot, "Enzo Cucchi, Groninger Museum," *Artforum*, vol. XXI, February 1983, p. 87

John Russell, "Enzo Cucchi," *The New York Times*, March 11, 1983, p. C22

Theodore F. Wolff, "A Revised View of Some Recent European Art—Thanks to Enzo Cucchi," *The Christian Science Monitor*, March 22, 1983, p. 23

Interview with Heiner Bastian, "Samtale med Enzo Cucchi," *Louisiana Revy*, vol. 23, June 1983, pp. 45–50, 54, 57

Donald B. Kuspit, "Enzo Cucchi at Sperone Westwater," *Art in America*, vol. 71, Summer 1983, pp. 159–160

Helena Kontova and Giancarlo Politi, "Interview with Enzo Cucchi," *Flash Art*, November 1983, pp. 12–21

Zdenek Felix, "Bilder des Staunens: Kraft der Imagination bei Enzo Cucchi," *Kunstmagazin*, vol. 22, 1983, pp. 38–56

Bice Curiger, "Enzo Cucchi: Galerie Bischofberger/Zürich," *Flash Art*, January 1984, p. 42

Jean-Christophe Ammann, "Jean-Christophe Ammann per Enzo Cucchi," *Domus*, February 1984, pp. 70–71

Interview with Helena Kontova and Giancarlo Politi, "Flash Art Interviste: Enzo Cucchi," *Flash Art*, February–March 1984, pp. 8–17

Jean-Christophe Ammann, "Giulio Cesare Roma!" *Parkett*, April 1984, pp. 52–54

Marja Bloem, "Ein Nachmittag mit Enzo Cucchi," *Parkett*, April 1984, pp. 61–63

Bice Curiger, "Enzo Cucchi," *Parkett*, April 1984, pp. 64–67

H. Zellweger, "Enzo Cucchi," *Kunstwerk*, vol. 37, April 1984, pp. 65–66

Interview with Xavier Girard, "Enzo Cucchi: Innocence et mémoire," *Art Press*, September 1984, pp. 12–15

Lars Nittve, "Quartetto," *Artforum*, vol. XXIII, September 1984, pp. 107–108

Grace Glueck, "Art: Apocalyptic Vision of Cucchi's Paintings," *The New York Times*, November 16, 1984, p. C22

Theodore F. Wolff, "Enzo Cucchi," *The Christian Science Monitor*, December 17, 1984, p. 30

Interview with Gerardo Delgado, "El territorio moral de Cucchi," *Figura*, Spring/Summer 1985, pp. 8–17

Achille Bonito Oliva, "'Come la lingua degli uccelli dai nati di domenica.' Enzo Cucchi," *Tema Celeste*, June 1985, pp. 13–18

Lisa Ponti, "Enzo Cucchi e i solchi d'Europa," *Domus*, November 1985, pp. 66–67

Ida Panicelli, "Enzo Cucchi: Al Guggenheim con le nuvole," *La Stampa*, May 3, 1986, p. 8

Michael Brenson, "Art: Enzo Cucchi Show at Guggenheim," *The New York Times*, May 9, 1986, p. C27

Theodore F. Wolff, "Cucchi vs. Guggenheim," *The Christian Science Monitor*, May 23, 1986, p. 26

Kay Larson, "Unbearable Lightness," *New York Magazine*, May 26, 1986, pp. 86–87

Amei Wallach, "Cucchi: Myth and Melodrama," *Newsday*, June 13, 1986, pp. 16–17

David Bourdon, "Art: Windows on a Strange World," *Vogue*, June 1986, p. 56

Jack Flam, "Italian 'Primitive,' Pre-Hitler Realists," *The Wall Street Journal*, July 1, 1986, p. 24

Ida Panicelli, "Enzo Cucchi: Solomon R. Guggenheim Museum," *Artforum*, vol. XXV, September 1986, pp. 130–131

Maurice Poirier, "Enzo Cucchi: Solomon R. Guggenheim Museum," *Art News*, vol. 85, September 1986, p. 126

Carter Ratcliff, "Enzo Cucchi in the New World," *The Print Collector's Newsletter*, vol. XVII, November–December 1986, pp. 170–173

Carolyn Christou-Bakargiev, "Enzo Cucchi: Gian Enzo Sperone," *Flash Art*, December 1986–January 1987, p. 67

SCOTT DAVIS

Born in Washington, D.C., September 4, 1944. Studied at University of California, Davis, M.F.A., 1974; Whitney Studio Program, Whitney Museum of American Art, New York, 1974. Lives in New York.

Selected One-Person Exhibitions

Institute for Art and Urban Resources, P.S.1, Long Island City, New York, December 7, 1980–January 25, 1981

Contemporary Arts Center, Cincinnati, *Abstraction: Two Views*, October 27–November 26, 1983. Brochure with text by Sarah Rogers-Lafferty

Laurie Rubin Gallery, New York, April 9–May 9, 1987

Selected Bibliography

Roberta Smith [review], *The New York Times*, May 8, 1987, p. C27

BERNARD FAUCON

Born in Apt (Provence), France, September 12, 1950. Studied at Université de Paris, La Sorbonne, Maîtrise, 1974. Lives in Paris and Provence.

Selected One-Person Exhibitions

Galerie Lop-Lop, Paris, April 28–May 28, 1977

Galerie-Librairie La Quotidienne, Aix-en-Provence, 1977

Galerie Fotomania, Barcelona, May 30–June 26, 1978

Galerie Agathe Gaillard, Paris, April 4–May 26, 1979; 1984; *Les Chambres d'amour*, June–July 1986

Castelli Graphics, New York, November 10–December 1, 1979; September 19–October 10, 1981; January 8–29, 1983; *The Rooms of Love*, May 2–24, 1986

Galerie Canon, Geneva, December 9, 1979–January 3, 1980

Galerie 't Venster, Rotterdam, December 9, 1979–January 21, 1980

Galerie Napalm, Saint-Etiènne, April 9–May 18, 1981

Galerie Junod, Lausanne, November 17–December 24, 1981; 1983; September–October 1987

Galerie Paula Pia, Antwerp, February 2–March 2, 1982

Musée de Toulon, *Bernard Faucon*, December 2, 1982–January 9, 1983. Catalogue with text by Marie-Claude Beaud

Zeit-Photo-Salon, Tokyo, December 13–28, 1982

Galerie Fiolet, Amsterdam, 1983; November 1986

Galerie Imagique, Saint-Saturin d'Apt, 1983

Galerie Axe Actuel, Toulouse, February 5–March 11, 1985

Houston Center of Photography, February 28–April 6, 1985

Galerie Images Nouvelles, Bordeaux, *La Part du calcul dans la grâce*, April 1985; December 1986, catalogue with text by Jean-Michel Michelena

Galerie Artem, Quimper, 1985

Galeria Modulo, Lisbon, 1985

Galerie de Prêt, Angers, 1985

Galerie Alexandre de la Salle, Saint Paul-de-Vence, 1985

Musée Nicephore Nièpce, Chalon-sur-Saône, 1985

Van Reekum Museum, Apeldoorn, The Netherlands, 1985

Galerie Jade, Colmar, April–May 1986

Musée d'Auriac, May–June 1986

Centre d'Art Contemporain, Forcalquier, July–August 1986

Musée de la Charité, Marseille, October 15–December 31, 1986. Catalogue

Watershed Gallery, Bristol, February 7–March 7, 1987

Galerie l'Hypodrome, Douai, France, February 13–March 30, 1987

Maison de la Culture, Amiens, March 5–April 12, 1987

Stills Gallery, Edinburgh, April 11–May 16, 1987

Centre Culturel, Montbéliard, April 17–May 8, 1987

Parco, Tokyo, April 19–May 25, 1987

Institute of Contemporary Arts, London, *Bernard Faucon: Photographs*, May 14–June 12, 1987

Torino Fotografia, Turin, June 15–August 3, 1987

Darkroom, Cambridge, July 11–August 23, 1987

Ecole Régionale des Beaux-Arts et d'Architecture, Marseille, July 12–17, 1987

Selected Bibliography

By the Artist

Summer Camp, New York, 1980. French edition, *Les Grandes Vacances*, Paris, 1981

"Les Créateurs," *Autrement*, no. 48, 1983

Mois de la photo, Paris, 1984

Evolution probable du temps, Paris, 1986

Les Papiers qui volent, Paris and Tokyo, 1986

On the Artist

Christian Caujolle, "Les Chromos d'enfance de Bernard Faucon," *Libération*, April 5, 1979, pp. 14–15

Hervé Guibert, "Bernard Faucon chez Agathe Gaillard: Les Plaisirs de l'enfance," *Le Monde*, April 5, 1979, p. 19

Michel Nuridsany, "Faucon: L'Enfance rêvée," *Le Figaro*, April 10, 1979, p. 26

André Laude, "Bernard Faucon: Chez Agathe Gaillard," *Les Nouvelles Littéraires*, April 26–May 3, 1979, p. 28

Pierre Jouvet, "Faux Vrais," *Le Cinématographe*, July 1979

Roland Barthes, "Bernard Faucon," *Zoom*, no. 57, 1979, pp. 46–53

Madeleine Burnside, "Bernard Faucon," *Arts Magazine*, vol. 54, February 1980, p. 44

Luc Pinhas, "Bernard Faucon, la force du dévoilement," *Masques*, Winter 1980–81, pp. 116–119

Interview with Hervé Guibert, "Un Entretien avec Bernard Faucon," *Le Monde*, January 14, 1981, p. 15

Jean-Pierre Thibaudat, "Bernard Faucon: Le Comble de la photographie," *Libération*, January 24, 1981, p. 16

Kineo Kuwabala, "Bernard Faucon," *Asahi Camera*, October 1981

Photography Year 1981, Alexandria, Virginia, 1981, pp. 12–14

Nicolas A. Moufarrege, "Bernard Faucon: Summer Camp," *Arts Magazine*, vol. 57, October 1982, p. 5

Christian Caujolle, "L'Enigme du papillon dans la Cène de Bernard Faucon," *Anthologie de la Critique 82*, Paris, 1982

Christian Caujolle, "Bernard Faucon," *Photomagazine*, February 1983, pp. 58–66

"Daniel Tremblay, Bernard Faucon, Musée de Toulon," *Art Press*, February 1983, p. 49

Dominique Carré, "L'Enfance réinventée: Bernard Faucon," *Beaux-Arts Magazine*, July–August 1983, pp. 78–79

Alain Bergala, "Le Vraix, le faux, le factice," *Les Cahiers du Cinéma*, September 1983, pp. 4–9

Philippe Mezescave, "Bernard Faucon: Un Oiseau fort," *Masques*, Spring 1984, pp. 166–169

Michel Nuridsany, "L'Univers rêvé de Bernard Faucon," *Art Press*, September 1984, p. 25

Hervé Guibert, "Faucon l'inspiré," *Le Monde*, November 13, 1984, p. 15

Christian Caujolle, "Photographie, Bernard Faucon," *Beaux-Arts Magazine*, November 1984, pp. 58–61

Allen Ellenzweig, "Bernard Faucon at Gallery Agathe Gaillard," *Art in America*, vol. 73, May 1985, p. 183

Lynn McLanahan, "Bernard Faucon: Growing Up," *Spot*, Spring 1985, pp. 8–9

Alexandra Anderson, "What's Hot at Foto Fest," *American Photographer*, March 1986, p. 16

John Stathatos, "Bristol: Bernard Faucon," *Artscribe*, May 1987, p. 71

PHILIPPE FAVIER

Born in Saint-Etienne, June 21, 1957. Studied at Ecole des Beaux-Arts de Saint-Etienne, 1979–83. Lives in Saint-Etienne.

Selected One Person Exhibitions

Galerie Napalm, Saint-Etienne, June 1981

Musée d'Art et d'Industrie, Saint-Etienne, *Philippe Favier*, March 29–April 30, 1982. Catalogue with texts by Bernard Ceysson and Gilbert Lascault

Galerie C. le Chanjour, Nice, July 5–31, 1983

Galerie Farideh Cadot, Paris, September 17–October 10, 1983; September–October 1985

Galerie Grita Insam, Vienna, November 5–December 2, 1983

Halle Sud, Geneva, May 7–June 2, 1985

Galerie Alma, Lyon, *Capitaine Coucou*, October 2–31, 1985. Catalogue with text by Eric Darragon

Musée du Dessin et de l'Estampe, Gravelines, *Capitaine Coucou*, June 8–July 7, 1986

Musée de l'Abbaye de Sainte-Croix, Sables-d'Olonne, *Philippe Favier: 1980–1985*, July 5–September 14, 1986. Catalogue with texts by Daniel Abadie, Jacques Bonnaval, Louise Ferrari, Jean-Claude Lebensztein, Eric Michaud and Guy Tosatto. Traveled to Villa Arson, Nice, October 11–December 7, 1986; Musée de Rochechouart, Limoges, January 12–February 28, 1987

Farideh Cadot Gallery, New York, November 22–December 28, 1986

Centre de Gravures Contemporaines, Geneva, *Lucky Luc*, January 1987

Galerie Pierre Huber, Geneva, January 1987

Selected Bibliography

Didier Semin, "Une Source de Philippe Favier," *Avant-Guerre*, no. 3, 1981

Inès Champey, "Philippe Favier," *Art Press*, April 1982, pp. 12–13

Hervé Gauville, "Parmi cent autres, Philippe Favier," *Libération*, October 1, 1982, p. 26

Frank Maubert, "Philippe Favier," *L'Express*, September 23–29, 1983

Olivier Céna, "P. Favier," *Télérama*, October 1, 1983

Christian Caujolle, "Philippe Favier, petit bonhomme," *Libération*, October 4, 1983, p. 29

Xavier Girard [review], *Art Press*, October 1983, p. 52

Elisabeth Couturier, "Philippe Favier, Galerie Farideh Cadot," *Art Press*, November 1983, p. 52

Jacques Bonnaval, "Philippe Favier," *Axe Sud*, Winter 1983

Interview with Valère Nuther, "Ce qui est dit est à retaire: Entretien avec Philippe Favier," *Halle Sud*, April 1985, pp. 2–3

Mireille Descombes, "Les Microcosmes de Favier," *Tribune de Genève*, May 17, 1985

"Miniatures, Samba figurative," *L'Hebdo*, May 23, 1985, p. 83

Françoise-Claire Prodhon, "Philippe Favier," *Flash Art*, Spring–Summer 1985, pp. 68–69

Catherine Borrini, "Philippe Favier: Halle Sud," *Art Press*, July–August 1985, p. 54

François-Yves Morin, "Philippe Favier: La Peinture en minuscules," *Mars*, Summer 1985, pp. 16–17

Olivier Céna, "Philippe Favier, légumes étranges et flamant rose," *Télérama*, October 2, 1985, p. 45

Henri-François Debailleux, "Philippe Favier," *Beaux-Arts Magazine*, October 1985, pp. 94–95, 130

Jean-Luc Chalumeau, "Et que tout soit pareil et que tout soit autre chose," *Eighty*, January–February 1986, pp. 60–61

Catherine Flohic, "Portrait," *Eighty*, January–February 1986, p. 63

Sonia Criton, "Philippe Favier," *Flash Art*, March 1986, p. 36

Catherine Francblin, "Philippe Favier, le sens de la démesure," *Art Press*, June 1986, pp. 33–35

Françoise-Claire Prodhon, "Philippe Favier: Le Monumental en miniature," *Vie des Arts*, vol. XXXI, September 1986, p. 60

Didier Semin, "Une Source de P. Favier," *Des Arts*, March 1987

Françoise-Claire Prodhon, "Philippe Favier: Musée de Rochechouart, Limoges," *Flash Art*, April 1987, p. 117

John Sturman, "Philippe Favier: Farideh Cadot," *Art News*, vol. 86, April 1987, p. 179

HEIDI GLÜCK

Born in Brooklyn, December 30, 1944. Studied at Bennington College, Vermont, B.A., 1966; Hunter College, New York, 1966–69. Lives in Jersey City.

Selected One-Person Exhibitions

Bertha Urdang Gallery, New York, *H. Glück: Paintings and Drawings*, February 9–March 4, 1978; February 13–March 10, 1979

Art Galaxy, New York, October 15–November 12, 1983

Selected Bibliography

Holland Cotter [review], *New York Arts Journal*, April–May 1977, p. 27

Robert Pincus-Witten, "Entries: Glück, Stephan, Acconci," *Arts Magazine*, vol. 52, March 1978, pp. 92–93

Barbara Flynn [review], *Artforum*, vol. XVI, April 1978, pp. 62–63

Holland Cotter [review], *New York Arts Journal*, vol. 3, April–May 1978, p. 30

Laurel Bradley [review], "Heidi Glück," *Arts Magazine*, vol. 52, June 1978, p. 51

Donald Kuspit, "Heidi Glück," *Arts Magazine*, vol. 53, June 1979, p. 2

Stephen Westfall [review], *Arts Magazine*, vol. 58, March 1984, pp. 40–41

Joseph Masheck, *Smart Art*, New York, 1984, pp. 40–43

ANTHONY PETER GORNY

Born in Buffalo, May 3, 1950. Studied at Università di Siena and Istituto dell'Arte, Siena, 1970–71; State University of New York, Buffalo, B.F.A., 1972; School of Art and Architecture, Yale University, New Haven, M.F.A., 1974. Lives in Philadelphia and Buffalo.

Selected One-Person Exhibitions

Jane Haslem Gallery, Washington, D.C., February 15–March 5, 1977; *Anthony Gorny: New Lithographs*, May 1981; *The Sympathy of All Things*, November 27, 1984–January 6, 1985

Nexus Gallery, Philadelphia, *Private*, May 8–26, 1979; *V.V.*, October 17–November 8, 1980; *Votives*, February 1982

Olin Gallery, Roanoke College, Virginia, *Anthony Gorny, Photographs*, September 15–October 2, 1981

Jeffrey Fuller Fine Arts, Philadelphia, *Anthony Gorny, Lithographs from the B·M·F·V·V· Cycle*, January–March 1982

The Pennsylvania Academy of Fine Arts, Philadelphia, *The Sympathy of All Things*, May 3–June 17, 1984. Catalogue with text by Judith Stein

Bryce Gallery, Moore College of Art, Philadelphia, *Anthony Gorny: Lithographs*, November 12–December 15, 1984

Museo de Arte Costaricense, University of Costa Rica, San José, January 6–February 10, 1985. Catalogue with text by Guido Saénz

G. H. Dalsheimer Gallery, Baltimore, January 22–March 1, 1986

Dolan/Maxwell Gallery, Philadelphia, *Anthony Gorny: New Sculpture, Prints and Drawings*, May 3–31, 1986

Korn Gallery, Drew University, Madison, New Jersey, *Lithographs/Anthony Gorny*, September 26–October 25, 1986

Nina Freudenheim Gallery, Buffalo, *Anthony Gorny, Recent Works*, November 8–December 3, 1986

Selected Bibliography

By the Artist

It's Another Thing All Together, independent publication, Philadelphia, 1978

On the Artist

David Tannous, "Anthony Gorny Is a Master of Sorts," *Washington Evening Star*, March 3, 1977

Ann Werstein, "Crisp Photographs Show Life's Fuzzy Edge," *Roanoke Times and World News*, September 28, 1980, p. E6

Jonathan Katz, "Are You Listening?" *The Philadelphia Bulletin*, October 26, 1980, section II, p. 8

Victoria Donahoe, "A Twin Bill to Make You Doubly Glad You Went," *The Philadelphia Inquirer–Weekend Magazine*, October 31, 1980, p. 30

Richard Huntington, "Preferring Education over Art," *The Buffalo Courier Express*, December 17, 1980, p. C6

Edward Sozanski, "Pursuing Art as a Kind of Secular Religion," *The Philadelphia Inquirer*, May 15, 1984, p. E4

Domingo Ramos Aray, "The Graphic Work of Anthony Gorny," *La Nación*, February 3, 1986, p. II-2

Edward Sozanski, "A Guggenheim Opening for Two Philadelphia Artists," *The Philadelphia Inquirer*, October 30, 1985, pp. C1, C6

Edward Sozanski, "Gorny's Works Show Extension of His Talents," *The Philadelphia Inquirer*, May 8, 1986, p. C5

Ann Jarmusch, "Anthony Peter Gorny," *Art News*, vol. 85, October 1986, p. 101

Richard Huntington, "Gorny's Jumbled Exuberance (Gives Exhibit Matter over Mind)," *The Buffalo News*, November 16, 1986, section 2, p. 20

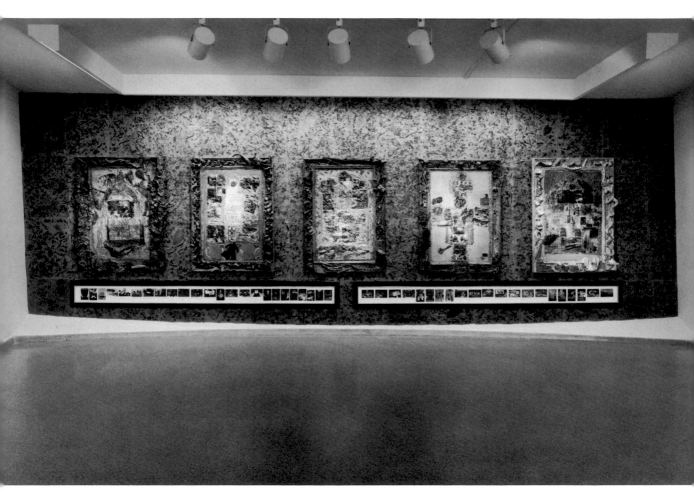

Installation view, *New Horizons in American Art: 1985 Exxon National Exhibition*, Anthony Peter Gorny, *Transitivity Volumes 1–5*, 1983–85, and *Predella Diptych*, 1972–76

ALAN GREEN

Born in London, December 22, 1932. Studied at Beckenham School of Art, Kent, 1949–53; Royal College of Art, London, 1955–58. Lives in London.

Selected One-Person Exhibitions

A.I.A. Gallery, London, May 1963

Annely Juda Fine Art, London, October 28–November 29, 1970; March 2–April 17, 1973; April–May 1975; September 1976; October 1978

Galerie Liatowitsch, Basel, July 1973

Galerie Hervé Alexandre, Brussels, March–April 1974; June 1975

Galerie Art in Progress, Munich, April–May 1974; *Alan Green: Bilder, Gouachen, Grafik*, January 20–February 19, 1977

Studio La Città, Verona, February 1975. Catalogue with text by Charles Spencer

Galerie de Gestlo, Hamburg, *Alan Green: Bilder, Gouachen, Grafik*, September 12–October 15, 1975

Galleria Vincianna, Milan, October 1975

Oliver Dowling Gallery, Dublin, January 1976; May 1978

The Tate Gallery, London, *Alan Green Etchings 73–76*, opened September 1976. Traveled to Mappin Art Gallery, Sheffield; University of Newcastle-upon-Tyne; Galerie Klaus Lüpke, Frankfurt

Painting Box Gallery, Zürich, November 1976–January 1977

Galerie Arneson, Copenhagen, December 1976

Galerie Art in Progress, Düsseldorf, *Alan Green: Neue Bilder*, September 1977; *Alan Green: Bilder und Zeichnungen*, November 15–December 20, 1980; October 27–December 8, 1982

Nina Freudenheim Gallery, Buffalo, April 29–May 27, 1978

Susan Caldwell, Inc., New York, May 3–27, 1978

Roundhouse Gallery, London, September–October 1978

Galerie Palluel, Paris, October–November 1978. Catalogue with text by Gerhard Weber

Kunsthalle Bielefeld, *Alan Green–Bilder 1969–79*, September 9–October 28, 1979. Catalogue with texts by Erich Franz, Bernd Growe and Martine Lignon

Galerie Loyse Oppenheim, Nyon, Switzerland, November–December 1979

Artline, The Hague, December 1979

Museum of Modern Art, Oxford, *Alan Green: Paintings 1969–1980*, February 24–April 5, 1980

St. Paul's Gallery, Leeds, *Alan Green: Drawings-Panels-Prints, 1976–1980*, September 13–October 11, 1980

Gallery Kasahara, Osaka, *Alan Green*, February 2–28, 1981, catalogue with text by Waldemar Januszczak; March 5–24, 1984, catalogue with text by Keinosuke Murata; November 25–December 13, 1986, catalogue with text by Seiji Oshima

Juda Rowan Gallery, London, *Alan Green: Recent Paintings and Drawings*, April 1–May 5, 1982; *Alan Green: Recent Paintings and Drawings*, July–August 1985, catalogue with text by Catherine Lacey

Gimpel Hanover und André Emmerich Galerien, Zürich, May 28–July 17, 1982; May 26–June 23, 1984

Galerij S65, Aalst, Belgium, September 10–October 17, 1982; September 7–October 14, 1984

Galerie Maeght-Lelong, Paris, *Alan Green: Peintures*, September 27–November 18, 1983

Galerie Nicole Gonet, Lausanne, August 30–September 30, 1984

Galerie Appel und Fertsch, Frankfurt, April 17–May 18, 1985

Galerie Klaus Lüpke, Frankfurt, April 17–May 18, 1985

Third Eye Centre, Glasgow, September 13–October 11, 1986

Sogetsu Gallery, Tokyo, November 5–15, 1986. Catalogue with text by Seiji Oshima

Donald Morris Gallery, Birmingham, Michigan, *Alan Green: Paintings and Drawings*,

November 15–December 31, 1986. Catalogue
with interview with the artist by William
Packer

Fondation Veranneman, Kruishoutem, Bel-
gium, March 21–April 30, 1987

Selected Bibliography

By the Artist

"Possibilities for Painting in 1980," *Aspects*,
Summer 1980, unpaginated

On the Artist

Andrew Forge, "A Note on Some Recent Pic-
tures by Alan Green," *Studio International*,
vol. 185, February 1973, pp. 76–77

Marina Vaizey, "Alan Green," *Financial Times*,
April 3, 1973, p. 3

Andrew Forge, "Alan Green on His Paintings,"
Studio International, vol. 186, October 1973,
pp. 144–145

Bernard Denvir, "Alan Green: A Dialogue,"
Art International, vol. XVIII, November 1974,
pp. 47–48

Judy Marle, "Judy Marle on Alan Green's
New Exhibition," *The Guardian*, April 25,
1975, p. 14

William Packer, "Alan Green," *Financial
Times*, April 25, 1975, p. 3

Peter Rippon, "Alan Green," *Artscribe*, Feb-
ruary 1977, p. 7

John McEwen, "Monochrome," *The Spec-
tator*, October 7, 1978, p. 24

Michael Billam, "Alan Green at Annely Juda,"
Artscribe, December 1978, pp. 56–57

Gerhard Weber, "Alan Green: La Peinture ne
s'explique pas," *Art Press*, December 1978,
p. 14

Waldemar Januszczak [review], *The Guardian*,
March 24, 1980

Robert Waterhouse [review], *The Guardian*,
September 30, 1980

Melanie Hart [review], *Arts Review*, April 9,
1982, p. 182

Waldemar Januszczak [review], *The Guardian*,
April 15, 1982

Sarah Kent [review], *Time Out*, April 23, 1982

John McEwen [review], *The Spectator*, May 1,
1982, p. 29

Marina Vaizey [review], *The Sunday Times*,
May 2, 1982, p. 39

Jos Knaepen [review], *The Bulletin*, September
17, 1982, pp. 10–11

Haruhiko Fujii [review], *Yomiuri Shimbun*,
March 15, 1984

Charlotte Stokes, "Alan Green," *Artforum*,
vol. XXV, May 1987, p. 153

DENISE GREEN

Born in Melbourne, Australia, April 7, 1946.
Studied at Ecole Supérieure des Beaux-Arts,
Paris, 1966–69; Université de Paris, La Sor-
bonne, degree, 1969; Hunter College, New
York, M.F.A., 1976. Lives in New York.

Selected One-Person Exhibitions

Whitney Museum Art Resources Center, New
York, May 1–15, 1975

Max Protetch Gallery, New York, October
2–23, 1976; December 9, 1977–January 15,
1978; November 6–29, 1980

Max Protetch Gallery, Washington, D.C.,
April 1977

Institute of Modern Art, Brisbane, *Denise
Green, 20 Recent Drawings*, August 22–
September 3, 1977; November 24–
December 15, 1977

Coventry Gallery, Sydney, September 6–24,
1977

School of Art Gallery, Royal Melbourne Insti-
tute of Technology, October 10–28, 1977

Protetch-McIntosh Gallery, Washington, D.C.,
February 5–March 1, 1980

Art Gallery of New South Wales, Sydney,
Denise Green, Project Show, September 13–
October 26, 1980. Catalogue with text by
Bernice Murphy

Galerie Albert Baronian, Brussels, October
11–November 4, 1980; April 24–May 17,
1986

Okun-Thomas Gallery, St. Louis, November 15–December 8, 1980

Institute for Art and Urban Resources at The Clocktower, New York, September 30–October 31, 1981

Anderson Gallery, Virginia Commonwealth University, Richmond, *Ellipses*, October 6–28, 1981

Gloria Luria Gallery, Bay Harbor, Florida, December 6–30, 1981

Ado Gallery, Bonheiden, Belgium, March 13–April 4, 1982

Axiom Gallery, Melbourne, August 7–26, 1982

Gallery A, Sydney, August 28–September 18, 1982; July 9–30, 1983

Christine Abrahams Gallery, Melbourne, August 8–25, 1983; March 4–28, 1985; June 2–28, 1986; March 31–May 1, 1987

Musée d'Art Moderne, Liège, Belgium, November 10–December 16, 1984. Catalogue with text by E. Schoffeniels

Roslyn Oxley9 Gallery, Sydney, March 13–30, 1985; July 15–August 2, 1986

Center for the Arts, Muhlenberg College, Allentown, Pennsylvania, *Paintings and Drawings 1975–1985*, April 26–June 14, 1985. Catalogue with texts by Tom Hudspeth and William Zimmer

M13 Gallery, New York, January 9–February 2, 1986

Althea Viafora Gallery, New York, January 12–February 12, 1986; November 4–29, 1986; April 2–30, 1987

Amand Sarabhai Studio, Ahmedabad, India, August 1986

Selected Bibliography

By the Artist

Statement in "Expositions Belgique," *Art Press*, January 1981, p. 34

On the Artist

Jeremy Gilbert Rolfe [review], *Artforum*, vol. XII, December 1973, pp. 88–89

Eneide Mignacca, "Rectangular Facades of Modern Mythology," *Nation Review*, July 11–17, 1975, p. 1014

Ann Lauterbach, "Denise Green at the Art Resources Center of the Whitney Museum," *Art in America*, vol. 63, November–December 1975, p. 107

David Salle [review], *Arts Magazine*, vol. 51, December 1976, pp. 39–40

Mona Da Vinci [review], *Art News*, vol. 75, December 1976, p. 126

Jeff Perrone [review], *Artforum*, vol. XVII, March 1979, pp. 62–63

Elwyn Lynn, "Denise Green," *Art International*, vol. XXIII, September 1979, pp. 50–53

Benjamin Folcy [review], *Washington Star*, February 17, 1980, pp. E2–3

Mary King, "Denise Green's Art Becomes More Abstract," *St. Louis Post-Dispatch*, November 28, 1980, p. F4

Michael G. Rubin, "Denise Green's Artwork at Gallery," *St. Louis Globe Democrat*, November 29–30, 1980, p. F4

Bernice Murphy [review], *Flash Art*, January-February 1981, pp. 60–61

Judith Wilson [review], *Art in America*, vol. 69, February 1981, pp. 148–149

Gerrit Henry [review], *Art News*, vol. 80, March 1981, p. 220

Interview with Philippa Hawker, *The Age*, August 18, 1981

William Zimmer, "Another Green World," *SoHo Weekly News*, October 14, 1981, p. 65

Peter Frank [review], *Art News*, vol. 81, January 1982, p. 159

Interview with Franco Paisio, "Denise Green," *Aspect, Art and Literature*, Spring 1983, pp. 3–7

Interview with Heather Kennedy, "Green Taken by US," *The Age*, March 9, 1985, p. 9

Terence Maloon, "Splashes of Radiance to Seduce the Eye," *The Sydney Morning Herald*, March 23, 1985, p. 44

Elwyn Lynn, "Different Roads to Modernism Mecca," *The Australian*, March 28, 1985

Jane Maulfair, "Exhibition Spans 10 Years of Artist's Work," *Allentown Morning Call*, May 9, 1985

Tiffany Bell [review], *Arts Magazine*, vol. 60, April 1986, p. 141

Nancy Grimes [review], *Art News*, vol. 85, April 1986, p. 135

Claude Lorent, "Arts Bruxelles Environs," *Arts, Antiques, Auctions*, April 1986, p. 40

Interview with Susan Bredou, *The Australian*, July 25, 1986, p. 10

Elwyn Lynn [review], *The Australian*, July 26, 1986

Gerrit Henry [review], *Art in America*, vol. 74, July 1986, p. 122

CAROL HEPPER

Born in McLaughlin, South Dakota, October 23, 1953. Studied at South Dakota State University, Brookings, B.S., 1975. Lives in New York.

Selected One-Person Exhibitions

Flagler College Gallery, St. Augustine, Florida, February 4–18, 1979

Brookings Cultural Center, South Dakota, December 3–31, 1980

Coffman Gallery, University of Minnesota, Minneapolis, November 16–December 9, 1981

Institute for Art and Urban Resources, P.S.1, Long Island City, New York, January 17–March 14, 1982

Invitational Space, Warm Gallery, Minneapolis, *Jerome Foundation National Competition*, January 1982

Ritz Gallery, South Dakota State University, Brookings, February 14–March 2, 1984

Dahl Fine Arts Center, Rapid City, South Dakota, April 3–30, 1987. Brochure with texts by John A. Day and Cynthia Nadelman. Traveled to University of South Dakota, Vermillion, October 1–28, 1987

Selected Bibliography

Don Boyd, *Art Express*, vol. 1, May–June 1981, p. 80

Palmer Poroner, "Art of Primitive Origins or Great Traditions," *Artspeak*, vol. IV, September 16, 1982, p. 5

Virginia Watson Jones, ed., *Contemporary American Women Sculptors*, Phoenix, 1986, p. 291

Mary Pat Fisher and Paul Zelanski, *Shaping Space: The Dynamics of Three-Dimensional Design*, New York, 1987, pp. 240–242

BRYAN HUNT

Born in Terre Haute, Indiana, June 7, 1947. Studied at Otis Art Institute, Los Angeles, B.F.A., 1971; Independent Study Program, Whitney Museum of American Art, New York, 1972. Lives in New York.

Selected One-Person Exhibitions

Institute for Art and Urban Resources at The Clocktower, New York, *C. B. Hunt: Recent Works*, October 17–November 16, 1974

Jack Glenn Gallery, Corona del Mar, California, December 7, 1974–January 12, 1975

Palais des Beaux-Arts, Brussels, *C. Bryan Hunt: 'Empire State/Graf,' 'Phobos,' 'Universal Joint,'* March 29–April 13, 1975

Daniel Weinberg Gallery, San Francisco, July 10–August 7, 1976; July 11–September 2, 1978; February 8–March 6, 1982

Blum Helman Gallery, New York, March 15–April 16, 1977; April 18–May 13, 1978; February 20–March 20, 1979; April 30–May 30, 1979; May 5–June 6, 1981; March 30–April 30, 1983; April 2–May 14, 1983, catalogue with text by Carter Ratcliff; May 1–June 8, 1985; April 30–May 31, 1986; May 2–June 13, 1987

The Greenberg Gallery, St. Louis, *Bryan Hunt*, December 5, 1977–January 31, 1978

Bernard Jacobson Ltd., London, *Bryan Hunt: Lakes-Waterfalls-Airships*, May 1979

Galerie Bruno Bischofberger, Zürich, *Bryan Hunt: Neue Werke*, December 15, 1979–January 12, 1980

Margo Leavin Gallery, Los Angeles, February 15–March 15, 1980; April 23–May 28, 1983

Akron Art Museum, Ohio, *Bryan Hunt: Sculptures and Drawings*, January 10–March 8, 1981

Galerie Hans Strelow, Düsseldorf, November 6–December 5, 1981

Bernier Gallery, Athens, May 18–June 19, 1982

Los Angeles County Museum of Art, *Gallery Six: Bryan Hunt, Recent Sculpture*, April 21–June 19, 1983

Amerika Haus, Berlin, *New Masters: Bryan Hunt*, September 20–October 28, 1983

The University Art Museum, California State University, Long Beach, *Bryan Hunt: A Decade of Drawings*, November 15–December 11, 1983. Catalogue

Knoedler, Zürich, *Bryan Hunt: Skulpturen und Zeichnungen*, December 19, 1984–February 23, 1985. Catalogue

Galerie Gillespie-Laage-Salomon, Paris, *Bryan Hunt: Sculptures*, March 22–April 16, 1986

Daniel Weinberg Gallery, Los Angeles, *Bryan Hunt: Airships, 1974–1986*, May 13–June 7, 1986

Akira Ikeda Gallery, Tokyo, *Bryan Hunt: Sculptures and Drawings*, June 7–30, 1986. Catalogue with text by Charlotta Kotik

University Art Museum, University of California, Berkeley, *Bryan Hunt*, July 16–September 21, 1986

Barbara Mathes Gallery, New York, *Bryan Hunt: Drawings*, May 2–June 13, 1987

Selected Bibliography

By the Artist

Conversations with Nature, New York, 1982

On the Artist

Stewart Buettner, "Six Los Angeles Artists," *Artweek*, January 31, 1976, p. 16

James Poett, "A Pail of Water Without the Pail," *The Village Voice*, March 28, 1977, p. 89

Jeanne Siegel, "Bryan Hunt," *Arts Magazine*, vol. 51, May 1977, p. 20

Jeff Perrone, "Bryan Hunt: Blum Helman Gallery," *Artforum*, vol. XV, Summer 1977, p. 68

Christopher Brown, "Bryan Hunt, Sculptures," *Artweek*, August 26, 1978, p. 1

Peter Frank, "Bryan Hunt: Blum Helman," *Art News*, vol. 77, October 1978, p. 178

William Zimmer, "Building Materials," *SoHo Weekly News*, March 8, 1979, p. 53

Dupuy Warrick Reed, "Bryan Hunt," *Arts Magazine*, vol. 53, April 1979, p. 7

Carrie Rickey, "Bryan Hunt: Blum Helman," *Artforum*, vol. XVII, May 1979, p. 58

Ellen Schwartz, "Bryan Hunt: Blum Helman," *Art News*, vol. 78, Summer 1979, p. 182

Robin White, "Bryan Hunt," *View*, vol. 3, April 1980, pp. 1–23

Wade Saunders, "Hot Metal," *Art in America*, vol. 68, Summer 1980, pp. 87–95

Michael I. Danoff, "Bryan Hunt: Sculpture and Drawings," *Dialogue*, January–February 1981, p. 51

Susie Kalil, "The American Landscape—Contemporary Interpretations," *Artweek*, April 25, 1981, pp. 8–10

William Zimmer, "Hunt's Points," *SoHo Weekly News*, May 13, 1981, p. 51

Kay Larson, "Between a Rock and a Soft Place," *New York Magazine*, June 1, 1981, p. 56

Hal Foster, "Bryan Hunt," *Artforum*, vol. XIX, September 1981, pp. 77–78

Deborah C. Phillips [review], *Art News*, vol. 80, September 1981, pp. 77–78

Dupuy Warrick Reed, "Bryan Hunt," *Flash Art*, October–November 1981, pp. 49–50

Yvonne Friedrichs, "Dem Wasser eine feste Form: Bryan Hunt in der Galerie Strelow," *Rheinische Post*, November 27, 1981

Robert Becker, "Bryan Hunt," *Interview*, vol. 12, January 1982, pp. 52–54

Constance W. Glenn, "Artist's Dialogue: A Conversation with Bryan Hunt," *Architectural Digest*, vol. 40, March 1983, pp. 68–74

Valerie Brooks, "Bryan Hunt: Blum Helman," *Flash Art*, Summer 1983, p. 63

Michael Shapiro, "Four Sculptors on Bronze Casting: Nancy Graves, Bryan Hunt, Joel Shapiro, Herk Van Tongeren," *Arts Magazine*, vol. 58, December 1983, pp. 111–117

Ellen Schwartz, "What's New in Nueva York?" *Art News*, vol. 83, April 1984, pp. 146–149

Vivien Raynor, "Art: 3 Friends Who Share Attitudes and a Show," *The New York Times*, July 20, 1984, p. C20

Michael Brenson, "A Lively Renaissance for Sculpture in Bronze," *The New York Times*, November 4, 1984, p. H29

Amei Wallach, "Bronze in Brooklyn," *Newsday*, November 4, 1984, part II, pp. 4–5

Grace Glueck, "Bronze in the Hands of American Sculptors," *The New York Times*, December 23, 1984, p. H29

Fritz Billeter, "Amerikanisch gewurzelt in Europa," *Tages Anzeiger*, January 11, 1985

Vivien Raynor, "Bryan Hunt," *The New York Times*, May 10, 1985, p. C26

Phyllis Tuchman, "Bryan Hunt's Balancing Act," *Art News*, vol. 84, October 1985, pp. 64–73

William Wilson, "The Art Galleries," *The Los Angeles Times*, May 16, 1986, part VI, p. 14

Del McColm, "Hovering Sculpture, Searing Paintings Exhibited," *The Davis Enterprise*, August 14, 1986, p. 7

Michael Brenson, "Art: By Bryan Hunt, Drawings and Bronzes," *The New York Times*, May 22, 1987, p. C24

WHIT INGRAM

Born in Pasadena, December 2, 1948. Studied at University of California, Berkeley, B.A., 1971; M.A., 1974. Lives in San Geronimo, California.

Selected One-Person Exhibitions

Worth Ryder Art Gallery, University of California, Berkeley, November 26–December 1, 1973

Braunstein/Quay Gallery, San Francisco, November 1–26, 1977

Braunstein/Quay Gallery, New York, June 6–July 1, 1978

Wingspread Gallery, Northeast Harbor, Maine, August 23–September 15, 1985

Carpenter Art Center, Cambridge, Massachusetts, October 17–November 12, 1985

Selected Bibliography

Allie Anderson, "Voice Choices," *The Village Voice*, July 3, 1978, p. 51

MARK INNERST

Born in York, Pennsylvania, February 26, 1957. Studied at Kutztown State College, Pennsylvania, B.F.A., 1980. Lives in New York.

Selected One-Person Exhibitions

The Kitchen, New York, May 1–29, 1982

Grace Borgenicht Gallery, New York, October 3–November 27, 1984

James Mayor Gallery, London, May 29–June 21, 1985

Curt Marcus Gallery, New York, November 1–29, 1986

Selected Bibliography

Richard Milazzo, *Wedge*, pamphlet 6, November 1983, unpaginated

Kim Levin, "Voice Choice," *The Village Voice*, October 17–23, 1984, p. 74

Richard Martin, "Mark Innerst," *Arts Magazine*, vol. 59, October 1984, p. 2

Michael Kohn, *Flash Art*, January 1985, p. 45

Ken Sofer [review], *Art News*, vol. 83, January 1985, p. 150

Gerrit Henry, "Mark Innerst at Grace Borgenicht," *Art in America*, vol. 73, April 1985, pp. 204–205

Michael Brenson [review], *The New York Times*, November 21, 1986, p. C26

Kim Levin [review], *The Village Voice*, December 2, 1986, p. 123

Ellen Lee Klein [review], *Arts Magazine*, vol. 61, January 1987, p. 122

Nancy Grimes [review], *Art News*, vol. 86, February 1987, pp. 136–137

TOBI KAHN

Born in New York, May 8, 1952. Studied at Tel Aviv University, 1970–71; Hunter College, New York, B.A., 1976; Pratt Institute, Brooklyn, M.F.A., 1978. Lives in Long Island City, New York.

Selected One-Person Exhibitions

Debel Gallery, Jerusalem, January 7–28, 1978

Pratt Institute Gallery, Brooklyn, February 19–24, 1978

Fordham University, Bronx, March 11–April 10, 1979

Robert Brown, New York, November 16–December 6, 1980

Blumberg Harris, New York, December 2–14, 1981

Althea Viafora Gallery, New York, November 29–December 20, 1983; October 16–November 8, 1984; March 11–April 12, 1986; September 29–October 31, 1987

Bernard Jacobson Ltd., Los Angeles, April 23–May 28, 1985

John Berggruen Gallery, San Francisco, March 10–April 4, 1987

Krygier Landau Contemporary Arts, Los Angeles, May 14–June 27, 1987

Selected Bibliography

Michael Brenson [review], *The New York Times*, December 16, 1983, p. C30

Douglas Dreishpoon, "Tobi Kahn," *Arts Magazine*, vol. 58, January 1984, p. 7

Grace Glueck [review], *The New York Times*, November 2, 1984, p. C25

Douglas Dreishpoon, "Essence of Vision: The Art of Tobi Kahn," *Arts Magazine*, vol. 59, January 1985, pp. 81–83

Susan A. Harris, *Arts Magazine*, vol. 59, January 1985, p. 40

Meg Perlman, *Art News*, vol. 84, April 1985, pp. 143–144

Kristine McKenna [review], *Los Angeles Times*, May 3, 1985, part VI, p. 15

Robert G. Edelman [review], *Art in America*, vol. 74, October 1986, pp. 165–166

Eleanor Heartney, "New York Reviews," *Art News*, vol. 85, October 1986, p. 148

Douglas Dreishpoon [review], *Arts Magazine*, vol. 61, January 1987, p. 127

AARON KARP

Born in Altoona, Pennsylvania, December 7, 1947. Studied at State University of New York, Buffalo, B.A., 1969; Indiana University, Bloomington, M.F.A., 1971. Lives in Albuquerque.

Selected One-Person Exhibitions

Wildine Galleries, Albuquerque, March 21–April 19, 1980; *Aaron Karp, Recent Paintings*, October 16–November 13, 1981; October 16–November 13, 1983

Leslie Levy Gallery, Scottsdale, Arizona, April 9–30, 1981; *Aaron Karp, New Paintings*, February 4–23, 1982

Mattingly-Baker Gallery, Dallas, April 1982; September 15–October 16, 1984

Roswell Museum and Art Center, New Mexico, *Artist-in-Residence Grant Exhibition*, June 6–July 4, 1982

Sebastian-Moore Gallery, Denver, September–October 23, 1982; December 6, 1983–January 19, 1984

Eve Mannes Gallery, Atlanta, March 8–April 27, 1983

Davis/McClain Gallery, Houston, February 16–March 9, 1984

Kron/Reck Gallery, Albuquerque, September 13–October 11, 1986

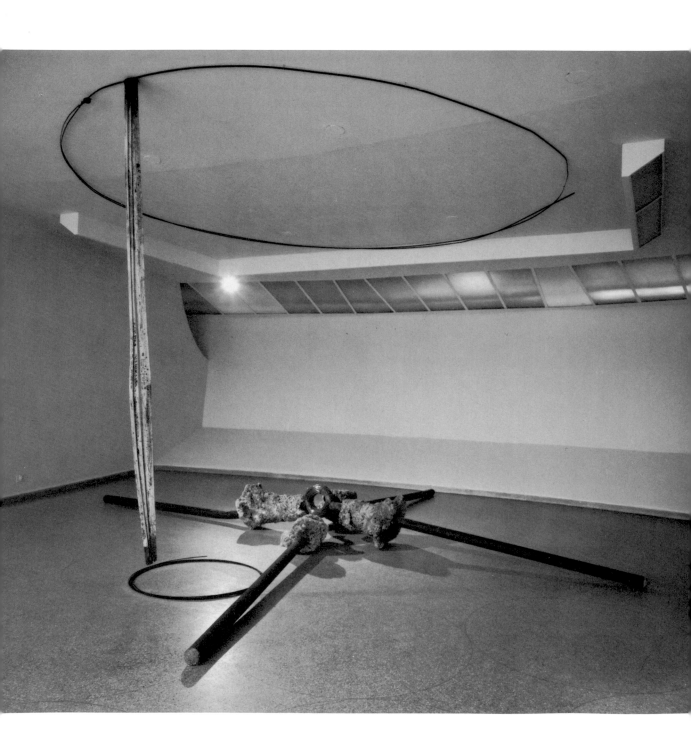

Selected Bibliography

Keith Raether, "Karp Exhibit Set for Wildine Galleries," *Albuquerque Tribune*, March 12, 1980

Jennie Lusk, "Aaron Karp Paintings Dynamic Works with Dazzling Tension," *Albuquerque Journal*, March 30, 1980, p. D3

Dana Asbury, "Aaron Karp," *Artspace*, vol. 6, Winter 1981–82, pp. 38–39

Deb Adler, "Works Reveal—and Hide— Artist," *Scottsdale Daily Progress*, February 12, 1982, p. 36

Bill Marvel, "Critic's Choice," *The Dallas Times Herald*, April 9, 1982

Kathy Shields and Steve Shipp, "The World According to Aaron Karp," *Arizona Arts & Lifestyle*, vol. 3, Winter 1982, pp. 32–36

Carole Mazur, "Artist's Relationship Enhances Success," *Albuquerque Journal*, April 10, 1983, pp. D1–2

Susan Zwinger, "Santa Fe Comes to Scottsdale at the Leslie Levy Gallery," *Artspace*, vol. 7, Spring 1983, p. 83

Olie Reed, Jr., "Paintings Spark All But Indifference," *Albuquerque Tribune*, August 19, 1983

Martin Moynihan, "Karp Exhibit at Guggenheim Had Roots in Feura Bush Stream," *Albany Times Union*, September 25, 1983, p. E7

Mel McCombie, "Aaron Karp," *Arts Magazine*, vol. 88, May 1984, p. 23

Janet Kutner, "Artistic Variety," *The Dallas Morning News*, September 18, 1984, p. E1

Catherine Fox, "Karp's Works Show Two Phases of His Development," *Atlanta Journal*, March 17, 1985

John Richardson, "Fractured Surfaces, Tape Yields Aaron Karp's Layered Vision," *Albuquerque Tribune*, September 13, 1986, p. A10

MARK KLOTH

Born in Minneapolis, August 26, 1954. Studied at Arizona State University, Tempe, B.F.A., 1978; Virginia Commonwealth University, Richmond, M.F.A., 1981. Lives in New York.

Selected One-Person Exhibitions

1116 South Ash, Tempe, performance, *Installed: An Installation*, October 23, 1977

Fine Arts Gallery, Arizona State University, Tempe, performance, *Three Days in a Strapped Room*, November 20–22, 1977; performance, *In Tight: Strapped in a Mattress*, December 9, 1977

Faculty Parking Lot, Arizona State University, Tempe, performance, *Suspension: Fifteen Feet in the Air*, May 15, 1978

1708 East Main, Richmond, *Penumbra*, March 6–30, 1981; performance, *Echo*, March 22, 1981

Institute for Art and Urban Resources, P.S.1, Long Island City, New York, *Monument and Moment*, October 17–November 17, 1982; *Encore*, January 15–February 15, 1983; *Stations of Temperament*, October 1– November 1, 1983

Siegel Contemporary Art, New York, *Blindfolds and Passages*, March 30–April 23, 1983

The New Museum of Contemporary Art, New York, *Blind Migration...Waves at Bay*, December 9, 1983–January 8, 1984

Ruth Siegel Ltd., New York, *Works*, February 20–March 9, 1985

Selected Bibliography

Ellen Lee Klein [review], *Arts Magazine*, vol. 57, June 1983, p. 44

Grace Glueck [review], *The New York Times*, March 1, 1985, p. C24

Installation view, *New Horizons in American Art: 1985 Exxon National Exhibition*, Mark Kloth, *Marked Entry*, 1985

BARBARA KRUGER

Born in Newark, New Jersey, January 26, 1945. Studied at Syracuse University, New York, 1965; Parsons School of Design, New York, 1966–67; School of Visual Arts, New York, 1968. Lives in New York.

Selected One-Person Exhibitions

Artists Space, New York, January 21–February 18, 1974

Fischbach Gallery, New York, January–February 1975

John Doyle Gallery, Chicago, March–April 1976

Ohio State University, Columbus, November 14–25, 1977

Franklin Furnace, New York, *Photograph/Paragraph*, January 3–February 5, 1979

ARC Space, Seattle, April 15–May 15, 1979

Printed Matter, New York, 1979

Institute for Art and Urban Resources, P.S.1, Long Island City, New York, December 1, 1980–January 25, 1981

Larry Gagosian Gallery, Los Angeles, March 3–April 3, 1982; October 13–November 5, 1983

CEPA Gallery, Buffalo, *No Progress in Pleasure*, April 9–30, 1982

Annina Nosei Gallery, New York, March 5–24, 1983; March 10–April 14, 1984; February 8–March 2, 1986

Institute of Contemporary Art, London, *Your Comfort Is My Silence*, November 4–December 11, 1983

Rhona Hoffman Gallery, Chicago, March 13–April 3, 1984; October 17–November 15, 1986

Nouveau Musée, Lyon, March 23–April 25, 1984

Galerie Crousel-Hussenot, Paris, April 19–May 16, 1984; February 14–March 21, 1987

Kunsthalle Basel, May 13–June 24, 1984

Wadsworth Atheneum, Hartford, January 12–March 10, 1985. Brochure with text by Andrea Miller-Keller

Los Angeles County Museum of Art, *New American Photography: Barbara Kruger, Untitled Works*, January 17–March 17, 1985

Contemporary Arts Museum, Houston, April 27–June 23, 1985. Catalogue with text by Marti Mayo

University Art Museum, Berkeley, August 16–October 26, 1986

Hillman/Holland Gallery, Atlanta, September 21–October 17, 1986

Krannert Art Museum, University of Illinois, Champaign-Urbana, October 4–November 9, 1986. Catalogue with text by Kenneth Baker

Mary Boone Gallery, New York, May 2–30, 1987. Catalogue with text by Jean Baudrillard

Monika Sprüth Galerie, Cologne, May–June 1987

Selected Bibliography

By the Artist

"Portraits," *Artforum*, vol. XX, May 1982, pp. 59–63

"Virtue and Vice on 65th Street," *Artforum*, vol. XXI, January 1983, pp. 66–67

"Kids R Us or Viva Poland or Laudable Odds and Ends," *Artforum*, vol. XXIII, February 1985, pp. 62–65

"Remote Control," *Artforum*, vol. XXIV, November 1985, p. 7

"Remote Control," *Artforum*, vol. XXIV, January 1986, p. 11

"Remote Control," *Artforum*, vol. XXIV, March 1986, p. 11

"Remote Control," *Artforum*, vol. XXIV, May 1986, p. 14

"Remote Control," *Artforum*, vol. XXV, September 1986, pp. 10–11

"Remote Control," *Artforum*, vol. XXV, November 1986, pp. 5–6

"Insert Barbara Kruger," *Parkett*, December 1986, pp. 111–124

"Remote Control," *Artforum*, vol. XXV, January 1987, p. 10

"Remote Control," *Artforum*, vol. XXV, March 1987, pp. 9–10

"Remote Control," *Artforum*, vol. XXV, May 1987, p. 12

On the Artist

Noel Frackman [review], *Arts Magazine*, vol. 49, March 1975, p. 8

Peter Frank [review], *Art in America*, vol. 64, July 1976, p. 103

Ross Bleckner, "Transcendent Anti-Fetishism," *Artforum*, vol. XVII, March 1979, pp. 50–56

Annelie Pohlen, "The Dignity of the Thorn," *Artforum*, vol. XX, September 1982, pp. 59–61

Hal Foster, "Subversive Signs," *Art in America*, vol. 70, November 1982, pp. 88–92

Andy Grundberg, "Photography: Biennial Show," *The New York Times*, April 1, 1983, p. C23

Therese Lichtenstein, "Barbara Kruger," *Arts Magazine*, vol. 57, May 1983, p. 4

Lynn Zelevansky, "Barbara Kruger," *Art News*, vol. 82, May 1983, p. 154

Kate Linker, "Barbara Kruger," *Artforum*, vol. XXI, September 1983, p. 77

Craig Owens, "The Medusa Effect on the Spectacular Ruse," *Art in America*, vol. 72, January 1984, pp. 97–105

Lucy Lippard, "One Liner After Another," *The Village Voice*, April 11, 1984, p. 73

Kate Linker, "Barbara Kruger Interview," *Flash Art*, March-April 1985, pp. 36–37

Michael Brenson, "Barbara Kruger," *The New York Times*, February 14, 1986, p. C32

John Sturman, "Barbara Kruger," *Art News*, vol. 85, May 1986, p. 129

Shaun Caley, "Barbara Kruger," *Flash Art*, May-June 1986, p. 55

Jamey Gambrell, "Barbara Kruger," *Art in America*, vol. 74, June 1986, pp. 123–124

Thomas McEvilley, "Barbara Kruger," *Artforum*, vol. XXIV, Summer 1986, pp. 122–123

Sylvia Falcon, "You Call Yourself Barbara Kruger," *International Eye*, January 1987, pp. 29, 54

Carol Squiers, "Divisionary (Syn)Tactics/ Barbara Kruger Has a Way with Words," *Art News*, vol. 86, February 1987, pp. 76–85

Claude Gintz, "Barbara Kruger: Galerie Crousel-Hussenot," *Art Press*, April 1987, p. 76

REX LAU

Born in Trenton, New Jersey, February 26, 1947. Studied at School of Visual Arts, New York, 1966–69. Lives in Montauk, New York.

Selected One-Person Exhibitions

Parsons-Dreyfus Gallery, New York, *Hobo Signs*, February 1–19, 1977; *Pranks of Nature*, March 13–31, 1979

Siegel Contemporary Art, New York, *Rex Lau, "The Wind Demons" and Other Recent Paintings, 1980–1981*, January 20–February 13, 1982; *Rex Lau—Paintings, 1981–1983*, October 4–22, 1983

Siegel Contemporary Art at *Chicago International Art Exposition 1983, Rex Lau*, May 19–21, 1983. Catalogue

John Berggruen Gallery, San Francisco, *Rex Lau—Recent Work*, July 14–August 13, 1983; *Rex Lau—Recent Paintings*, November 25, 1986–January 3, 1987

Nina Freudenheim Gallery, Buffalo, *Rex Lau—Recent Work*, March 23–April 24, 1985

Ruth Siegel Ltd., New York, *Rex Lau: Paintings and Works on Paper, 1983–1985*, April 30–May 18, 1985, catalogue with text by Stephen Westfall; April 1–25, 1987

Selected Bibliography

Jill Dunbar, "The Trend from Thinking to Feeling," *The Villager*, April 12, 1978, p. 10

John Russell, "Rex Lau and Roxanne Blanchard," *The New York Times*, February 5, 1982, p. C23

John Russell, "Rex Lau and Maria Scotti," *The New York Times*, October 14, 1983, p. C23

Ellen Lee Klein, "Rex Lau," *Arts Magazine*, vol. 58, December 1983, p. 37

Jean E. Feinberg, "Rex Lau," *Arts Magazine*, vol. 58, March 1984, p. 13

Anthony Bannon, "In Plane Sight," *The Buffalo News*, March 22, 1985, p. A5

Anthony Bannon, "Lau Captures Natural Beauty in Linear Form," *The Buffalo News*, April 13, 1985, p. A12

Ellen Lee Klein, "Rex Lau," *Arts Magazine*, vol. 60, September 1985, p. 38

ANGE LECCIA

Born in Minerviu, Corsica, April 19, 1952. Studied at Lycée Artistique de Bastia, Corsica, 1962–71; Faculté des Arts Plastiques, Paris I–Saint Charles, 1972–76. Lives in Paris.

Selected One-Person Exhibitions

Galerie du Haut Pavé, Paris, May 13–June 7, 1980

Galerie Lucien Durand, Paris, March 19–April 11, 1981; February 7–March 10, 1984, catalogue with text by Marie-Laure Bernadac

Galleria Arco d'Alibert, Rome, October 25–December 1983

Galleria Deambrogi, Milan, June 4–July 4, 1984

Espace Lyonnais d'Art Contemporain, Lyon, February 25–March 10, 1985

A.R.C., Musée d'Art Moderne de la Ville de Paris, *Ange Leccia*, June 27–September 22, 1985. Catalogue with texts by Laurence Bossé and Suzanne Pagé

College of Art and Design, Halifax, Nova Scotia, June 1985

Ecole des Beaux-Arts, Mâcon, *Ange Leccia*, October 7–November 10, 1985. Catalogue with texts by Jean-Louis Maubant and Ida Minnini

Athénéum, Dijon, November 13–December 10, 1985

Galerie Arlogos, Nantes, February 22–March 22, 1986

Musée de Grenoble, *Ange Leccia*, November 6–December 10, 1986. Catalogue with texts by Serge Lemoine, Jean-Paul Monery and Christine Poullain

Fundació Joan Miró, Barcelona, December 17, 1986–January 10, 1987

Galerie Montenay-Delsol, Paris, January 8–31, 1987

Cable Gallery, New York, April 16–May 14, 1987

De Lege Ruimte, Bruges, Belgium, *Ange Leccia*, May 9–31, 1987

De Vleeshal, Middelburg, The Netherlands, May 17–June 15, 1987. Catalogue with texts by Catherine Strasser et al.

Selected Bibliography

Jean-Marie Tasset, "Leccia: Un Point c'est tout," *Le Figaro*, April 1, 1981, p. 23

Maïten Bouisset, "Ange Leccia," *Le Matin*, April 4, 1981

Claude Bouyeure, "Ange Leccia," *Politique Hebdo*, April 28, 1981

Orsan, "Ange Leccia," *Rock en stock*, April 1981

Lisa Licitra Ponti, "Fame 5," *Domus*, October 1983, p. 74

Lorenzo Mango, "Il ricordo dell'occhio," *Paese Sera*, November 15, 1983

David O'Brien, "The Roman Art Scene," *Daily American*, November 24, 1983

Jean-Marie Tasset, "Leccia: Point à l'image," *Le Figaro*, February 10, 1984, p. 24

Jean-Pierre Bordaz, "Ange Leccia," *Beaux-Arts Magazine*, February 1984, p. 84

Gaya Goldcymer, "Ange Leccia: D'Une Mémoire à l'autre," *Art Press*, June 1984, p. 19

Catherine Strasser, "Histoire de sculptures/ Lumières et sons," *Art Press*, September 1984, p. 47

Arielle Pélenc, "Pour en finir avec la bêtise du peintre," *Artistes*, October 1984, pp. 110–115

Daniel Soutif, "Ange Leccia, artiste corse," *Libération*, August 14, 1985, p. 24

Elisabeth Lebovici, "L'Anémique Cinéma d'Ange Leccia," *L'Evénement du Jeudi*, August 1985

Catherine Francblin, "Anselmo, Leccia, Werner," *Art Press*, October 1985, p. 70

Philippe Piguet, "Ange Leccia," *Flash Art*, Fall 1985, p. 31

Mona Thomas, "Ange Leccia, portrait," *Beaux-Arts Magazine*, December 1985, pp. 90–91

Michel Nuridsany, "Ange Leccia: L'Ecran du rêve," *Public*, no. 3, 1985, pp. 66–69

Pierre Giquel, "Philippe Dufour, Ange Leccia: Galerie Arlogos," *Art Press*, May 1986, p. 66

Françoise-Claire Prodhon, "Interview," *Flash Art*, October–November 1986, p. 102

Françoise-Claire Prodhon, "Les Arrangements d'Ange Leccia," *Vie des Arts*, December 1986, p. 50

Arielle Pélenc, "Ange Leccia: Le Flambeur," *Art Press*, January 1987, pp. 26–27

[Review], *Kanal*, January–February 1987, p. 17

TOM LIEBER

Born in St. Louis, November 5, 1949. Studied at University of Illinois, Champaign-Urbana, B.F.A., 1971; M.F.A., 1974. Lives in Albany, California.

Selected One-Person Exhibitions

Levis Faculty Center, University of Illinois, Champaign-Urbana, March 3–April 1, 1974

Michael Wyman Gallery, Chicago, December 3, 1974–January 4, 1975; April 5–May 10, 1975

William Sawyer Gallery, San Francisco, August 2–20, 1976; November 22–December 9, 1977; March 4–April 4, 1980

Nancy Lurie Gallery, Chicago, March 3–25, 1978; September 17–October 15, 1980

Kirk De Gooyer Gallery, Los Angeles, August 2–30, 1981; September 11–October 9, 1982

Tom Luttrell Gallery, San Francisco, September 8–October 20, 1981

The Grayson Gallery, Chicago, September 11–October 13, 1982

Pamela Auchincloss Gallery, Santa Barbara, April 22–May 25, 1983; September 14–October 17, 1984; September 19–October 22, 1986, catalogue with text by Peter Frank

John Berggruen Gallery, San Francisco, January 18–February 18, 1984; June 19–July 20, 1985; June 23–July 25, 1987

Gruenebaum Gallery, New York, February 1–26, 1986

Tortue Gallery, Los Angeles, September 6–October 4, 1986

Selected Bibliography

Alan G. Artner, "Lieber, Nuzum: Two Modes, Mixed and Matched," *Chicago Tribune*, December 29, 1974, p. 14

Alfred Frankenstein, "The Big, Yet Subtle Works of Tom Lieber," *San Francisco Chronicle*, August 14, 1976, p. 34

Robert McDonald, "Tom Lieber: Physicality Finds Its Place," *Artweek*, August 14, 1976, p. 4

Robert McDonald, "Tom Lieber's Environmental Paintings," *Artweek*, December 3, 1977, p. 5

Christopher Brown, "Handmade Painting," *Artweek*, March 29, 1980, p. 5

Alan G. Artner, "Tom Lieber," *Chicago Tribune*, October 1, 1980, p. 5

Alan G. Artner, "Art Galleries," *Chicago Tribune*, September 17, 1982, section 3, p. 9

Sheldon Figoten, "Downtown," *Los Angeles Times*, September 24, 1982, part VI, p. 9

Sheldon Figoten, "Energy into Image," *Artweek*, October 2, 1982, p. 6

Mac McCloud, "Tom Lieber," *Images and Issues*, vol. 3, January/February 1983, pp. 60–61

Katie Phillips, "Tom Lieber," *Images and Issues*, vol. 4, November/December 1983, p. 22

Joanne Dickson, "Art Notes," *Point Reyes Light*, June 27, 1985, p. 19

Kenneth Baker, "Art: Modernism Is a Matter of Context," *San Francisco Chronicle*, July 8, 1985, p. 62

Colin Gardner [review], *Los Angeles Times*, September 12, 1986, part VI, p. 6

ROBERT LAWRANCE LOBE

Born in Detroit, August 15, 1945. Studied at Oberlin College, Ohio, B.A., 1967; Hunter College, New York, 1967–68. Lives in New York.

Selected One-Person Exhibitions

Zabriskie Gallery, New York, September 10–October 5, 1974

Dag Hammarskjold Plaza Sculpture Garden, New York, March 7–May 20, 1977

Willard Gallery, New York, March 8–April 2, 1980; December 1–23, 1981; February 4–29, 1984; March 13–April 5, 1986; January 7–31, 1987

Texas Gallery, Houston, April 2–28, 1982

Margo Leavin Gallery, Los Angeles, April 5–May 10, 1985

Marian Locks Gallery, Philadelphia, May 30–June 28, 1986

Anderson Gallery, Virginia Commonwealth University, Richmond, January 20–March 1, 1987

Selected Bibliography

Carter Ratcliff, "Bob Lobe: Bykert," *Art News*, vol. 70, December 1971, p. 17

Jeanne Siegel, "Robert Lobe at Zabriskie," *Art in America*, vol. 62, September–October 1974, p. 105

Roberta Smith, "Robert Lobe: Zabriskie Gallery," *Artforum*, vol. XII, December 1974, p. 64

Hedy O'Beil, "Robert Lobe," *Arts Magazine*, vol. 54, June 1980, p. 36

Phyllis Tuchman, "Robert Lobe at Willard," *Art in America*, vol. 68, September 1980, p. 123

Mimi Crossley [review], *Houston Post*, April 12, 1981

Kay Larson, "Robert Lobe," *New York Magazine*, December 21, 1981, p. 63

David Gilmartin, "Sculptures Recreate Natural Setting," *Reading Times*, March 12, 1982

Kenneth Baker, "Hammering the Landscape," *The Christian Science Monitor*, August 26, 1983, p. 20

Richard Armstrong [review], *Artforum*, vol. XXII, May 1984, p. 87

Kenneth Baker [review], *Art in America*, vol. 72, May 1984, p. 177

Anthony Bannon, "For Really Real Realism Try Lobe's Devil's Hole," *Buffalo News*, April 7, 1985

Suzanne Muchnic [review], *Los Angeles Times*, April 26, 1985, part VI, p. 6

Michael Brenson [review], *The New York Times*, March 28, 1986, p. C30

Victoria Donahoe, "Nature Sculptures Plus Map Paintings, *The Philadelphia Inquirer*, June 6, 1986, p. E42

NINO LONGOBARDI

Born in Naples, November 30, 1953. Lives in Naples.

Selected One-Person Exhibitions

Studio Gianni Pisani, Naples, December 1977–January 1978

Galerie Paul Maenz, Cologne, July 1978. Included in catalogue of 1978 exhibitions, *Paul Maenz Jahresbericht*

Galleria Lucio Amelio, Naples, February 1979; December 1980, catalogue with texts by Lucio Amelio, Achille Bonito Oliva and Michele Bonuomo; February 1982; *Opere su carta*, July 1984

Marilena Bonomo, Bari, November 1979

Städtische Galerie im Lenbachhaus, Munich, *Nino Longobardi und Ernesto Tatafiore*, March 7–28, 1980. Catalogue with text by Helmut Friedel

Galerie 't Venster, Rotterdam, May 1980

Centre d'Art Contemporain, Geneva, *7 juin 1980*, June 1980. Catalogue with text by Fulvio Salvadori

Galleria Giuliana De Crescenzo, Rome, March–April 1981. Catalogue with text by Achille Bonito Oliva

Galerie Fina Bitterlin, Basel, October 1981

Internationaler Kunstmarkt, Cologne, *Förderprogramm für junge Kunst*, October 1981

Galleria Leyendecker, Santa Cruz de Tenerife, *Nino Longobardi*, April 1982. Catalogue

Galerie Art in Progress, Munich, May 1982

Galleria Fernando Vijande, Madrid, *Nino Longobardi*, October 1982. Catalogue with text by Achille Bonito Oliva

Istituto Italiano di Cultura, Madrid, October 1982

Galleria Il Ponte, Rome, *Nino Longobardi: Opere su carta*, December 2, 1982–January 15, 1983, catalogue with texts by Antonio d'Avossa, Danny Berger and the artist; December 7, 1983–January 14, 1984; *Nino Longobardi: Opera grafica*, May–June 1984, catalogue

Kunstmuseum Luzern, February 20–April 24, 1983. Catalogue

Charles Cowles Gallery, New York, April 1983

Galleriet, Lund, Sweden, October 1983; November 1984

Paul Cava Gallery, Philadelphia, January 1984

Galerie Montenay-Delsol, Paris, *Nino Longobardi: Viens la mort on va danser*, November 1984. Catalogue with text by Philippe Piguet

Kunstnernes Hus, Oslo, *Nino Longobardi*, March 8–April 13, 1986. Catalogue with text by Michele Bonuomo

Galleria Il Ponte at *Chicago International Art Exposition*, May 8–13, 1986

Nationalgalerie, Berlin, *Nino Longobardi: Zeichnungen und Bilder*, May 24–July 13, 1986. Catalogue with text by Michele Bonuomo

Musée Savoisien, Chambéry, France, *Nino Longobardi: Oeuvres récentes*, July 19–September 30, 1986. Catalogue with texts by Elio Grazioli and Giovanni Joppolo

Galerie Bugdahn & Szeimies, Düsseldorf, *Nino Longobardi–Neue Werke*, March 6–April 30, 1987. Catalogue with text by Achille Bonito Oliva

Anders Tornberg Gallery, Lund, Sweden, *Nino Longobardi*, May 9–31, 1987. Catalogue with text by Barbara Rose

Selected Bibliography

Vitaliano Corbi, "Gli ambienti de Longobardi," *Il Mattino*, March 8, 1979

Giulio De Martino, "Arte: Il risentimento dell'artista dequalificato–nuova creatività: una mostra a Napoli," *Manifesto*, April 24, 1979

Peter M. Bode, "Liebe zu Magie und Sachlichkeit," *Münchener Abendzeitung*, March 10, 1980, p. 11

Jürgen Morschel, "Quax war da," *Süddeutsche Zeitung*, March 19, 1980

Arcangelo Izzo, "L'artista impollinato," *La Voce della Campania*, May 11, 1980, p. 54

Fulvio Salvadori, "Nino Longobardi," *Art Press*, May 1980, p. 11

Giulio De Martino, "Una mostra di Longobardi a Napoli," *Manifesto*, December 18, 1980

Michele Bonuomo, "Questo quadro lo dedico a me," *Il Mattino*, December 20, 1980

Maria Di Domenico, "Il colore dell'inconscio," *Paese Sera*, January 2, 1981

Enzo Battara, "Nino Longobardi esalta superfici," *Paese Sera*, January 9, 1981

Arcangelo Izzo, "Nino Longobardi," *Flash Art*, March–April 1981

Barbara Tosi, "Nino Longobardi," *Segno*, May–June 1981

Siegmar Gassert, "Nino Longobardis Anspielungen," *Basler Zeitung*, October 7, 1981, p. 39

Severo Sanduy, "Un Art monstre," *Art Press*, October 1981, pp. 7–8

Antonio d'Avossa, "Nino Longobardi: Lo stile e il naufragio," *Flash Art*, December 1981–January 1982

Michele Bonuomo, "Italiano è bello, napoletano è meglio: Longobardi, uno dei 7 pittori invitati al Museo Guggenheim di New York," *Il Mattino*, March 18, 1982

Andrés Sànchez Robayna, "El cuerpo, la muerte, la tierra," *Jornada*, April 24, 1982

Eduardo Westerdahl, "Presentación de Longobardi," *Jornada Literaria*, April 24, 1982

Fernando Castro, "De un volcan a otro," *Jornada Literaria*, May 1, 1982

Danny Berger, "Nino Longobardi in New York: An Interview," *The Print Collector's Newsletter*, vol. XIII, May–June 1982, pp. 41–43

"Prints and Photographs Published: Nino Longobardi," *The Print Collector's Newsletter*, vol. XV, July–August 1984, p. 105

Interview with Michele Bonuomo, "Nino Longobardi," *Flash Art*, March 1985, p. 23

Giovanni Joppolo, "Longobardi, avant et après le cataclysme," *Opus International*, Spring 1985, p. 28

Don Hawthorne, "Prints from the Alchemist's Laboratory," *Art News*, vol. 85, February 1986, pp. 89–95

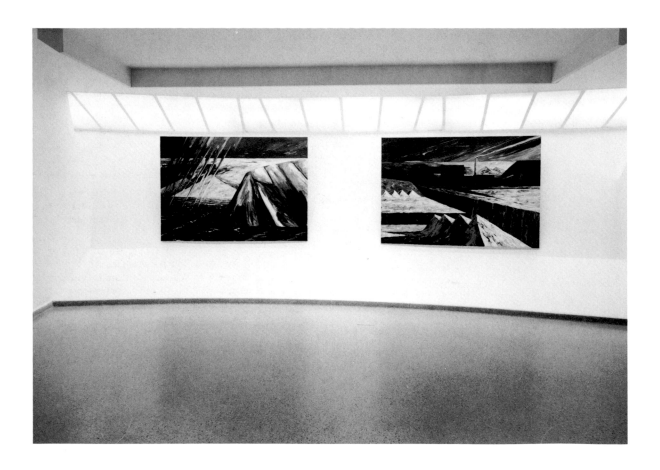

MANDY MARTIN

Born in Adelaide, Australia, November 18, 1952. Studied with Ruth Tuck, Adelaide, 1961–69; at South Australia School of Art, Adelaide, 1972–75. Lives in Canberra.

Selected One-Person Exhibitions

Hogarth Galleries, Sydney, *Screenprints*, June–July 1977; August 1978

Bonython Galleries, Adelaide, September 1977

Abraxas Gallery, Canberra, October 1977

Contemporary Art Society, Adelaide, November 1977

Robin Gibson, Sydney, *Mixed Media Works on Paper*, August 1980

Solander Gallery, Canberra, December 1980

Powell Street Gallery, Melbourne, November–December 1981; *Between the Ordinary and the Metaphysical*, July–August 1983

Roslyn Oxley9, Sydney, *Mandy Martin: Paintings*, March 1983, brochure with text by John Buckley; October–November 1984; April 1986

Institute of Modern Art, Brisbane, June–July 1984

Michael Milburn Galleries, Brisbane, July 1986

Anima Gallery, Adelaide, December 1986. Catalogue with text by Peter Haynes

Selected Bibliography

By the Artist

"Different Strokes," *Art & Text*, vol. 14, Winter 1984, pp. 80–83

On the Artist

Heresies, January 1977, pp. 1, 95

Arthur McIntyre, "Mandy Martin—An Artist with Something to Say," *Aspect*, vol. 4, no. 1–2, 1979, pp. 66–69

R. E. Phillips, C. Portley and Maurice J. Symonds, *The Visual Arts*, 2nd ed., Sydney, 1980, p. 188

Janine Burke, "Art for the End of the World," *Meanjin*, vol. 40, October 1981, pp. 375–388

Elwyn Lynn, "Letter from Australia," *Art International*, vol. XXV, May–June 1982, p. 78

"John McCaughey Memorial Art Prize 1983," *National Gallery of Victoria Bulletin*, April 1983, p. 10

Joanna Mendelssohn, "Jenny Watson and Mandy Martin–Roslyn Oxley9," *Art Network*, June 1983, pp. 17, 32, 65, 95

MICHAEL C. McMILLEN

Born in Los Angeles, April 6, 1946. Studied at San Fernando Valley State College, California, B.A., 1969; University of California, Los Angeles, M.A., 1972, M.F.A., 1973. Lives in Santa Monica.

Selected One-Person Exhibitions

312 Westminster, Venice, California, *The Traveling Mystery Museum*, June 16–26, 1973

Los Angeles Institute of Contemporary Art, performance, *The Living Brain of Picasso*, January 1975

California State University, Northridge, performance, *Mr. Potatohead's Alpha Waves*, May 13, 1975

Los Angeles County Museum of Art, *Inner City*, November 1–December 31, 1977. Traveled to Whitney Museum of American Art, New York, October 3–December 3, 1978

Cerro Coso College, Ridgecrest, California, *Ray Cathode's Garden*, April 8–28, 1978

Art Gallery of New South Wales, Sydney, *Project 29: Michael McMillen*, March 8–April 13, 1980. Catalogue with text by Bernice L. Murphy

Macquarie Galleries, Sydney, April 23–May 19, 1980; March 10–27, 1982

Asher/Faure, Los Angeles, October 16–November 22, 1980; October 16–November

Installation view, *Australian Visions: 1984 Exxon International Exhibition*, Mandy Martin, l. to r., *Red Break* and *Chasm*, 1984

13, 1982; *Subterrania*, October 26–November 23, 1984; *Intimate Works*, October 26–November 23, 1985

Mills College Art Gallery, Oakland, *Ars Longa Vita Brevis*, January 29–March 10, 1985

447 Fifth Avenue, San Diego, *Journey to the Surface*, June 29–August 24, 1985

Patricia Hamilton at 112 Greene Street, New York, *Michael C. McMillen: The New World*, September 30–October 27, 1986

Art Gallery, California State University, Northridge, *The Pavilion of Rain: Michael C. McMillen*, February 17–March 20, 1987

Selected Bibliography

By the Artist

"True Confessions," *LAICA Journal*, November–December 1975, pp. 21–22

"Special FX Breakdown," *LAICA Journal*, April–May 1977, pp. 37–39

On the Artist

William Wilson, "Sculpture That's Hard to Put Down," *Los Angeles Times*, February 18, 1974, part IV, p. 8

Walter Gabrielson, "The Ironic Los Angeles Artist," *LAICA Journal*, October–November 1976, p. 25

William Wilson, "Miniatures at LACMA: Touchstone of the 70's," *Los Angeles Times*, November 27, 1977, p. 110

Christopher Knight, "Some Recent Art and an Architectural Analogue," *LAICA Journal*, January–February 1978, pp. 50–54

Melinda Wortz, "Inner City of the Mind," *Art News*, vol. 77, February 1978, pp. 106–108

Barbara Radice, "L'arte è una realità in scala 1/100," *Modo*, vol. 2, April 1978, pp. 67–68

Peter Frank, "Inner City," *The Village Voice*, November 13, 1978, p. 113

Deborah Perlberg, "Michael McMillen, Whitney Museum," *Artforum*, vol. XVI, December 1978, pp. 66–67

Richard Whelan, "Michael McMillen at the Whitney," *Art in America*, vol. 67, May–June 1979, p. 134

Susanna Short, "Lilliputian Illusions," *The National Times* (Australia), May 4, 1980, p. 55

Christopher Knight, "Behold: A Power Plant or Frankenstein's Lab?" *Los Angeles Herald Examiner*, October 30, 1980, pp. C1–2

Mark Stevens, "California Dreamers," *Newsweek*, August 17, 1981, pp. 78–79

Sandra McGrath, "Lilliputian View of Two Worlds," *The Australian*, March 1982

Ruth Weisberg, "Fragmented Histories," *Artweek*, November 6, 1982, p. 16

Peter Clothier, "Michael C. McMillen, Asher/Faure Gallery," *Art in America*, vol. 71, January 1983, pp. 127–128

Susan C. Larsen, "Michael C. McMillen, Asher/Faure Gallery," *Artforum*, February 1983, vol. XXI, pp. 85–86

Suzanne Muchnic, "Subterrania," *Los Angeles Times*, October 26, 1984, part VI, p. 5

Neal Menzies, "Anthropomorphic Survivors," *Artweek*, November 10, 1984, p. 6

Christopher French, "Constructions in Shadowed Places," *Artweek*, February 16, 1985, p. 1

Robert L. Pincus, "Mystery Vessel Rises at Artist's Command," *The San Diego Union*, June 29, 1985, p. D15

Robert L. Pincus, "A 'Journey' to Another World Brings Us Back to Our Own," *The San Diego Union*, July 4, 1985, p. D9

Robert McDonald, "'Journey' Invites You to Come Along," *Los Angeles Times*, August 9, 1985, San Diego County edition, part VI, pp. 1, 10

Elizabeth Richardson, "Questions That Are Answered," *Artweek*, December 7, 1985, p. 6

Jane Greenstein, "McMillen Sees into Nature of Things," *Los Angeles Times*, February 4, 1986, part VI, p. 5

Zan Dubin, "Pavilion of Rain at Cal State Northridge," *Los Angeles Times*, February 15, 1987, part VI, p. 94

Kristine McKenna, "An Artist's Pavilion Memorializes Father," *Los Angeles Times*, February 25, 1987, part V, p. 9

KEITH MILOW

Born in London, December 29, 1945. Studied at Camberwell School of Art, London, 1962–67; Royal College of Art, London, 1967–68. Lives in New York.

Selected One-Person Exhibitions

Nigel Greenwood Gallery, London, *Keith Milow: Improved Reproductions*, May 5–27, 1970; November 13–December 1, 1973; October 31–November 1974; *Keith Milow: Recent Works*, June 8–July 9, 1976; April 4–29, 1978; *A Series of Watercolours by Keith Milow Dedicated to . . .*, April–May 1986

Institute of Contemporary Arts, London, February–March 1971

Park Square Gallery, Leeds, July 1971; April–May 1972

Kings College, Cambridge, January 1972

Utrecht, The Netherlands, *Utrechtkring*, February 1972. Catalogue with text by Jeroen Grosfeld

Leeds City Art Gallery, *Gregory Fellows Exhibition*, March–April 197_

J. Duffy & Sons, New York, April–May 1973

Galerie Jacomo Santiveri, Paris, May 1975

Arnolfini Gallery, Bristol, October–November 1975

Hester Van Royen Gallery, London, October–November 1975

Kettle's Yard Gallery, Cambridge, April–May 1976. Catalogue with text by William Feaver

Galerie Albert Baronian, Brussels, March–April 1977

Park Square Gallery, Leeds, and Walker Art Gallery, Liverpool, November 1977

Roundhouse Gallery, London, *Just Crosses*, August–September 1978

Galerie Loyse Oppenheim, Nyon, Switzerland, 1979

Rowan Gallery, London, November 1979

Annina Nosei Gallery, New York, May 19–June 4, 1981; September 11–October 2, 1982

Alexander Wood Gallery, New York, *Keith Milow: Recent Sculpture*, March 21–April 18, 1987

Selected Bibliography

Richard Morphet, *Improved Reproductions, Notes in Progress on Keith Milow*, London, 1970

Marina Vaizey, "Keith Milow and Dieter Roth," *Financial Times*, March 11, 1971

William Feaver, "Keith Milow," *Art International*, vol. XVI, October 1972, pp. 34–37, 131

William Feaver, "Keith Milow," *Financial Times*, November 14, 1974, p. 3

William Feaver, "Keith Milow," *Art Spectrum*, vol. 1, January 1975, p. 47

Simon Wilson, "Keith Milow," *Studio International*, vol. 193, September/October 1976, pp. 213–214

Adrian Lewis, "Keith Milow at Nigel Greenwood," *Artscribe*, June 1978, p. 58

John Russell, "Keith Milow," *The New York Times*, October 1, 1982, pp. C1, C20

Donald Kuspit, "Keith Milow," *Artforum*, vol. XXI, January 1983, p. 74

John Russell, "Recent Sculptures by Keith Milow," *The New York Times*, April 10, 1987, p. C26

"Album: Keith Milow," *Arts Magazine*, vol. 61, April 1987, pp. 104–105

JAN MURRAY

Born in Ballarat (Victoria), Australia, 1957. Studied at Ballarat College of Advanced Education, 1976–78; Victorian College of the Arts, Melbourne, 1980–81. Lives in Melbourne.

Selected One-Person Exhibitions

Roslyn Oxley9, Sydney, October–November 1983; June 1986

Kunstlerhaus Bethanien, Berlin, *Malerei*, January–February 1985. Catalogue with text by Bernhard Schultz

Melbourne University Gallery, *Berlin Works*,
May–June 1985

Selected Bibliography

Terence Maloon, "Arts Review," *The Sydney
Morning Herald*, May 22, 1982

Sandra McGrath, "Arts Review," *The Weekend
Australian*, June 5–6, 1982

Memory Holloway, "A Powerful View Across
the Berlin Wall," *The Age*, June 29, 1985

John Barbour [review], *Art Network*, Winter
1985

DAVID NASH

Born in Esher (Surrey), England, 1945. Studied
at Kingston College of Art, Kingston-upon-
Thames (Surrey), 1963–67; Brighton College
of Art, 1964–65; Chelsea School of Art, Lon-
don, 1969–70. Lives in Blaenau Ffestiniog,
Wales.

Selected One-Person Exhibitions

Queen Elizabeth Hall, St. William's College,
York, *Briefly Cooked Apples*, July–August
1973

Oriel Gallery, Bangor, Wales, August–
September 1973; September 1976; March
11–April 17, 1982, catalogue with text by
William Varley

Arnolfini Gallery, Bristol, *Loosely Held Grain*,
October–November 1976, catalogue with text
by the artist; February 1979

AIR Gallery, London, *Fletched Over Ash*, July
1978

Chapter Gallery, Cardiff, Wales, November
1978

Elise Meyer Gallery, New York, *Wood Quarry*,
May 10–June 10, 1980, catalogue; *David
Nash: Two Views of Nature*, February 6–27,
1982

Southampton University Gallery, England,
Mixed Wood, Summer 1980

Galleria Cavallino, Venice, November 1980

St. Paul's Gallery, Leeds, *Pyramids and
Catapults*, October 1981

Rijksmuseum Kröller-Müller, Otterlo, The
Netherlands, *Wood Quarry: David Nash*,
May 29–July 12, 1982. Catalogue with text
by Rudolf W. D. Oxenaar

Yorkshire Sculpture Park, Wakefield, *Fellow-
ship '81–'82: David Nash*, July–August 1982.
Catalogue with texts by P. Murray and the
artist

Kilkenny Art Gallery, Kilkenny Castle, Ireland,
August–December 1982

Third Eye Centre, Glasgow, *Sixty Seasons:
David Nash*, January 15–February 12, 1983.
Catalogue with text by Hugh Adams. Traveled
to Fruitmarket Gallery, Edinburgh, February–
March 1983; Mostyn Art Gallery, Llandudno,
Wales, April–May 1983; Glynn Vivian Art
Gallery and Museum, Swansea, England, July
1983; City Museum and Art Gallery, Stoke-on-
Trent, England, August 1983

The Douglas Hyde Gallery, Trinity College,
Dublin, January–February 1983

Nagisa Park No. 2, Moriyama City, Shiga,
Japan, September 1–October 10, 1984.
Catalogue with text by Julian Andrews.
Traveled to Tochigi Prefectural Museum of
Fine Arts, Tochigi-ken, November 23–
December 23, 1984; Miyagi Museum of Art,
Sendai, January 5–February 17, 1985;
Fukuoka Art Museum, February 26–March
31, 1985; Sogetsu Gallery, Tokyo, May 5–June
8, 1985

Kamakura Gallery, Tokyo, November 26–
December 15, 1984

Bixby Gallery, Washington University,
St. Louis, January 6–27, 1985

Rijksmuseum Kröller-Müller, Otterlo, The
Netherlands, April–May 1985

Heide Park and Art Gallery, Melbourne,
Elmwattle Gum, October 10–November 10,
1985

Juda Rowan Gallery, London, *Tree to Vessel:
Sculpture*, April 17–May 24, 1986. Catalogue
with text by the artist

Selected Bibliography

By the Artist

Briefly Cooked Apples, York, 1973

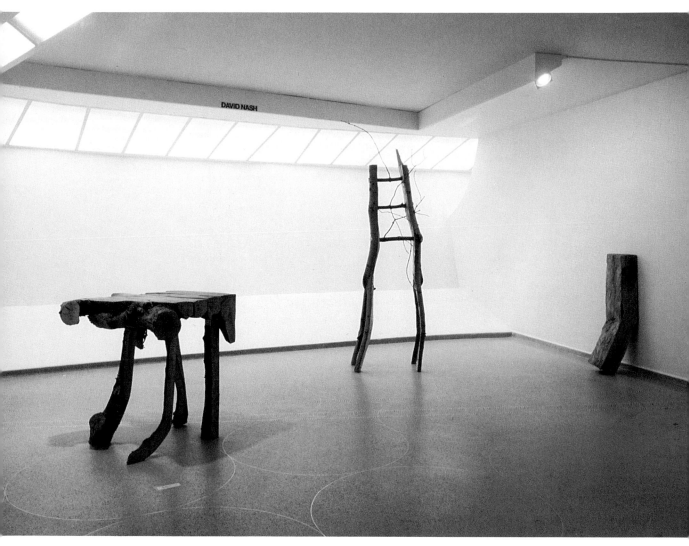

Installation view, *British Art Now: An American Perspective, 1980 Exxon International Exhibition*, David Nash, l. to r., *Corner Table*, 1977, *Ash Ladder*, 1978, and *Wall Leaner–A Lazy Log*, 1976

Fletched Over Ash, London, 1978

"David Nash," *Aspects*, Summer 1979, unpaginated

"David Nash," *Aspects*, Spring 1980, unpaginated

Stoves and Hearths, London, 1982

On the Artist

Jonathan Robertson, "David Nash," *Link*, Winter 1976, pp. 8–9

Hilary Chapman, "David Nash—The Reconstruction of Awareness," *Arts Review*, February 3, 1977, p. 86

Alan McPherson, "Interview with David Nash," *Artscribe*, June 1978, pp. 30–34

John McEwen, "From Structure to Surface," *The Spectator*, July 22, 1978, p. 25

Marina Vaizey, "The Men Who Built Our Cages," *The Sunday Times*, July 23, 1978, p. 35

Terence Maloon, "David Nash at AIR," *Artscribe*, August 1978, p. 55

William Feaver, "Woodwork," *Observer Magazine*, November 19, 1978, p. 65

Hugh Adams, "The Woodman," *Art and Artists*, vol. 13, April 1979, pp. 44–47

Cordelia Oliver, "David Nash," *The Guardian*, January 25, 1983

William Packer, "In Pursuit of Nature," *Financial Times*, January 25, 1983, p. 15

Virginia Fabbri Butera, "Album: Hayward Annual: British Drawing," *Arts Magazine*, vol. 57, January 1983, p. 48

Ciaram Carty, "The Man Who Gave Modern Art the Chop," *Sunday Independent Ireland*, February 6, 1983

Brian Fallon [review], *The Irish Times*, February 10, 1983

Duncan McMillan, "David Nash: Brancusi Joins the Garden Gang," *Art Monthly*, April 1983, pp. 7–9

Marina Vaizey [review], *The Sunday Times*, July 31, 1983, p. 39

John Beardsley, *Earthworks and Beyond: Contemporary Art in the Landscape*, New York, 1984, pp. 44–50

Peter Davies and Tony Knipe, eds., *A Sense of Place: Sculpture in Landscape*, Sunderland, England, 1984, pp. 56, 75, 87, 95, 101-107

Frederick J. Nelson, "David Nash," *New Art Examiner*, vol. 12, Summer 1985, p. 74

Waldemar Januszczak, "David Nash," *The Guardian*, April 19, 1986

William Packer, "In Response to Raw Timber," *Financial Times*, April 22, 1986, p. 21

Lieven Van Den Abeele, "David Nash: Nature as the Only Reality," *Artefactum*, vol. 3, April–May 1986, pp. 19–23

William Feaver, "Dead Wood Sculpture," *The Observer*, May 4, 1986

Larry Berryman, "David Nash: Tree to Vessel," *Arts Review*, May 9, 1986, p. 249

John Teets, "Artist Carves Niche in Nature," *Chicago Tribune*, February 4, 1987, p. 5

Richard Cork, "Mapping Out Images," *The Listener*, April 2, 1987

Marina Vaizey, "The Lords of All Creation," *The Sunday Times*, April 12, 1987, p. 55

JOAN NELSON

Born in Torrance, California, May 28, 1958. Studied at Washington University, St. Louis, B.F.A., 1981. Lives in Brooklyn.

Selected One-Person Exhibitions
P·P·O·W·, New York, January 16–February 10, 1985; February 12–March 9, 1986

Michael Kohn Gallery, Los Angeles, June 5–July 23, 1986

Selected Bibliography
Vivien Raynor [review], *The New York Times*, February 8, 1985, p. C32

Shellie R. Goldberg [review], *Art News*, vol. 85, May 1986, pp. 132–133

Kristine McKenna [review], *Los Angeles Times*, June 13, 1986, part VI, p. 17

NIC NICOSIA

Born in Dallas, June 24, 1951. Studied at North Texas State University, Denton, B.A., 1974; North Texas State University and University of Houston, 1979–80. Lives in Dallas.

Selected One-Person Exhibitions

Brown Lupton Gallery, Texas Christian University, Fort Worth, *Nic Nicosia–Photographs*, October 12–30, 1981

Galveston Arts Center Gallery, *Steve Dennie/ Nic Nicosia*, November 6–29, 1981

Artists Space, New York, *Nic Nicosia*, November 16–December 4, 1982

Delahunty Gallery, Dallas, *Nic Nicosia/ Domestic Dramas*, December 18, 1982– February 2, 1983

Light Song Gallery, University of Arizona, Tucson, *Nic Nicosia*, March 16–April 8, 1983

The Akron Museum, Ohio, *Nic Nicosia: Photographs*, January 29–March 25, 1984

Delahunty Gallery, New York, *Nic Nicosia/ Near (Modern) Masters*, January 31–March 3, 1984

Jane Corkin Gallery, Toronto, *Nic Nicosia, Domestic Dramas/Near (Modern) Disasters*, June 9–July 7, 1984

Milwaukee Art Museum, *Nic Nicosia's Realities*, May 23–September 22, 1985. Catalogue with text by Verna Curtis

Houston Center of Photography, *Nic Nicosia, Domestic Dramas/Near (Modern) Disasters*, September 6–October 20, 1985

Marcuse Pfeifer Gallery, New York, *The Cast*, October 19–November 22, 1985

Dart Gallery, Chicago, *The Cast*, November 15–December 11, 1985

The Dallas Museum of Art, *Concentrations 13-Nic Nicosia*, February 1–March 30, 1986. Catalogue with text by Sue Graze

Wellesley College Museum, Jewett Arts Center, Massachusetts, *Nic Nicosia: Recent Photographs*, February 8–March 23, 1986

Texas Gallery, Houston, *Nic Nicosia: The Cast*, March 4–30, 1986

Film in the Cities, St. Paul, Minnesota, *Nic Nicosia*, May 7–28, 1986

Maurice Keitelman Gallery, Brussels, May 22–June 26, 1986

Eve Mannes Gallery, Atlanta, *Nic Nicosia: Photographs*, September 12–October 13, 1986

Albert Totah Gallery, New York, *Life As We Know It*, February 22–March 26, 1987

Selected Bibliography

Judy Gossitt Anderton, "Nic Nicosia," *Dallas Photo Magazine*, vol. 1, October 1978, pp. 16–17

Bill Marvel, "League Lobbies Quality Show," *The Dallas Times Herald*, March 21, 1981, p. C1

Janet Kutner, "Photographers Call the Shots with Fantasy," *The Dallas Morning News*, May 2, 1981, p. C1

Robert Raczka, "Stephen Dennie and Nic Nicosia," *Artspace*, vol. 5, Fall 1981, pp. 62–63

Andy Grundberg, "Explaining the Improbable," *The New York Times*, July 11, 1982, p. H1

Charles Dee Mitchell, "Nicosia's Domestic Dramas," *Dallas Observer*, December 16–29, 1982, p. 15

Janet Kutner, "Is It Live or Is It Nicosia? Staged Sets, Sharp with Causes, Inspired Irony," *The Dallas Morning News*, January 27, 1983, p. C1

"Camera at Work: Scene Stealers," *Life*, vol. 6, May 1983, pp. 10–11

Andy Grundberg and Carol Squiers, "Family Fables," *Modern Photography*, vol. 47, June 1983, pp. 78–83

Susan Freudenheim, "Nic Nicosia at Delahunty," *Art in America*, vol. 71, Summer 1983, p. 163

Eleanor Heartney, "Nic Nicosia," *Arts Magazine*, vol. 58, April 1984, p. 15

Douglas Davis, "Seeing Isn't Believing," *Newsweek*, June 3, 1985, p. 68

Yoshi Higa, "Nic Nicosia, The Cast," *Nippon Camera*, January 1986, p. 134

Janet Kutner, "Photo Unreality...," *The Dallas Morning News*, February 2, 1986, p. C1

Charles Dee Mitchell, "The Cast Features a Little Help from Nic's Friends," *Dallas Observer*, February 27, 1986, p. 3

Ed Symkus, "Unnatural Disasters," *TAB*, March 11, 1986, section 3, p. 12

Ellen Pulda, "Freeze Frames... Nicosia...," *News West*, March 12, 1986, p. 27

Bill Marvel, "Two Small Shows Are Largely Entertaining," *The Dallas Times Herald*, March 13, 1986, pp. B3, B5

Meredith Fife Day, "Nicosia at Wellesley," *Century Newspapers*, March 13, 1986

Charles Dee Mitchell, "Nic Nicosia," *New Art Examiner*, April 1986, p. 66

Janet Kutner, "Offbeat Views of Texas History," *The Dallas Morning News*, July 8, 1986, p. E1

Nancy Roth, "Engineered Images," *Artpaper*, vol. 5, Summer 1986, p. 24

Vince Aletti [review], *The Village Voice*, March 17, 1987, p. 73

Eleanor Heartney [review], *Art News*, vol. 86, May 1987, p. 153

JOHN NIXON

Born in Sydney, Australia, December 13, 1949. Studied at Preston Institute of Technology, Melbourne, 1967–68; National Gallery of Victoria Art School, Melbourne, Diploma of Art, 1970; State College of Victoria, Melbourne, Diploma of Education, 1973. Lives in Melbourne.

Selected One-Person Exhibitions

Pinacotheca, Melbourne, June–July 1973; June 1974; August 1975; April 1977

Experimental Art Foundation, Adelaide, October 1975; September 1979

Watters Gallery, Sydney, June 1976; April 1979

National Gallery of Victoria, Melbourne, October 1976

Barry Barker Ltd., London, July 1978; February 1980

Art Projects, Melbourne, February 1979; September 1979; March 1980; October 1980; April 1981; October 1981; April 1982; April 1983; February 1984; October 1984

Roslyn Oxley 9 Gallery, Sydney, February 1983; *John Nixon/Self Portrait/(Non-Objective Composition)*, July–August 1983, catalogue with texts by Paul Taylor and the artist; August–September 1985, catalogue with text by the artist; *Painting and Sculpture*, October–November 1986, catalogue with text by John Barleycorn

United Artists Gallery, Melbourne, March–April 1986; December 1986

Gallery Dusseldorf, Perth, May 1986

Sue Crockford Gallery, Auckland, *John Nixon and Jenny Watson*, June–July 1986

University Gallery, Melbourne, *Song of the Earth*, March–April 1987

Selected Bibliography

By the Artist

John Nixon Catalogue Raisonné 1968–1981, Melbourne, 1981

with Imants Tillers, *One Painting with Many Titles*, Melbourne, 1983

"1986," *Tension*, September–October 1986, pp. 23–26

"John Nixon," *Press*, vol. 2, April 1987

On the Artist

Jenny Watson, "Urgent Images," *Art & Text*, Winter 1984, p. 71

Judith Blackall, "John Nixon," *Juliet*, no. 24, 1986

Peter Hamilton, "John Nixon," *Art Network*, no. 18, 1986

SUSAN NORRIE

Born in Sydney, Australia, July 1, 1953. Studied at National Art School, Sydney, 1973; Victorian College of the Arts, Melbourne, Diploma of Painting, 1976. Lives in Sydney.

Selected One-Person Exhibitions

Students' Gallery, Sydney, August 1980

Mori Gallery, Sydney, July 1982

Realities Gallery, Melbourne, September 1983

Melbourne University Gallery, *Susan Norrie: Paintings 1983–86*, October 15–November 14, 1986

Selected Bibliography

By the Artist

with Ewen McDonald, "On Margaret Preston," *Follow Me*, February–March 1986, p. 217

"Artist's Choice: Toni Warburton—Congewol I," *Art and Australia*, vol. 24, Winter 1987, p. 505

"Creative Tension," *Times on Sunday*, February 8, 1987, p. 25

On the Artist

Mervyn Horton, "Exhibition Commentary," *Art and Australia*, vol. 18, Summer 1980, p. 115

Terence Maloon, "A Woman Takes a Macabre Look at Mummy's Baubles," *The Sydney Morning Herald*, October 23, 1982, p. 24

Memory Holloway, "A Glimpse into a Private World," *The Age*, September 14, 1983, p. 4

Ronald Millar, "Norrie Turns Out Visual Poetry," *The Herald*, September 15, 1983, p. 12

Suzanne Davies, "Susan Norrie—Realities," *Art Network*, September 1983, p. 51

Betsy Brennan, "The Artist Exposed," *Vogue Living*, October 1984, pp. 82–84

Ursula Prunster, "Norrie's Landscapes of Fantasy," *Art Express*, special edition, 1984, p. 16

Jo Holder, "Conversations with Susan Norrie: Gothic Femininity," *Follow Me*, January 1985, pp. 58–61

Maggie Gilchrist, "Male Monoliths, Female Symbols," *Art and Australia*, vol. 23, Summer 1985, pp. 206–213

Pamela Hansford, "Women Raid the Old to Bring In the New," *The Sydney Morning Herald*, November 20, 1985, p. 10

Terence Maloon, "Polemical Remarks in a Cheeky Vein," *The Sydney Morning Herald*, July 27, 1986, p. 23

Terence Maloon, "Disney with a Sombre Touch," *The Sydney Morning Herald*, September 20, 1986, p. 21

Gary Catalano, "A Display of Perplexity," *The Age*, October 22, 1986, p. 14

Robert Rooney, "Susan Norrie: Paintings," *The Australian*, October 25, 1986, p. 25

John Macdonald, "To Fantasy from Kitsch," *Times on Sunday*, October 26, 1986, p. 28

Joanne Murray-Smith, "Applying the Brush with Consistent Boldness," *The Melbourne Times*, October 29, 1986, p. 17

HUGH O'DONNELL

Born in London, June 4, 1950. Studied at Camberwell College of Art, London, 1968–69; Falmouth College of Art, Cornwall, B.A., 1972; Birmingham School of Art, H. Dip. A.D., 1973; Fellowship to Gloucestershire College of Art, 1973–74; Japanese Government Scholarship to Kyoto University of Arts, 1974–76; Royal College of Art, London, 1976–79. Lives in London.

Selected One-Person Exhibitions

Nishimura Gallery, Tokyo, February 1976

AIR Gallery, London, October 1977

Ikon Gallery, Birmingham, June 1979. Catalogue with text by Moira Kelly

Marlborough Gallery Inc., New York, *Hugh O'Donnell–Recent Paintings and Drawings*, December 2–31, 1982; *Hugh O'Donnell–Recent Works on Paper and Monotypes*, February 4–March 3, 1984; *Hugh O'Donnell: Recent Work*, February 5–28, 1987

Rahr-West Museum, Manitowoc, Wisconsin, *Hugh O'Donnell*, March 31–May 8, 1983

Marlborough Graphics, London, *Hugh O'Donnell, Works on Paper*, April 1984

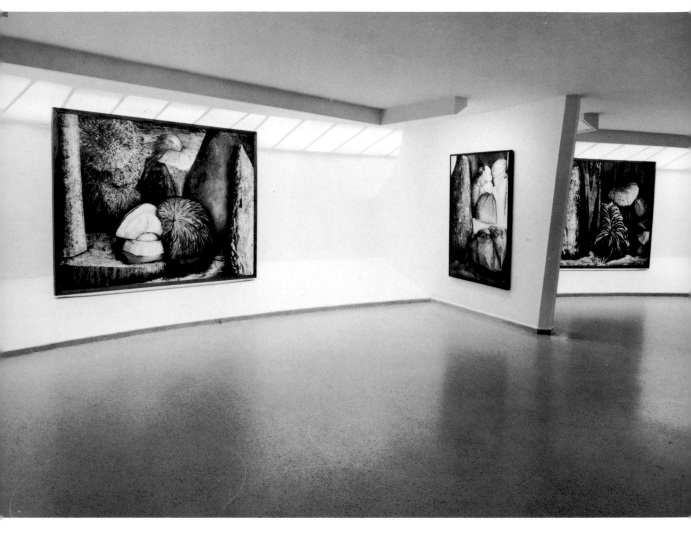

Installation view, *Australian Visions: 1984*
Exxon International Exhibition, Susan Norrie,
l. to r., *Shielded, Flaunted-Fleeced* and
Encroached, 1984

Marlborough Fine Art, London, *Hugh O'Donnell-Recent Work, April 1984-April 1985*, April 17-May 17, 1985

Selected Bibliography

Richard Walker, "Young Painters," *Arts Review,* September 22, 1973, p. 630

Moira Kelly, "Hugh O'Donnell," *Artscribe,* vol. 20, November 1979, pp. 38-41

Lisa Dennison, "Hugh O'Donnell," *Arts Magazine,* vol. 57, February 1983, p. 7

Mary Rose Beaumont, "Hugh O'Donnell, Marlborough Graphics," *Arts Review,* March 2, 1984, p. 100

Leonard Lee, "Hugh O'Donnell," *Artscribe,* vol. 47, July-August 1984, pp. 32-35

John Russell, "Bill Jacklin and Hugh O'Donnell at Marlborough Gallery," *The New York Times,* February 20, 1987, p. C26

GIUSEPPE PENONE

Born in Garessio, Italy, April 3, 1947. Studied at Accademia di Belle Arti, Turin, 1966-68. Lives in Garessio and Turin.

Selected One-Person Exhibitions

Deposito d'Arte Presente, Turin, 1968

Galleria Sperone, Turin, December 1969; *Il pelo, come l'unghia e la pelle, occupa spazia,* October 1973; *Giuseppe Penone: 1216 peli,* March-April 1975

Aktionsraum I, Munich, February 1970

Galleria Toselli, Milan, April 1970; April 1973

Incontri Internazionali d'Arte, Rome, *Rovesciare i propri occhi,* November 1971

Galerie Paul Maenz, Cologne, July 8-29, 1972; May 15-June 16, 1973; February 15-March 8, 1975; January 31-February 24, 1978

Galleria Multipli, Turin, February 1973; *6 opere,* March 1975

Galerie Klaus Lüpke, Frankfurt, August 4-31, 1973

Galleria Sperone-Fischer, Rome, December 1973

Galerie 't Venster, Rotterdam, *Piede/1972,* November-December 1974

Galleria Schema, Florence, December 11, 1974-January 10, 1975

Samangallery, Genoa, April 1975

Nuovi Strumenti, Brescia, 1976

Studio De Ambrogi, Milan, 1976

Kunstmuseum Luzern, *Giuseppe Penone: Bäume, Augen, Haare, Wände, Tongefässe,* May 22-June 26, 1977. Catalogue with texts by Jean-Christophe Ammann, Ugo Castagnotto and the artist

Staatliche Kunsthalle Baden-Baden, *Giuseppe Penone,* January 28-February 26, 1978. Catalogue with texts by Jean-Christophe Ammann, Renato Barilli, Hans Albert Peters and the artist

Galerie Rudolf Zwirner, Cologne, March 1978

Museum Folkwang, Essen, *Giuseppe Penone,* September 1-October 1, 1978. Catalogue with texts by Germano Celant, Zdenek Felix and the artist

Galleria De Crescenzo, Rome, October 1978

Galleria Salvatore Ala, Milan, November 1978; December 12, 1982-February 15, 1983

Galerie Durand-Dessert, Paris, January 1-February 23, 1979; March 1983; February 22-April 19, 1986; *Giuseppe Penone: Pages de terre,* March 14-April 18, 1987

Halle für Internationale Neue Kunst, Zürich, *Giuseppe Penone: Zucche e nero assoluto d'Africa,* November 1979-January 1980

Studio G7, Bologna, 1979

Stedelijk Museum, Amsterdam, *Giuseppe Penone,* February 15-March 30, 1980. Catalogue with texts by Germano Celant and the artist

Kabinett für Aktuelle Kunst, Bremerhaven, *Giuseppe Penone,* April 26-May 18, 1980

Galleria Christian Stein, Turin, May-June 1980; March 16-April 16, 1983

Galleria Salvatore Ala, New York, March 11-April 25, 1981; *Essere fiume,* April 3-May 15, 1982

Galerie Konrad Fischer, Düsseldorf, *Giuseppe Penone: Essere fiume,* September 12-October 8, 1981; *Giuseppe Penone: Pfad/Sentiero,* March 9-April 10, 1985

Städtisches Museum Abteiberg, Mönchengladbach, *Giuseppe Penone*, June 23–August 22, 1982. Catalogue with texts by Johannes Cladders and the artist

Galerie Konrad Fischer, Zürich, November 1982

National Gallery of Canada, Ottawa, *Giuseppe Penone*, October 7–December 4, 1983. Catalogue with texts by Jessica Bradley and the artist. Traveled to Fort Worth Art Museum, January 28–March 18, 1984; Museum of Contemporary Art, Chicago, June 2–August 12, 1984

Fischer Gallery, University of Southern California, Los Angeles, January 1984

Musée d'Art Moderne de la Ville de Paris, *Giuseppe Penone*, July–September 1984. Catalogue with texts by Jessica Bradley and the artist and interview with the artist by G. Ceruti

Marian Goodman Gallery, New York, January 31–March 2, 1985; *Giuseppe Penone*, February 11–28, 1987

Musée de Peinture et de Sculpture, Grenoble, March 27–June 9, 1986. Catalogue with text by Jean Paul Monery and Christine Poullain

Musée des Beaux-Arts, Nantes, June–September 1986. Catalogue with texts by Jean-Louis Baudry, Remo Guidieru and Daniel Soutif

Selected Bibliography

By the Artist

Svolgere la propria pelle, Turin, 1971

with Jean-Christophe Ammann, *Rovesciare gli occhi*, Turin, 1977

"Giuseppe Penone," *Data*, Summer 1978, pp. 28–29

On the Artist

Germano Celant, *Arte Povera—Conceptual, Actual or Impossible Art*, Milan, 1969

Tommaso Trini, "The Sixties in Italy," *Studio International*, vol. 184, November 1972, pp. 165–170

Tommaso Trini, "Anselmo, Penone, Zorio e le nuove fonti d'energia per il deserto dell'arte," *Data*, Autumn 1973, pp. 62–67

Lea Vergine, *Il corpo come linguaggio*, Milan, 1974

Achille Bonito Oliva, "Process, Concept and Behavior in Italian Art," *Studio International*, vol. 191, January–February 1976, pp. 3–9

Peter Killer [review], *Du*, vol. 37, June 1977, p. 19

Rolf-Gunter Dienst, "Giuseppe Penone: Staatliche Kunsthalle, Baden-Baden," *Kunstwerk*, vol. 31, June 1978, pp. 83–84

[Review], "Giuseppe Penone: Folkwangmuseum, Essen," *Heute Kunst*, January 1979, p. 8

[Review], "Giuseppe Penone: Giuliana De Crescenzo/Roma," *Flash Art*, January–February 1979, p. 13

[Review], "Giuseppe Penone: Studio Ala/Milano," *Flash Art*, January–February 1979, p. 9

Germano Celant, "Giuseppe Penone," *Parachute*, Spring 1980, pp. 12–17

Giuseppe Risso, "Giuseppe Penone: Each Blow of the Hoe," *Domus*, September 1980, p. 53

G. S. Brizio, "Giuseppe Penone," *D'Ars*, vol. 22, April 1981, pp. 140–143

Lisa Liebmann, "Giuseppe Penone at Salvatore Ala," *Art in America*, December 1981, pp. 147–148

F. Dagenais, "Ephemera Fossilized: Giuseppe Penone," *Vanguard*, vol. 13, March 1984, pp. 10–13

Wade Wilson, "Impressions of Ephemera," *Artweek*, April 17, 1984, p. 13

Claude Gintz, "Archaïsme et contemporanéité dans la sculpture de Giuseppe Penone," *Art Press*, June 1984, pp. 16–18

[Review], *The New York Times*, February 22, 1985, p. C21

R. DeMarco [review], *Studio International*, March 1985, pp. 46–47

Donald Kuspit, "Giuseppe Penone," *Artforum*, vol. XXIII, May 1985, pp. 106–108

Jean-Pierre Bordaz, "Giuseppe Penone," *Flash Art*, March 1986, pp. 62–63

P. Piguet, "Giuseppe Penone," *L'Oeil*, July–August 1986, pp. 93–94

Donald Kuspit, "Giuseppe Penone," *Artforum*, vol. XXV, May 1987, pp. 145–146

VETTOR PISANI

Born in Naples, July 12, 1934. Lives in Rome.

Selected One-Person Exhibitions

Castello Svevo, Bari, July 15–August 12, 1970

Galleria Sperone, Rome, April 1976

Galleria Pieroni, Pescara, February 1–March 15, 1978

Istituto Nazionale di Architettura, Palazzo Taverna, Rome, *Piccolo monumento R.C. agli animali*, 1979

Galleria Pieroni, Rome, October 15–November 30, 1980; *L'Isola azzurra*, June 2–July 15, 1985; June 2–July 15, 1987

Salvatore Ala, New York, *R.C. Theatrum*, December 1980–January 1981

Museum Folkwang, Essen, *Io lavoro con la squadra e il compasso*, May 21–July 4, 1982. Catalogue with texts by Maurizio Calvesi and Zdenek Felix

Galerie Von Braunbehrens, Munich, March 11–April 25, 1986

Selected Bibliography
By the Artist

"Vettor Pisani," *Data*, Summer 1978, p. 33

On the Artist

Achille Bonito Oliva, "Vettor Pisani," *Domus*, April 1976, p. 62

Tommaso Trini, "Vettor Pisani," *Data*, October–November 1976, pp. 20–25

Arcangelo Izzo, "Vettor Pisani," *Art Press*, May 1977, p. 22

Bruno Corà, "Il conglio non ama Joseph Beuys," *Domus*, May 1978, pp. 48–50

Roberto G. Lambarelli, "Vettor Pisani," *Flash Art*, January–February 1979, p. 14

Roberto G. Lambarelli [review], *Flash Art/Heute Kunst*, March–April 1979, p. 52

Ida Panicelli [review], *Artforum*, vol. XIX, February 1981, pp. 87–88

Marjorie Welish [review], *Art in America*, vol. 69, May 1981, pp. 141–142

Bruno Corà, "V.P., R.C. Theatrum, teatro di artisti e di animali," *A.E.I.U.O.*, vol. 2, 1981, p. 51

Laura Cherubini [review], *Flash Art*, May 1982, p. 53

Arcangelo Izzo, "Teatro di verità e di varietà," *Lapis/Arte*, vol. IV, 1983, unpaginated

NICHOLAS POPE

Born in Sydney, Australia, February 26, 1949. Studied at Bath Academy of Art, 1970–73. Lives in Herefordshire, England

Selected One-Person Exhibitions

Garage Gallery, London, March 1976

City of Portsmouth Museum and Art Gallery, *Nicholas Pope, Sculpture 1973–1976*, September–October 1976

Anthony Stokes Gallery, London, February–March 1979

Art and Project, Amsterdam, May 1979; January 17–February 14, 1981; April 7–May 12, 1984; October 5–26, 1985

Gallery "A," Sydney, November 1979

Ray Hughes Gallery, Brisbane, March 1980

La XXXIX Biennale di Venezia, British Pavilion, *Nicholas Pope*, June 1–September 28, 1980. Catalogue with text by Norbert Lynton

Rijksmuseum Kröller-Müller, Otterlo, The Netherlands, August 15–September 28, 1981

John Hansard Gallery, Southampton University, England, November 2–28, 1981

Waddington Gallery, London, *Nicholas Pope*, May 2–26, 1984, catalogue with text by the artist; October 29–November 22, 1986

Selected Bibliography
By the Artist

"Sculptors' Replies," *Artscribe*, Summer 1976, pp. 9–10

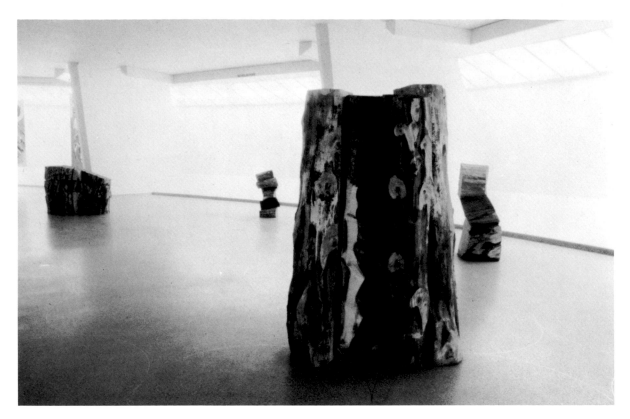

Installation view, *British Art Now: An American Perspective, 1980 Exxon International Exhibition*, Nicholas Pope, l. to r., *Thirty Wood Block*, 1978, *Apple Pile*, 1979, *Tall Block* and *Round Pile*, 1978

"Nicholas Pope," *Aspects*, Spring 1980, unpaginated

On the Artist

Marina Vaizey, "Object Lessons," *The Sunday Times*, March 7, 1976, p. 35

Caroline Tisdall, "Rumanian Rich," *The Guardian*, March 12, 1976, p. 10

William Packer, "Nicholas Pope and Patrick Hughes," *Financial Times*, March 15, 1976, p. 3

Ben Jones, "Nicholas Pope," *Artscribe*, Spring 1976, p. 10

Fenella Crichton, "Nicholas Pope," *Studio International*, vol. 193, May–June 1976, p. 299

Ben Jones, "A New Wave in Sculpture: A Survey of Recent Work by Ten Younger Sculptors," *Artscribe*, September 1977, p. 15

William Packer, "4 Artists of the 80s," *Vogue*, March 15, 1978, p. 126

John McEwen, "Aspects of British Sculpture," *Artforum*, vol. XVI, April 1978, pp. 27–31

William Packer, "Silver, Dante and Wood," *Financial Times*, February 6, 1979, p. 15

B. Wright, "Nicholas Pope," *Arts Review*, vol. 31, February 16, 1979, p. 66

John Glaves Smith, "Nicholas Pope," *Art Monthly*, March 1979, p. 21

Paul Groot, "Nicholas Pope," *Nark/Handelsbad*, May 1979

Jan Zumbrink, "Nicholas Pope," *Artzien*, vol. 1, May 1979, unpaginated

Memory Holloway, "Woodsman from the Hills of Hampshire," *The Australian*, October 1979

James Bustard, "Nicholas Pope," *Art Log*, no. 4, 1979

Ian Ball, "Log Pile Shows There Is Still Life in Britain," *Daily Telegraph*, January 17, 1980

J. Bumpus, "Two for Venice," *Art and Artists*, vol. 15, January 1980, pp. 34–39

Dale Harris, "The Art That Caught the Lady's Eye," *The Guardian*, February 25, 1980

John Russell Taylor, "Bloodshot View of the World," *The Times*, May 8, 1984, p. 8

William Feavor, "A Classic Orgy," *The Observer*, May 13, 1984

MARTIN PURYEAR

Born in Washington, D.C., May 23, 1941. Studied at Catholic University of America, Washington, D.C., B.A., 1963; Swedish Academy of Art, Stockholm, 1966–68; School of Art and Architecture, Yale University, New Haven, M.F.A., 1971. Lives in Chicago.

Selected One-Person Exhibitions

Grona Palleton Gallery, Stockholm, May 18–30, 1968

Henri 2 Gallery, Washington, D.C., January 8–February 4, 1972; September 8–October 3, 1973

Fisk University, Nashville, 1972

The Corcoran Gallery of Art, Washington, D.C., July 29–September 18, 1977

Protetch-McIntosh Gallery, Washington, D.C., May–June 1978; November 20–December 15, 1979

Museum of Contemporary Art, Chicago, February 1–March 11, 1980. Catalogue with text by Judith Russi Kirshner

Young Hoffman Gallery, Chicago, May 2–31, 1980

Joslyn Art Museum, Omaha, August 2–September 14, 1980. Catalogue with text by Holliday T. Day

Delahunty Gallery, Dallas, October 10–November 11, 1981

McIntosh-Drysdale Gallery, Washington, D.C., February 6–March 3, 1982

Young Hoffman Gallery, Chicago, May 21–July 6, 1982

Donald Young Gallery, Chicago, September 24–November 3, 1983

University Gallery, University of Massachusetts, Amherst, *Martin Puryear*, February 4–March 16, 1984. Catalogue with texts by Hugh M. Davies, Helaine Posner and the artist. Traveled in the United States, 1984

Margo Leavin Gallery, Los Angeles, *Martin Puryear*, January 12–February 16, 1985

Chicago Cultural Center, *Public and Personal*, February 6–April 4, 1987

Carnegie-Mellon University Art Gallery, Pittsburgh, April 12–May 30, 1987. Catalogue with text by Elaine A. King

Selected Bibliography

David Bourdon, "Martin Puryear at Henri 2," *Art in America*, vol. 62, January–February 1974, p. 110

David Tannous, "Martin Puryear at the Corcoran," *Art in America*, vol. 66, May–June 1978, p. 119

Mary Swift and Clarissa Wittenberg, "An Interview with Martin Puryear," *The Washington Review of the Arts*, October–November 1978, p. 33

Jonathan Crary, "Martin Puryear's Sculpture," *Artforum*, vol. XVIII, October 1979, pp. 28–31

Benjamin Forgey, "Puryear's Circles: Subtle, Brooding Presence," *The Washington Star*, December 7, 1979, p. C3

Alan Artner, "Martin Puryear, Museum of Contemporary Art," *Chicago Tribune*, February 22, 1980, section 3, p. 13

Mary Swift, "Martin Puryear–Protetch McIntosh Gallery," *The Washington Review of the Arts*, February–March 1980, p. 21

Buzz Spector, "Martin Puryear," *New Art Examiner*, vol. 7, April 1980, p. 22

Franz Schultz, "Puryear Works: Elegant Simplicity," *Chicago Sun Times*, May 18, 1980, p. 11

Matthew Kangas, "Martin Puryear, Gallery Seattle," *Vanguard*, vol. 10, September 1981, p. 42

Lee Fleming, "Martin Puryear, McIntosh-Drysdale Gallery," *The Washington Review of the Arts*, April–May 1982, p. 28

Alan Artner, "Martin Puryear," *Chicago Tribune*, June 25, 1982, section 3, p. 13

John Ashbery, "Visions of the Olympics," *Newsweek*, January 24, 1983, pp. 74–75

Henry Hanson, "Puryear's Poster," *Chicago*, July 1983, p. 13

Laura Holland, "Martin Puryear: Sculpture, Berkshire Museum, Pittsfield," *Art New England*, May 1984

Christine Temin, "Puryear's Primitive Sophistication," *The Boston Globe*, July 7, 1984, p. 8

Kenneth Baker, "Journal of the Puryear," *The Boston Phoenix*, July 10, 1984, pp. 5, 14

Michael Brenson, "Sculpture: Puryear Post-minimalism," *The New York Times*, August 10, 1984, p. C24

Randy Opincar, "The Puryear Exhibition," *Reader* (San Diego), October 11, 1984, pp. 1, 12

Jeff Kelley, "Puryear's Sculpture Casts a Spell," *Los Angeles Times*, October 29, 1984, part IV, pp. 1, 3

Robert Pincus, "A Transformer of Minimalism," *Los Angeles Times*, November 5, 1984, part IV, pp. 1, 6

Marla Hellman, "LJMCA & Puryear: What a Combination," *The UCSD Guardian*, November 8, 1984, p. 1

Michael Brenson, "Sculptors Find New Ways to Work with Wood," *The New York Times*, December 2, 1984, pp. C29, C32

Jeanne Silverthorne, "Martin Puryear," *Artforum*, vol. XXII, December 1984, p. 82

Stacy Paleologos Harris, ed., *Insights/On Sites: Perspectives on Art in Public Places*, Washington, D.C., 1984, p. 26

Cynthia Nadelman, "Broken Premises...," *Art News*, vol. 85, February 1985, pp. 88–95

Judith Russi Kirshner, "Martin Puryear, Margo Leavin Gallery," *Artforum*, vol. XXIII, Summer 1985, p. 115

Sue Taylor, "Poetic Resonance Marks Puryear's New Sculpture," *Chicago Sun Times*, October 23, 1985, p. 50

Alan Artner, "Perfection Is Hallmark of Puryear's Sculpture," *Chicago Tribune*, October 25, 1985, pp. 51–52

Michael Brenson, "How Sculpture Freed Itself from the Past," *The New York Times*, December 15, 1985, p. C39

Charlotte Moser, "Martin Puryear at Donald Young," *Art News*, vol. 85, January 1986, p. 116

Vivien Raynor, "After Nature," *The New York Times*, February 21, 1986, p. C26

Alan Artner, "A Sculptor's 2 Sides: Martin Puryear on His Public and Private Art," *Chicago Tribune*, February 1, 1987, section 13, pp. 14–15

Colin Westerbeck, "Martin Puryear," *Artforum*, vol. XXV, May 1987, p. 154

SIMON READ

Born in Bristol, England, May 23, 1949. Studied at Somerset College of Art, 1968–69; University of Leeds, 1969–73; Chelsea School of Art, London, 1973–75. Lives in London.

Selected One-Person Exhibitions

Acme Gallery, London, *Twelve Stern Presences*, August 1976

Park Square Gallery, Leeds, *Entente*, April 1977

Wakefield Art Gallery, *Trajectory*, April–May 1977

Anthony Stokes Gallery, London, *An Imposition at Anthony Stokes*, November 1977; *Simon Read: Optical Wedges*, March 19–April 19, 1981

Roundhouse Gallery, London, *Faltering Steps-Staggering Feat*, July 1978

Galerie Swart, Amsterdam, *3 works for an anamorphic camera*, August 1979

De Appel Foundation, Amsterdam, *There Are Capabilities*, April 8–20, 1980

Sunderland Arts Centre, *Simon Read: The Chase*, June 23–July 25, 1981. Catalogue. Traveled to Arnolfini Gallery, Bristol, August 15–September 5, 1981; Ikon Gallery, Birmingham, October 1981; Minories, Colchester, February 1982

Camerawork, London, *Terra Incognita*, September 28–October 23, 1982

Lewis Johnstone Gallery, London, *A Clean Set of Heels*, November 25–December 18, 1982

Mendel Art Gallery, Saskatoon (Saskatchewan), *Simon Read: Landmarks*, March 8–April 15, 1984. Catalogue with texts by Grant Arnold and Lewis Biggs. Traveled to Mackenzie Art Gallery, Regina (Saskatchewan), April 27–June 3, 1984; Southern Alberta Art Gallery, Lethbridge, June 9–July 8, 1984

Chelsea School of Art Gallery, London, May 21–June 2, 1984

National Museum of Photography, Film and Television, Bradford (Yorkshire), *Other Works and River Entries*, March 25–June 29, 1986.

Catalogue with texts by Lewis Biggs, Teresa Gleadowe and the artist

Selected Bibliography

By the Artist

"Simon Read," *Aspects*, Spring 1980, unpaginated

"Simon Read," *Aspects*, Spring 1981, unpaginated

"The Chase," *Aspects*, Summer 1981

"Neither to Run with the Hare nor Hunt with the Hounds," *And*, Spring 1986

On the Artist

Richard Cork, "When a One-Man Show Clicks," *Evening Standard*, August 26, 1976

Sarah Kent, "Twelve Stern Presences," *Time Out*, August 1976, p. 47

Mike Hazzledine, "Simon Read," *Studio International*, vol. 193, January/February 1977, pp. 47–48

Bill Oliver, "Park Square Gallery Leeds," *Yorkshire Evening Post*, April 15, 1977

Stephen Chaplin, "Stephen Chaplin Looks at Work of Simon Read in Leeds and Wakefield," *Yorkshire Arts Association Magazine*, April 1977, pp. 12–13

Bill Oliver, "Trajectory," *Yorkshire Evening Post*, May 5, 1977

Sarah Kent, "An Imposition at Anthony Stokes' Gallery," *Time Out*, November 2, 1977, p. 47

Ian Banks, "A Camera Obscurer," *Photography Magazine*, vol. 13, October 1978, p. 715

Andrea Hill, "Simon Read at the Roundhouse," *Artscribe*, October 1978, pp. 56–57

"The Biggest Pinhole Camera in the World," *Photographic Technique*, vol. 6, December 1978, p. 27

Stuart Morgan, "Chase, Arnolfini Gallery, Bristol," *Artforum*, vol. XX, December 1981, pp. 81–82

Richard Gorenko, "Simon Read: Mendel Art Gallery, Saskatoon," *Vanguard*, vol. 13, September 1984, p. 33

GEORGES ROUSSE

Born in Paris, July 28, 1947. Lives in Paris and Rome.

Selected One-Person Exhibitions

Cabinet des Estampes, Bibliothèque Nationale, Paris, *Georges Rousse*, December 7, 1981–January 23, 1982

Galerie Farideh Cadot, Paris, *Georges Rousse*, January 8–February 1, 1983; September 15–October 15, 1984; November 16, 1985–January 15, 1986; September 20–November 20, 1986

Nicola Jacobs Gallery, London, *Georges Rousse*, February 1–26, 1983

Centre des Arts Plastiques Contemporains, Musée d'Art Contemporain de Bordeaux, *Georges Rousse, Photographies*, March 18–April 23, 1983

Galerie Grita Insam, Vienna, *Georges Rousse*, January 1984; *Georges Rousse, Kunst Raum, Wien*, November 15–December 5, 1985

The Quay Gallery, San Francisco, *Georges Rousse*, March 5–30, 1984

Comédie de Caen, Centre Dramatique National de Normandie, *Georges Rousse*, April 2–30, 1984

Musée Municipal de La Roche-sur-Yon, *Georges Rousse*, May 16–June 16, 1984. Catalogue with text by Catherine Strasser

Galerie Michael Haas, Berlin, *Georges Rousse*, July 1984

Halle Sud, Geneva, *Georges Rousse*, September 7–30, 1984

Annina Nosei Gallery, New York, *Georges Rousse*, September 11–October 11, 1984

Mendelsohn Gallery, Pittsburgh, September 1984

Musée des Beaux-Arts d'Orléans, *Georges Rousse*, April 19–June 3, 1985. Catalogue with interview with the artist by Jean de Loisy

Galerie Graff, Montreal, *Georges Rousse, Photographies*, May 29–June 26, 1985

Eglise Saint Martin-du-Mejan, Arles, *Georges Rousse*, May 17–July 15, 1986

Dolly Fiterman Gallery, Minneapolis, *Georges Rousse*, January 20–March 2, 1987

Centre d'Art Contemporain, Castres, *Georges Rousse*, March 4–April 15, 1987. Catalogue with text by Didier Arnaudet

Galleria Claudio Guenzani, Milan, *Georges Rousse*, March 23–May 15, 1987

Arnolfini Gallery, Bristol, *Georges Rousse*, July 4–August 16, 1987. Catalogue with texts by Elio and Luigi Grazioli. Traveled to Third Eye Centre, Glasgow, September 12–October 11, 1987

Selected Bibliography

Michel Nuridsany, "Georges Rousse," *Art Press*, April 1982, p. 20

Laurent Pesenti, "Georges Rousse," *Artistes*, June–July 1982, pp. 37–38

"Georges Rousse, Biennale de Paris," *Axe Sud*, Autumn 1982

Michel Nuridsany, "Georges Rousse, un baroque flamboyant," *Le Figaro*, January 19, 1983, p. 26

Philippe Dagen, "Rousse," *Le Quotidien de Paris*, January 20, 1983

Geneviève Breerette, "Georges Rousse: Figures de l'éphémère," *Le Monde*, January 27, 1983, p. 16

Maïten Bouisset, "Georges Rousse: Une Photographie pour un instant de peinture," *Le Matin*, January 28, 1983, p. 36

Michel Nuridsany, "Georges Rousse: Un Baroque épris de synthèse," *Art Press*, January 1983, pp. 28–29

Georgina Oliver, "Georges Rousse: From Shambles to Success," *Images*, April 1983, pp. 60–61

Didier Arnaudet, "Georges Rousse, C.A.P.C.," *Art Press*, May 1983, p. 48

Patrice Bloch and Laurent Pesenti, "Georges Rousse, un timide sûr de lui," *Beaux-Arts Magazine*, May 1983, pp. 82–87

Delphine Renard, "Georges Rousse, Farideh Cadot," *Flash Art*, May 1983, p. 74

Michael Brenson, "'Three French Artists' at Zabriskie Gallery," *The New York Times*, August 5, 1983, p. C19

Andy Grundberg, "In the Arts: Critics' Choices," *The New York Times*, August 7, 1983, p. G3

Jérôme Sans, "Georges Rousse, Musée Municipal," *Art Press*, July–August 1984, p. 66

Catherine Strasser, "Georges Rousse, Musée Municipal," *Art Press*, July–August 1984, p. 66

Mireille Descombes, "La Magie de Georges Rousse," *La Tribune de Genève*, September 23, 1984

Christian Caujolle, "Georges Rousse, architecte, peintre, photographe," *Libération*, October 11, 1984

Catherine Flohic, "Georges Rousse: Biographie," *Eighty*, November–December 1984, pp. 62–63

Catherine Strasser, "Georges Rousse, No Escape, No Tarrying," *Artefactum*, November–December 1984, pp. 45–47

Catherine Strasser, "Resistance," *Eighty*, November–December 1984, pp. 33–61

Olivier Céna, "L'Enlumineur de mémoire: Les Rêves éphémères de Georges Rousse," *Télérama*, May 1, 1985, p. 40

Jean Tourangeau, "Georges Rousse, *Graff*, Montreal," *Vanguard*, vol. 14, September 1985, p. 46

Gilles Daigneault, "Une Oeuvre montréalaise de Georges Rousse," *Le Devoir*, October 18, 1985, p. 6

Jocelyne Lepage, "Un Drôle d'aventurier," *La Presse*, October 19, 1985

"Espaces pièges," *Connaissance des Arts*, November 1985, p. 6

Philippe Dagen, "Georges Rousse, le géomètre du trompe-l'oeil," *Le Monde*, January 1, 1986, p. 12

Jocelyne Lupien, "Georges Rousse ou la dérobade de l'anamorphose," *Parachute*, March–May 1986, pp. 13–15

Mona Thomas, "Georges Rousse," *Galeries Magazine*, April 1986, pp. 44–47

Michael Brenson, "Georges Rousse," *The New York Times*, October 10, 1986, p. C32

Dan Cameron, "In the Realm of Hyperabstract," *Arts Magazine*, vol. 61, November 1986, pp. 36–40

Michel Enrici, *Georges Rousse*, Arles, 1986

Jean-Michel Michelena, ed., *L'Eternité heureuse*, Sommevoire, France, 1986, pp. 29–38

Eleanor Heartney, "Georges Rousse at Farideh Cadot," *Art in America*, vol. 75, January 1987, p. 131

GAEL STACK

Born in Chicago, April 28, 1941. Studied at University of Illinois, Champaign-Urbana, B.F.A., 1970; Southern Illinois University, Carbondale, M.F.A., 1972. Lives in Houston.

Selected One-Person Exhibitions

The Graphics Gallery, San Francisco, *Gael Stack*, January 2–February 2, 1974

Meredith Long Gallery, Houston, July 25–August 6, 1975; June 17–26, 1976; April 28–May 28, 1977; August 2–September 2, 1978; March 13–April 18, 1980; June 23–July 18, 1981

Museum of South Texas, Corpus Christi, *Gael Stack*, November 3–December 18, 1977

Contemporary Arts Museum, Houston, *Four Painters*, October 10–November 29, 1981. Catalogue with text by Linda Cathcart

Janie C. Lee Gallery, Houston, September 23–October 29, 1983; December 5, 1985–January 10, 1986; January 29–March 31, 1987

Selected Bibliography

Thomas Albright, "Unusual Art in San Francisco," *San Francisco Chronicle*, January 7, 1974, p. 41

John Marlowe, "In San Francisco, " *West Art*, January 11, 1974, p. 2

Charlotte Moser, "Bigger Art Has Never Meant Better Art," *Houston Chronicle*, August 3, 1975, p. 12

Donna Tennant [review], *Houston Chronicle*, April 3, 1980, section 5, p. 14

"Gael Stack at the Guggenheim," *Houston Chronicle—Texas Magazine*, May 3, 1981, pp. 50–51

Charlotte Moser, "Artists the Critics Are Watching," *Art News*, vol. 80, May 1981, pp. 86–87

A. H. Roberts, "Gael Stack at the Guggenheim," *ArtScene*, May–June 1981, p. 4

Patricia Johnson, "Viewer Gets Pleasure of Attempting to Unravel Mysteries of 'Witches,'" *Houston Chronicle*, June 27, 1981, section 3, p. 5

Mimi Crossley, "Four Poetic Painters," *Houston Post*, October 1, 1981, pp. 12–13AA

Patricia Johnson, "Gael Stack: Artist-Teacher," *Houston Chronicle*, October 4, 1981, pp. 15–16

Patricia Johnson, "Painting from the Inside," *Houston Chronicle*, October 18, 1981, p. 18

Gary McCay, "Four Artists, Four Styles," *Houston Home and Garden*, vol. 8, February 1982, pp. 28–32

Susie Kalil, "Four Painters at the Contemporary Arts Museum," *Art in America*, vol. 70, April 1982, pp. 144–145

Patricia Johnson, "Art," *Houston Chronicle*, October 2, 1983, pp. 15–16

Jana Vanderlee, "Gael Stack and Clyde Connell: Hinged on Time," *Artspace*, vol. 7, Fall 1983, pp. 23–25

Susan Freudenheim, "Gael Stack: Narrator of Emotions," *Texas Homes*, vol. 8, July 1984, pp. 20–24

Patricia Johnson, "Stack Fights Battle of Revelation," *Houston Chronicle*, December 14, 1985, section 6, p. 1

Suzanne Bloom and Ed Hill, "Gael Stack," *Artforum*, vol. XXIV, March 1986, p. 125

Carl Bocksch-Juul, "Le Choix des Connaisseurs," *Connaissance des Arts*, December 1986, p. 50

Gay Block and Annette Carlozzi, *Fifty Texas Artists: A Critical Selection of Painters and Sculptors Working in Texas*, San Francisco, 1986, pp. 88–89

Susan Chadwick, "Gael Stack at Janie C. Lee," *Houston Post*, February 8, 1987, p. F8

Patricia Johnson, "Touring the Galleries," *Houston Chronicle*, February 8, 1987, p. 18

PATRICK TOSANI

Born in Boissy l'Aillerie (Val d'Oise), France, September 28, 1954. Studied at Ecole Spéciale d'Architecture, Paris, 1973–79. Lives in Paris.

Selected One-Person Exhibitions

Espace Avant-Première, Paris, June 1–26, 1982

Galerie Liliane et Michel Durand-Dessert, Paris, May 25–July 22, 1983; *Livre d'artiste: "Portraits,"* May 30–June 29, 1985

Association l'Oeil Permanent, Nantes (organizer), *Patrick Tosani*, Palais de la Bourse, Nantes, December 15, 1983–January 7, 1984; Musée Municipal de La Roche-sur-Yon, February 4–March 13, 1984; Athénéum and Le Consortium, Dijon, April 17–30, 1984; Palais des Congrès et de la Culture, Le Mans, May 3–29, 1984. Catalogue with text by Jean de Loisy

Gallery Taka Gi, Nagoya, April 1–20, 1986

Galerie Christian Laune, Montpellier, May 24–June 28, 1986

Selected Bibliography

Jean de Loisy, "Patrick Tosani: Photographe de glaçons," *Art Press*, February 1982, p. 35

Patrice Bloch and Laurent Pesenti, "F.I.A.C., Patrick Tosani," *Beaux-Arts Magazine*, October 1983, pp. 58–59

Bernard Blistène, "Patrick Tosani, Galerie Durand-Dessert," *Flash Art*, Fall 1983, p. 46

Mona Thomas, "Paris: Patrick Tosani," *Beaux-Arts Magazine*, June 1985, p. 93

Elisabeth Vedrenne, "Une Consécration, Patrick Tosani," *Décoration Internationale*, June 1985, p. 10

Philippe Nottin, "Patrick Tosani, portraits," *Kanal*, Summer 1985, p. 44

Philippe Piguet, "Patrick Tosani: A fleur de peau," *L'Art Vivant*, Summer 1985, p. 13

Régis Durand, "Patrick Tosani, Galerie Durand-Dessert," *Art Press*, September 1985, pp. 68–70

Jean-Pierre Bordaz, "Montpellier: Patrick Tosani," *Beaux-Arts Magazine*, June 1986, p. 94

Philippe Piguet, "Montpellier, Patrick Tosani," *L'Oeil*, June 1986, p. 86

Régis Durand, "Photographies, événements de l'espace," *Art Press*, April 1987, pp. 28–31

DANIEL TREMBLAY

Born in Angers (Anjou), France, March 7, 1950. Studied at Royal College of Art, London, 1977–80. Died in Angers, April 9, 1985.

Selected One-Person Exhibitions
Galerie Farideh Cadot, Paris, *Un Regard autre*, September 15–October 15, 1981; June 17–July 8, 1983; *Sculptures récentes*, March 22–April 20, 1985

Musée de Toulon, *Daniel Tremblay*, December 2, 1982–January 9, 1983. Catalogue with texts by Marie-Claude Beaud and Guillemette Coulomb

Selected Bibliography
Maïten Bouisset, "Les Jeunes au banc d'essai," *Le Matin*, October 6, 1981

Catherine Strasser, "Galerie Farideh Cadot, un regard autre," *Art Press*, November 1981, p. 38

Daniel Bombert, "Daniel Tremblay, Bernard Faucon: Musée de Toulon," *Art Press*, February 1983, p. 49

Maïten Bouisset, "L'Un est anglais, l'autre pas," *Le Matin*, June 17, 1983, p. 38

Frank Maubert, "Daniel Tremblay," *L'Express*, June 24–30, 1983, p. 160

Hans-Peter Schwerfel, "Malen macht wieder spass," *Art, Das Kunstmagazin*, June 1983, pp. 84–93

Patrice Bloch and Laurent Pesenti, "Daniel Tremblay: Accumulations oniriques," *Les Nouvelles Littéraires*, September 14–20, 1983, p. 54

Anne Tronche, "Daniel Tremblay," *Opus International*, Winter 1983, pp. 22–23

"Fondation Jourdon, l'hôtel revisité," *City Magazine International*, December 1984

Henri-François Debailleux, "Paris: Daniel Tremblay," *Beaux-Arts Magazine*, April 1985, p. 87

Catherine Strasser, "Daniel Tremblay, mirage," *Halle Sud*, April 1985, p. 1

Anne Dagbert, "Daniel Tremblay, Galerie Farideh Cadot," *Art Press*, May 1985, pp. 64–66

Catherine Strasser, "Daniel Tremblay, apparence d'espace," *Art Press*, July–August 1985, p. 27

DANNY WILLIAMS

Born in Waco, Texas, May 4, 1950. Studied at Southern Methodist University, Dallas, B.A., 1972; University of Iowa, Iowa City, M.A., 1976. Lives in Dallas.

Selected One-Person Exhibitions
The Art Center, Waco, *Danny Williams–Travels 1977-1978*, October 11–November 9, 1980

Delahunty Gallery, Dallas, *Danny Williams: Paintings 1979–1980*, November 8–December 10, 1980; *Danny Williams–New Works*, April 20–June 4, 1983; *Danny Williams–Works on Paper*, April 16–July 4, 1984

Butler Gallery, Houston, *Danny Williams–Paintings*, July 12–August 30, 1986

Barry Whistler Gallery, Dallas, *Danny Williams: Works and Days*, September 13–October 22, 1986

Selected Bibliography
Susan Freudenheim, "Danny Williams: Geometric Abstractions," *Texas Homes*, May 1983, pp. 16–19

Michael Ennis, "The Retrograde Sophisticate: Danny Williams," *Texas Monthly*, June 1983, pp. 162–167

Janet Kutner [review], *The Dallas Morning News*, May 4, 1984, p. C1

Janet Kutner [review], *The Dallas Morning News*, October 14, 1986, p. E6

Susan Freudenheim [review], *Artforum*, vol. XXV, December 1986, pp. 120–121

GILBERTO ZORIO

Born in Adorno Micca, Italy, September 21, 1944. Studied at Accademia Albertina di Belle Arti, Turin, degree, 1970. Lives in Turin.

Selected One-Person Exhibitions

Galleria Sperone, Turin, November 1967, catalogue with text by Tommaso Trini; February 1969; May 1971; December 1973; November 1974

Centro Colautti, Salerno, May 1968. Catalogue with text by Alberto Boatto

Galerie Sonnabend, Paris, February 1969

Galleria Toselli, Milan, May 1970; May 1974

Galleria Flori, Florence, March 1971

Modern Art Agency, Naples, June–July 1971

Incontri Internazionali d'Arte, Palazzo Taverna, Rome, December 1971

Galerie MTL, Brussels, December 1973

Galleria Sperone, Rome, January 1974

Galleria dell'Ariete, Milan, October 1975

Kunstmuseum Luzern, *Gilberto Zorio*, May–June 1976. Catalogue with texts by Jean-Christophe Ammann, Ugo Castagnotto and Werner Lippert

Galleria Schema, Florence, October 1976

Studio De Ambrogi/Cavellini, Milan, December 1976

Galleria del Tritone, Biella, January 1977; April 1978

Studio G7, Bologna, March 1977, catalogue with text by Roberto Daolio; April 1980, catalogue with text by Luciana Rogozinski

Studio Cesare Manzo, Pescara, December 1977

Piero Cavellini, Brescia, January 1978; January 1982

Galerie Eric Fabre, Paris, February 1978; May 1980

Galerie Albert Baronian, Brussels, February–March 1978; April 3–May 31, 1980; April 5–May 31, 1984; December 5, 1986–January 31, 1987

Galerie 't Venster, Rotterdam, March 1978

Piero Cavellini, Milan, April 1978; February–March 1982

Salone Annunciata, Milan, April 1978

Studio Carlo Grossetto, Milan, April 1978

Jean and Karen Bernier, Athens, February 1979; November 1980

Galleria Christian Stein, Turin, February 1979; *Gilberto Zorio*, October–November 1982; January 16–February 28, 1986

Stedelijk Museum, Amsterdam, *Gilberto Zorio*, March 29–May 13, 1979. Catalogue with text by Jean-Christophe Ammann

Emilio Mazzoli, Modena, September 1979

Halle für Internationale Neue Kunst, Zürich, February 19–April 3, 1980

Galleria De Crescenzo, Rome, February 1980; October 1982

Galleria Salvatore Ala, Milan, February 1981

Galerie Meyer-Hahn, Düsseldorf, May 1981

Galerie Rudiger Schöttle, Munich, July 1981

Sonnabend Gallery, New York, October 1981

Galerie Appel und Fertsch, Frankfurt, November 4–December 12, 1981. Catalogue with text by Werner Lippert

Pinacoteca Comunale, Ravenna, *Gilberto Zorio*, December 11, 1982–January 31, 1983. Catalogue with texts by Beatrice Merz, Denys Zacharopoulos and the artist

Galerie Müller-Roth, Stuttgart, May 6–June 11, 1983

Galerie Storms, Munich, June 24–August 6, 1983

Forum Kunst, Rottweil, West Germany, June 1983

Galerie Au Fond de la Cour à Droite, Chagny, France, January 21–February 21, 1984; February 26–March 25, 1985

Galerie Plurima, Udine, May 1984

Galleria Civica del Comune di Modena, *Gilberto Zorio, opere: 1967–84*, January 20–March 5, 1985. Catalogue with texts by Catherine David, Beatrice Merz, Luciana Rogozinski, Tommaso Trini et al.

Württembergischer Kunstverein, Stuttgart, *Gilberto Zorio*, November 6–December 8, 1985. Catalogue with texts by Sylvia Chessa, Beatrice Merz and the artist. Traveled to Centre d'Art Contemporain, Geneva, April 14–May 24, 1986; Stedelijk van Abbemuseum, Eindhoven, The Netherlands, October–December 1987

Galerie Elisabeth Kaufmann, Zürich, May 27–July 12, 1986

Galerie Jean Bernier, Athens, June 2–July 5, 1986

La XLII Biennale di Venezia, Wunderkammer, June 29–September 28, 1986

Musée National d'Art Moderne, Centre Georges Pompidou, Paris, September 24–December 14, 1986. Catalogue with texts by Alberto Boatto, Catherine David and Denys Zacharopoulos

Galleria Christian Stein, Milan, February 1987

The Tel Aviv Museum, *Energy with a Human Dimension*, March 31–May 23, 1987. Catalogue with text by Nehama Guralnik

Rhona Hoffman Gallery, Chicago, April 24–May 30, 1987

Selected Bibliography

By the Artist

"Gilberto Zorio," *Extra*, July 1975, pp. 32–44

"Gilberto Zorio," *Data*, Summer 1978, p. 30

On the Artist

Germano Celant, "Nuove tecniche d'immagine," *Casabella*, October 1967, p. 59

Germano Celant, "Poor art–arte povera," *B'T*, November 1967

G. E. Simonetti, "Gilberto Zorio alla Galleria Sperone," *B'T*, November 1967, p. 25

Germano Celant, "Appunti per una guerriglia," *Flash Art*, November–December 1967, p. 3

[Review], *Flash Art*, November–December 1967, p. 10

Paolo Fossati, "Gilberto Zorio," *L'Unità*, December 1967

Tommaso Trini, "La scuola di Torino," *Domus*, December 1967, p. 69

Piero Gilardi, "Primary Energy and the 'Microemotive Artists,'" *Arts Magazine*, vol. 43, September–October 1968, pp. 48–52

Maurizio Calvesi, "Schermi TV al posto dei quadri," *L'Espresso*, March 15, 1970, p. 39

Jean-Christophe Ammann, "Zeit, Raum, Wachstrum, Prozasse," *Du*, vol. 8, August 1970, p. 546

Jole de Sanna, "Gilberto Zorio: Corpo di energia," *Data*, vol. 2, April 1972, pp. 16–23

T. Kneubuhler, "Zorio und Odermatt im Luzerner Kunsthaus," *Vaterland*, May 12, 1976

"Manchmal traume ich…Gilberto Zorio im Kunstmuseum Luzern," *Neue Zurcher Zeitung*, May 28, 1976

Peter Killer, "Zorio und Odermatt: Zwischen Aggressivität und Zerbrechlichkeit," *Tages Anzeiger*, June 11, 1976

P. Burri, "Energi wird greifbar," *National Zeitung*, June 12, 1976

Mirella Bandini, "La stella di Zorio," *Data*, December 1976, pp. 48–51

Roberto Daolio, "Energia in forma di stella," *G 7 Studio*, vol. II, March 1977, pp. 4–7

G. Risso, "Gilberto Zorio, energia, ricerca e somiglianza," *Stampa Sera*, November 16, 1978

Luciana Rogozinski, "Gilberto Zorio," *G 7 Studio*, vol. V, March 1980, pp. 4–7

Roberto G. Lambarelli, "Gilberto Zorio," *Segno*, March–April 1980, p. 24

Interview with G. Risso, "L'Acido della verità, incontro con l'artista: Gilberto Zorio," *Gazzetta del Popolo*, May 21, 1980

Renato Barilli, "Gilberto Zorio,"*L'Espresso*, March 29, 1981, p. 99

Lisa Licitra Ponti, "Zorio," *Domus*, May 1981, p. 69

Flaminio Gualdoni, "Gilberto Zorio," *G 7 Studio*, vol. VI, June 1981, pp. 4–5

Luciana Rogozinski, "Gilberto Zorio: Galleria Ala, Milan," *Artforum*, vol. XIX, Summer 1981, p. 102

Ross Skoggard, "Gilberto Zorio at Sonnabend," *Art in America*, vol. 10, December 1981, p. 143

Denys Zacharopoulos, "Gilberto Zorio," *Artistes*, October–November 1982, pp. 46–53

S. Fesser, "Gilberto Zorio," *Kunstwerk*, vol. 35, no. 1, 1982

Luciana Rogozinski, "Zorio a Ravenna," *Domus*, June 1983, p. 67

S. Sprocati, "Gilberto Zorio antologica 1967–1984, Galleria Civica di Modena," *Segno*, December 1984, pp. 28–29

Roberto Vidali, "Gilberto Zorio," *Juliet*, no. 17, 1984, p. 21

Claudio Cerritelli, "Gilberto Zorio, Galleria Civica Modena," *Flash Art*, March 1985, pp. 51–52

R. Händler, "Er ist der härteste Brocken, Gilberto Zorio," *Art das Kunstmagazin*, November 1985, pp. 128–129

Anne Krauter, "Gilberto Zorio," *Kunstforum*, December 1985–February 1986, pp. 289–291

Catherine Grenier, "Gilberto Zorio," *Flash Art*, no. 7–8, 1985, pp. 52–54

M. Teresa Roberto, "Gilberto Zorio, Christian Stein," *Flash Art*, April–May 1986, pp. 48–49

Installation view, *Angles of Vision: French Art Today, 1986 Exxon International Exhibition*, Daniel Tremblay, l. to r., *Untitled*, 1981, and *Untitled*, 1982

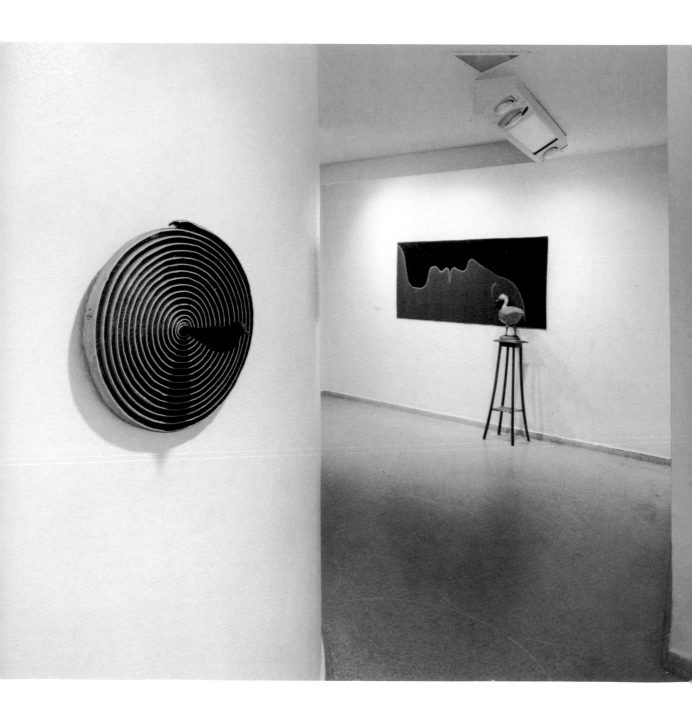

PHOTOGRAPHIC CREDITS

COLOR

Myles Aronowitz: p. 62

Mary Donlon: pp. 25, 119

Carmelo Guadagno: p. 33

Carmelo Guadagno and David Heald: pp. 68, 73, 74

David Heald: pp. 14–15, 62, 69, 72

Robert E. Mates: p. 46

BLACK AND WHITE

Myles Aronowitz: pp. 35, 40

Myles Aronowitz and David Heald: p. 53

Maria Benelli: p. 66

Galerie de Paris: p. 41

Carmelo Guadagno: pp. 30, 31, 34, 50–52, 65, 70, 71

Carmelo Guadagno and David Heald: pp. 67, 114, 124

David Heald: pp. 11, 12, 27–29, 42–45, 47–49, 54–61, 63–65, 75–77, 98, 106, 139

Robert E. Mates: pp. 26, 32, 38, 39, 78, 87, 128

Enzo Ricci: p. 79

Sarah Wells: p. 36

Alan Zindman, courtesy Sonnabend Gallery: p. 37

INDEX OF ARTISTS IN THE CATALOGUE

Exhibition 87/4

3,000 copies of this catalogue, designed by
Malcolm Grear Designers, Inc., and typeset by
Schooley Graphics/Craftsman Type, have
been printed by Eastern Press in August
1987 for the Trustees of The Solomon R.
Guggenheim Foundation on the occasion
of the exhibition **Emerging Artists 1978–1986:
Selections from the Exxon Series.**